GET YOUR PHOTOGRAPHY ON THE WEB

THE FASTEST, EASIEST WAY TO SHOW & SELL YOUR WORK

Rafael "RC" Concepcion

The *Get Your Photography on the Web* Book Team

CREATIVE DIRECTOR
Felix Nelson

ASSOCIATE ART DIRECTOR
Jessica Maldonado

TECHNICAL EDITORS
Kim Doty
Cindy Snyder

TRAFFIC DIRECTOR
Kim Gabriel

PRODUCTION MANAGER
Dave Damstra

PHOTOGRAPHY BY
Rafael "RC" Concepcion

PUBLISHED BY
Peachpit Press

Copyright ©2011 by Kelby Corporate Management, Inc.

Composed in Univers, St. Ryde, and Cholla by Kelby Media Group, Inc.

Trademarks
All terms mentioned in this book that are known to be trademarks or service marks have been appropriately capitalized. Peachpit Press cannot attest to the accuracy of this information. Use of a term in the book should not be regarded as affecting the validity of any trademark or service mark.

Photoshop is a registered trademark of Adobe Systems Incorporated.
Photoshop Elements is a registered trademark of Adobe Systems Incorporated.
Photoshop Lightroom is a registered trademark of Adobe Systems Incorporated.
Macintosh is a registered trademark of Apple, Inc.
Windows is a registered trademark of Microsoft Corporation.

Warning and Disclaimer
This book is designed to provide information about getting photography on the Web. Every effort has been made to make this book as complete and as accurate as possible, but no warranty of fitness is implied.

The information is provided on an as-is basis. The author and Peachpit Press shall have neither the liability nor responsibility to any person or entity with respect to any loss or damages arising from the information contained in this book or from the use of the discs or programs that may accompany it.

ISBN 10: 0-321-75393-3
ISBN 13: 978-0-321-75393-9

9 8 7 6 5 4 3 2 1

Printed and bound in the United States of America

www.kelbytraining.com
www.peachpit.com

To my wife Jennifer:
I can remember very clearly the
first day we met. That's the day I realized
I'd met my true love. You've been the rock
that I lean on, and the shoulder that I cry on.
You're my alpha and omega, and the reason
I have to be a better me. I love you.

FOREWORD

It was about five years ago, and I was down in Miami. On the day before each Photoshop World Conference & Expo, we teach half-day pre-conference workshops, and this year I was teaching a workshop (along with fellow instructors Dave Cross and Matt Kloskowski) called "So You Think You Can Teach Photoshop?" (a take-off on the TV series, *So You Think You Can Dance*).

The class was filled with Photoshop teachers—from in-house trainers, to college professors, to experts wanting to make their living teaching this amazing program. The first part of the class was dedicated to making them better teachers by sharing what we had learned training tens of thousands of students over the years, but in the second part, each of them would be invited to teach a technique to the entire class, and then we would critique their instruction. At the end of the class, the students would vote on the best presentation, and that person would get the opportunity to teach a 30-minute class in the Photoshop World Expo theater the following day (no pressure there, eh?).

The students unanimously made their choice heard for "best in the class" (honestly, it was pretty obvious from the outset who would win. One of them was just that good—head and shoulders above the rest), and the following day, he taught his 30-minute session at the Expo theater (which had to be pretty nerve-wracking, transitioning from student to instructor at the world's largest Photoshop event in just one day).

The next day, I was preparing for my upcoming class when I got a call on my cell phone from the moderator who was running the Expo theater. She said, "You need to get down here!" My heart started racing. I thought something must have gone horribly wrong. She continued, "This guy is amazing! You've gotta see this!" I went down to the Expo right away. Everybody was talking about him, and talking *to* him. He blew everybody away in just 30 minutes.

The next time I talked to him, I was trying to convince RC Concepcion to leave his current job, and move from New York down to Florida to work as a full-time instructor for us at the National Association of Photoshop Professionals (NAPP, for short). Yes, he was that good. And lucky for us, he accepted our offer.

Besides his presentation skills and ability to relate to and engage his students, another reason we wanted him on our team was that he wasn't just another Photoshop guy. He was also an expert in Web design and development, and he would bring a whole new facet to our training.

So I knew RC was an expert instructor, a Photoshop shark, and a Web genius. But it wasn't until one day in the photo studio, when I was short a studio light, and RC casually said, "I can bring in one of my studio strobes if you want," that I realized RC was also a photographer. Not surprisingly, he's not just a photographer—he's a really accomplished photographer and a total "studio rat." He and I spent the next few years in the studio every chance we could (I even had RC do most of the product photography for a few of my best-selling books on photography), and over the past few years RC's fame as a photographer has continued to grow and grow through his own work.

A lot of photographers in our industry knew RC was a Web guru, but once they realized he was a photographer in his own right, they started coming to him to help get them on the Web. Before long, he was helping some of the biggest names in the photo industry build their Web presence. These are working photographers who couldn't spend the time, or the thousands of dollars up front, or the recurring monthly hosting fees the big photo hosting sites were charging to build and maintain websites for pros. The word got out that RC was the go-to guy to get your photo business on the Web, and last year at Photo Plus Expo in New York, I was there as some of the legends of this industry were tracking him down saying, "I heard you're the guy to talk to about getting me on the Web."

He is that guy. After I saw a site that RC had created for a pro sports photographer, I asked him to create an online portfolio for me, and in a day or so, it was up and running. It looked amazing, and not only did I not have to spend thousands of dollars up front, I spend more on coffee in one day than I do on my monthly hosting tab.

Now, everybody who has seen my site wants to get RC to set up their site (it's a vicious cycle, but that's how desperate we, as photographers, are these days to have our custom presence, done our way, without spending an arm and a leg).

One day, after realizing that without RC I wouldn't have a decent Web presence, I called him into my office and asked him, "RC, what do regular photographers do? What do photographers do who don't have an RC to call for help?"

RC agreed that it's a big problem and getting bigger, because we as photographers just want to make images. We don't want to have to learn HTML, Web design software, how to maintain servers, and we don't want to pay a ton for someone else to do it.

That's when I told RC (actually, I begged him), "RC, all the pros know you as the guy leading photographers to the Web. You have got to write a book for everybody else, where you share all this stuff you've been doing for me, and all these other guys, but where we can do it all ourselves. Without becoming Web experts. Without learning all the HTML stuff. And without spending a ton of money."

RC immediately starting riffing about all the stuff he would cover in a book like that, and the insider tips he would share, and how it would start from scratch and take photographers through the entire process. He would be the one to show them exactly how it's done, and how for only about $7 a month they could have a serious Web presence and really start using the Web to build their business.

But he wanted to go beyond just setting up a website. He wanted to show how to leverage social media like Facebook and Twitter to bring people to the sites once they were up and running, and how to take advantage of the tools that are out there today, many of them for free, to give them that big site look for next to nothing.

He knew there had never been a book like it, and I knew he was the guy to write that book. Just like I knew that out of all the people in our industry I could have hired as our next "Photoshop Guy" at NAPP, RC was the one. Yes, he's that good.

I can't tell you how excited I am that you're about to learn from one of the most gifted, talented, and passionate photographers out there today about how to put your business on the Web. RC has a way of cutting through all the baloney, and just telling you exactly what you need to know to get your site up and running, today, and pretty soon everybody will be asking you who set up your site, and who's maintaining it. The cool thing is that you'll be able to say, "I did and I do!"

You're just a few pages, and lots of smiles and ah-ha moments, away from opening a new chapter in your career as a photographer. I'm glad you've found RC, and this book, and now it's time to put both of them to work for you. See you on the Web!

All my best,

Scott Kelby
President, National Association
of Photoshop Professionals

ACKNOWLEDGMENTS

This book was written on the shoulders of so many incredible people. While the list of people that I'd want to thank specifically would be a book in and of itself, I'm going to try to do the best that I can to keep it as short as possible.

I'd love to extend my deepest gratitude and thanks to my mother, Cristela Concepcion. Growing up in the Bronx with so very little, she's the perfect example of how, with love and respect, you can raise an incredible family. Not a day passes that I don't think of all of the gifts you've given me. I love you.

Agradezco profundamente a mi madre, Cristela Concepción, que humildemente sirve como un ejemplo de cómo con amor y respeto se puede criar a una familia increíble. No pasa un día que no recuerdo todo lo que hiciste por mí. Por eso, te quiero con todo mi corazon.

To my father, Rafael Concepcion, who has since passed on. I'm sure he's watching down, smiling at what he was able to create, and I'm grateful to him for raising me with a sense of right and wrong, and giving me the intelligence to choose.

To my brothers, Victor, Everardo, Jesus, and "baby bro" Tito, for being there when I've needed them. A special thanks goes out to my brother Carlos and his wife Vicky. One conversation with Carlos changed the course of what I've done, and I'm grateful for that. Last, but not least, to my brother Dave: you've been a sounding board and confidant for so long, it was hard to imagine a time when I wasn't with you.

To my uncle Rene, who is always a trusted advisor in my life. To my sister Daisy Concepcion and Norman Wechsler, who always believed I would be able to achieve great things. To Jim and Danielle Bontempi, the best in-laws one could ever ask for. To Merredith Bontempi and Tim Ruymen for being so supportive. Erin and Bill Irvine round out a great family that I'm thankful for.

I've been blessed with great friends. Jennifer Vacca and Lucy Cascio at Zoot Shoot Photographers gave me my start in a studio. Charlie Enxuto and Steve Zimic taught me so much at Split Image Photo. Annie Gambina of New Horizons let me wreak havoc in her classrooms. Matt Davis has always been a great cheerleader and sounding board. I've received inspiration and sage advice from Brigitte and Debbie Calisti. I've spent days on end laughing with Kyle Robinson and his wife Teresa. Bruce "Disco" McQuiston and I shared many a tender moment listening to Enigma. Mike McCarthy will forever be one of the funniest guys I know. Jane Caracciolo has been the person whom I'd call in the middle of the night to answer the most complex of problems. Her mother Jane Caracciolo, Sr., will forever be known as my second mother—one whom I love immensely. To Andrea Barrett: I miss you! Matt Wanner's a heck of a firefighter, and an even better writer and friend. Then there's Jeremy Sulzmann and Mohammed al Mossawi, two of my mates while living in Germany. Here are two friends I can call on to fly around the world (or share a tube ride) to meet me in London for just one night.

To my Tampa crew: Alan and Nicolle Brusky, Kathy Porupski, Erik Valind, David Rogers, Michael Sheehan, Keith Winn, Rob Hererra, Scott Krebs, Dan Underwood, Tony Gomes, Emily Haskin, and Wendy Weiss, who gets to pull double duty as my photography buddy and doctor. You couldn't imagine what an office visit is like now!

A special thanks goes out to Yolanda, Neil, and the Corteo family for being such great friends to us here in Tampa (and for having the best pizza around).

To Bonnie Scharf: I've known you for over 18 years, and you're like a sister to me. Fortunately for me, you've been there through thick and thin. Unfortunately for you, you've had to put up with me for that long!

To Albert J. Fudger: you are my best friend. I've talked to you on a daily basis for over 16 years and there's not been a time when I have not been laughing through it. Thank you for letting me write this book on your kitchen table. An even bigger thanks for being the friend that you are to me and my family. Boop!

This book would not have been possible without the guidance and tutelage of Scott Kelby. I met Scott several years ago, and still keep a picture of that meeting to this day. While I'm grateful for his experience and skill at being the best in the business, I'm an even bigger admirer of his grace, candor, goodwill, trust, and unbending dedication to his friends and his family. He's an awesome mentor, and he and his wife Kalebra are models for what true friends and dedicated Christians should be. For that, I am forever grateful.

I'm privileged to have Moose Peterson as a mentor and friend. Through countless meetings, you've served as a photographic compass for me. You and Sharon will always be near and dear to our family for that.

I've been inspired by Joe McNally's work for longer than I've been using Photoshop. To be able to count him and his wife, Annie, as trusted friends and mentors has been one of the best gifts a person could ask for.

To Bert Monroy: you embody what it means to be brilliant at Photoshop. Thank you for being a great friend and inspiration to me.

Then there's my family at Kelby Media Group. To my editors, Cindy Snyder and Kim Doty: thank you for chiseling and polishing this book to perfection. To Jessica Maldonado: you're the best book designer in the business! To Kathy Siler, for always making me smile! To Felix Nelson, our Creative Director: thank you for steering this ship on top of the five thousand other things you're busy amazing people with. To Justin Finley and Tommy Maloney: you guys are aces in the design and programming biz. Thanks for all of your help. To Brad Moore: thanks for being such a great sounding board and lunch partner. To our IT director, Paul Wilder: thanks for keeping me up and running, and letting me run my experiments on the computer. To Dave Moser: thank you for being our fearless leader, and such a wonderful friend.

A special shout out to my fellow Photoshop Guys, Dave Cross, Corey Barker, and Matt Kloskowski. Matt, I can't thank you enough for being such a great advisor on so many things. It's a privilege and an honor to call you my friend.

My sincere appreciation goes out to all of my friends at Peachpit Press: Scott Cowlin, Sara Jane Todd, Gary-Paul Prince, Nikki McDonald, Glenn Bisignani, Barbara Gavin, Jennifer Bortel, Laura Pexton Ross, Kara Murphy, and Nancy Aldrich-Ruenzel. A special thanks goes out to my editor, Ted Waitt, for all of his help on the book!

The work of the following people never ceases to inspire me: Jay Maisel, Katrin Eismann, Deke McClelland, Terry White, Eddie Tapp, Jim DiVitale, Joe Glyda, Rich Harrington, David Ziser, Trey Ratcliff, Cliff Mautner, Rick Sammon, John Paul Caponigro, Lois Greenfield, David Lynch, Andrzej Dragan, David Hobby, Steve McCurry, Jeremy Cowart, Susan Meiselas, Gregory Heisler, Vincent Versace, and John Loengard. To Jeff Revell: thanks for being such a great supporter of this book, and being my PR agent at Photoshop World!

To my wife, Jennifer Concepcion, to whom this book is dedicated: thank you for believing in me, sometimes more than I could in myself. You gave me a book several years ago and said, "You know, I think you can be on that stage, if you really want it." Fast-forward to today, and we're living this dream. It all happens because of you.

To my little girl, Sabine Annabel: out of all of the things that I've accomplished, being your daddy is the one that I was made for. I love you more than I could ever say.

Last, but certainly not least, thank you, my dear reader. By the sheer grace and goodwill from the Almighty, He has blessed me with a life where I get to share the things that I truly love with each and every one of you. It's a gift I accept with great humility, and enormous pride, and I am very grateful.

ABOUT THE AUTHOR

Rafael "RC" Concepcion is an education and curriculum developer for the National Association of Photoshop Professionals, and one of the Photoshop Guys. An award-winning photographer and Adobe Certified Instructor in Photoshop, Illustrator, and Lightroom, RC has over 14 years in the tech industry, designing sites and training thousands in technologies from Adobe and Microsoft. RC spends his days developing content for all applications in the Adobe Creative Suite at Kelby Media Group. His ability to speak passionately about technology and the Web has engaged audiences in the U.S., Europe, and Latin America. Most recently, RC has combined his photographic and Web experience to teach with famed wildlife photographer Moose Peterson at the "You Can Do It, Too" workshops in Mammoth, California, the Digital Landscape Workshop Series, and at the Voices That Matter Web Conference in San Francisco. RC also writes columns for *Photoshop User* magazine. He lives in Tampa, Florida, with his wife, Jennifer, and daughter, Sabine Annabel.

< XIV > GET YOUR PHOTOGRAPHY ON THE WEB

INTRODUCTION

You're probably standing in the aisle of a bookstore wondering whether this is the book that you need to get to make your website, or if the one you just put down is the one you really need. You're anxious about the decision, and want some clear sign to point you in the right direction.

Here's my suggestion: take this book and the other book and go over to the coffee bar in the bookstore (hopefully there is one—I love testing books out there), order your favorite beverage, and read a few pages. You'll be able to figure out whether this book will solve your problem by just skimming through the chapters and reading this Introduction.

This book is meant to solve a very specific problem: I'm assuming you're a photographer who has a bunch of images that you want to share online, but you've never really done so. You've probably dabbled with Facebook or Flickr, but you've shuddered at the thought of actually jumping in and setting up a website from scratch. You'd like to be able to do this as easily and as cost effectively as possible. On top of all of that, you'd love it if you could find a way to sell some of those images online to pay for your investment.

This book is set up in a recipe format, and you'll really benefit from going through it from start to finish. Whenever someone asks me to design a website for them, these are the same steps that I follow. I start with a domain name, order some space, and go from there. In a perfect world, you'll have this book by your side as you're going through the process, but it's not really necessary.

If you're a little more Web savvy, you can jump around the chapters in this book. Each one has sections that highlight a part of the process, so you can quickly find a technique or a tip. This will also help you have a quick reference for later on.

Since this book details how to get you up to speed as fast (and cheaply) as possible, I'm very specific about the companies I use in the book. Now, I can't stop someone from thinking, "Hey, what about company X? They do this cheaper/faster/better/more efficiently." But, how annoying would it be if you bought this book to get some answers and I just sat here and said, "Well…it depends…lots of people have lots of things that you can use to help solve lots of problems"? So, instead, I can tell you that I've looked at a lot of companies out there and based on my experience, this is what I think you should do. I should also say that, aside from some thank you emails here and there, these companies are not sending my child to college. I've picked them becuse I believe they help. You should expect no less.

Now, while you're in the process of making your site, you might want to visit with some of the people who make the pieces of the puzzle you're building. I've included sections in the book called "Along the Way," where I interviewed some of these people to help give you some inspiration or offer insight on your Web journey. Think of it as a "Who Are the People in Your Neighborhood" segment, but for techie folks. (Sorry, I can't help it. I'm a *Sesame Street* fan!) At the end of the book, I included some examples of people out there who have used this very same approach that you'll learn here in the book to design their websites to show you how easy this all can actually be.

I've recorded a couple of videos and compiled some files that you can download to get you up and running. You can access all of them at the book's companion website at **www.kelbytraining.com/books/rcweb**. Shooter Themes has provided us with some free themes to use with your website, and FWDesign was more than gracious in letting us use their Flash portfolio design in Chapter 9. The one thing that I will ask is this: they were so cool to do this for us, I think you should consider them for any needs you may have. And remember that websites are constantly changing, so don't be alarmed if what you see when you go to one of the websites shown in the book doesn't look the same as the screen capture of it. The information should still be available, but you may have to look a little to find it.

So, that's about it. I hope that you find in this book just what you're looking for to help you get your photography on the Web. Let's get started!

> **"** The name of your website is one of the most important choices you'll make, and you really don't want to mess this up. **"**

domains & space: you need these first!

You Need a Domain Name & Space Online

Setting up a website involves two components: a domain name and online space. While they are interrelated, the two are actually different pieces of the puzzle. When you set up a domain name, you are basically buying the rights to use that name for a specific period of time and you do this through a domain registrar. GoDaddy.com is probably one of the biggest domain registrars out there, so we'll be using them to buy our domain name and set up online space.

Now, once you have your domain name, that name needs to take you to your site. Think of the domain name as the address to an empty plot of land where you're building a house. In order to set yourself up, you're going to need to decide how big a house you want to build, how it will be built, and how it will be decorated. All of that is solved by purchasing space for your website, called Web hosting. Once you've made your choice of where to buy your online space, all that's left is to tie the two together—to link your domain name to the space you've purchased. Easy enough.

The Part That's Not So Easy: Getting Your Domain Name

This is usually the part that creates the most stress. What do you call your site? I advise you to sit back and really give this some thought. The name of your website is one of the most important choices you'll make, and you really don't want to mess this up. Here are some things to keep in mind:

- If you have a name that you need to spell to someone, that probably isn't the best choice for a domain name. Imagine yourself talking to someone over the phone. If you have to say "M as in Mary, N as in Nancy, E, W, S as in Sam," it's time to rethink the name.

- Don't use too many words in a domain name—www .thiswillbehardforsomeonetoremember.com is not a good idea.

- If you can help it, try not to use dashes in your domain name. People will often confuse it with an underscore, or just omit it entirely.

- Don't pick any words that you think a junior high school student might have trouble spelling. Cool as it may sound, www.sanguinarius.com is just asking for people to miss your website.

- Try your best to stick to .com domain names. If you need to branch out to something else, use a .org name. If those two fail, rethink your name. While there are other domains, the public generally mistrusts websites that don't have .com names.

- Just because you're a photography site, it doesn't mean you need to have photography in the domain name. My site is www.aboutrc.com—simple.

These are some good tips to keep in mind when looking for a domain name, but I'll give you some other ideas when we actually start looking for one.

Never Fall For "Free" Domain Names

In designing our website, we'll use GoDaddy.com to buy our online hosting space, as well as our domain name. I know tons of people who would rather do searches for better/cheaper/faster Web hosting providers. That's okay, but the one thing that I strongly recommend is to *never* accept an offer for a free name with your space purchase. More often than not, if you decide to leave that Web host and try to take your domain name with you, you will not be able to

buy enough Advil for the headache you'll get. *Always* buy your domain names (through someone like GoDaddy.com), and then decide where you want to host.

Always Pay for Privacy

Registrars need to keep a record of who bought a specific domain name. Most of the time, that information is part of a public record called WHOIS. This means that someone could go to the WHOIS website, search a domain name, and find the name, address, email, and telephone number of the person who registered it. Creepy, huh? GoDaddy.com, along with other domain registrars, provide a way to hide this information, so the stalkers of the world are not able to see it. This way, if you get into an argument with someone on your website, and they decide to "look you up," they won't be able to get any of your info.

Review Sites Suck

If you're tech-savvy, you're probably going to want to do some research on Web host providers, and do some comparison shopping. Just go to Google and search for "Web Hosting Review," and you'll get *tons* of websites giving you feedback on the best ones. But here's the catch: most of those sites are fake and use a mock review storefront to swindle a sale. The companies that are number one on the site paid for that placement, or are offering a commission to the review site if people sign up. So, yet another reason I play it safe and just use GoDaddy.com.

Space, Service, Security

If you decide to do some research to find the best Web host provider, make sure that the provider you choose provides the following:

- A large amount of storage space (above 5 GB)
- Unlimited bandwidth
- 24-hour support via fax, email, phone, or online
- A way to back up and restore your website if it goes down

Now, the nice thing about this part of setting up your website is that it should only take you a few minutes to do. You'll spend more time waiting for confirmation emails and for backend stuff to finish than anything else. This will lay the foundation for your website, finally giving all of those photos you take a home. So what are we waiting for? Let's get this party started!

CREATING A GODADDY.COM ACCOUNT

Whether you own one domain name or 1,000, all of them can be managed with one GoDaddy.com account. Setting up this account is free to do and you'll only pay for whatever you buy. Think of it like setting up an Amazon.com account, only the things you buy here are names and space!

STEP ONE:

Open your Web browser and go to www.godaddy .com. You'll notice that there is a Create Account link near the top left of the page. Click on that link and you'll be brought to the Create a New Customer Account page. Fill out all of the required information that is marked with an asterisk and click the Create a New Account button. *Note:* If you don't want to get a lot of annoying emails from third-party providers, make sure you decline the third party notifications at the bottom of the page.

STEP TWO:

Once your account is created, you'll be taken to your account page. This page will show you everything you buy—domain names, hosting accounts, email accounts, etc. You'll also receive a confirmation email. Make sure you keep a printed copy of this, in addition to a copy somewhere on your computer. You may need to refer to it later.

REGISTERING A DOMAIN NAME

Now that we have an account set up with GoDaddy.com, let's begin a search for a domain name that we can use for our sample website. Let's use www.rcphotostudio.com as the website that we'll build from the ground up. But, first, we need to find out whether the domain name is even available.

STEP ONE:

Log into your GoDaddy.com account, and click on the My Account tab near the top right of the page. This page will show you anything you have purchased. Also at the top right of the page, you'll see the Start Domain Search field. Type in the domain name you want to find and click on the magnifying glass icon to begin searching (don't include "www"). Again, in our example here, we'll search for "rcphotostudio.com."

STEP TWO:

There are two ways this is going to go: you're either going to get a screen telling you that the domain name is available (like you see here) or a screen telling you that it is already taken. Once you find a domain name that is available, click on the Continue to Registration button. *Note:* If you get any "Buy Now" ads, and you're not interested, just click the No Thanks button. They are a little pushy about that kinda stuff.

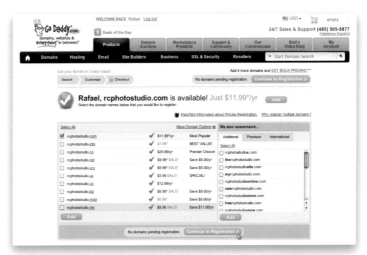

< CONTINUED >

More Ideas for Searching for a Domain Name

With so many websites out there, I bet you'll spend quite a bit of time seeing the "already taken" screen. So, in addition to the tips I gave you in the chapter intro, let's talk about a couple more ways to make this easier:

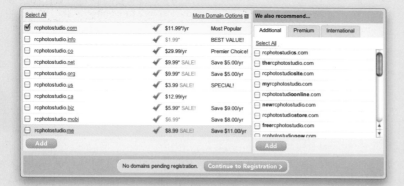

- While I think it's great that they offer alternatives to the .com extension, instead of considering those other options, take a look at their recommendations for the name on the right (shown here). Those suggestions will help stir up some other ideas.

- Another word for "photography" is "images." Have you thought about using the word "images"? YourNameImages.com is certainly shorter than PhotographyByYourName.com.

- Let's say, for example, your name is Jim Smith. Here are some examples of domain names to try:

 www.jimimages.com
 www.jsi.com
 www.imagesbyjim.com
 www.imagesbyjames.com
 www.heyjim.com
 www.hijim.com
 www.aboutjim.com

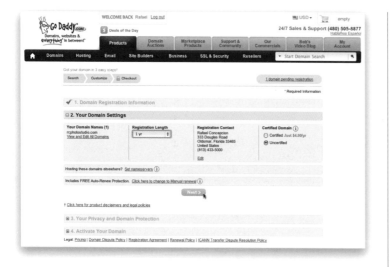

STEP THREE:

In the Your Domain Setting section, you have the option to choose how often this domain name renews (from the Registration Length pop-up menu), and you'll be able to pay for those years in advance at a savings. Set yourself up for one year, with an automatic renewal option (which is included for free). This way your outlay is small, but you have the protection of having it automatically renew. Sometimes people think of this as an "I don't want someone to take my name from me, so I will just get it for 10 years" kind of investment, but that's unnecessary. With the auto renew, you will always get the domain re-registered, so no need to worry here. If a year into it you decide that you don't want to keep the name, you can choose not to renew and release the domain name. Here you can also edit your Registration Contact information and choose if you want to include a Certified Domain Seal on your site. After you've made your choice(s), click the Next button.

STEP FOUR:

In the Your Privacy and Domain Protection section, you'll choose the type of privacy service you want. Notice that the Private Registration option appears under the Deluxe option. I would choose the Standard option here, and add the Private Registration service later (you'll see how to do this in Step Six), and click the Next button.

TIP: Business Registration

When someone checks to see if a domain name is available, and it's taken, they have the option to see who has it registered with a service called WHOIS. Business Registration lets you put your business information in that record, in the event you want to market to those people. I usually don't use it, but that's up to you.

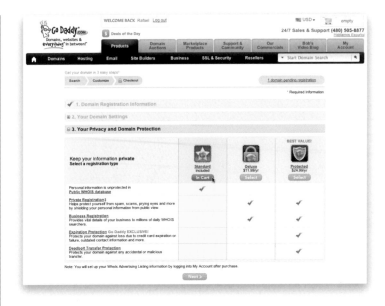

STEP FIVE:

If you are looking into registering your domain name and hosting your site at GoDaddy.com, they will usually give you a discount on one of the services. So, if you know that you're keeping it all here, save yourself some money and choose this while you're here, under Choose Hosting or Website Builder in the Activate Your Domain section. (We're going to look at how to set up a GoDaddy.com hosting account next, as it's my preferred way to do things, so I'm not going to purchase that right now. But you certainly don't have to use GoDaddy.com if there's another service you prefer.) When you're done here, click the Next button.

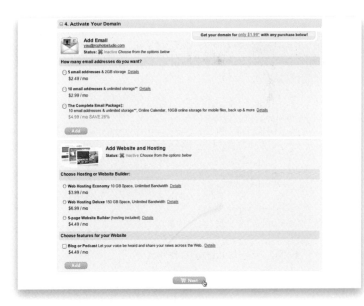

< CONTINUED >

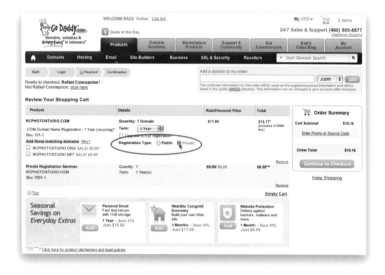

STEP SIX:

Once you've selected all your items, they will be placed inside your shopping cart. Here, you'll see the two options for registration: Public and Private. This is where you'll want to select the Private registration option (as shown here). Your cart will recalculate your total, adding the Private registration fee to the domain name fee. You're now ready to checkout, so click the Continue to Checkout button.

STEP SEVEN:

After you provide your billing and credit card information and click the Place Order Now button to process your order, you'll see the Confirmation screen letting you know that the purchase is complete. GoDaddy.com will ask if there are any other services that you would like to add to this, but generally it's okay to close out of the Web browser here when you're done.

PURCHASING ONLINE SPACE AT GODADDY.COM

Now that we've taken care of registering a domain name with GoDaddy.com, let's go ahead and purchtase the space that we're going to need to set up our website. If you purchased your hosting space when you registered your domain name, then you can skip this part.

STEP ONE:

Log back into your GoDaddy.com account and click on Hosting on the left side of the options bar at the top of the Products tab. You'll see all of the Web hosting plans available for both Windows and Linux operating systems (this is the operating system for their servers, not your computer). We'll be choosing a Linux-based plan here, because of the software we are going to install later (WordPress), but you can select either option. To begin, I recommend choosing the Economy plan, because it provides you with basic space, but has unlimited bandwidth (how fast data transfers), which I like. If you find that you are storing too many files on your site for the Economy plan, you can upgrade later. But I think for a majority of users, this is probably a great place to start. Once you've made your choice, click the Add to Cart button.

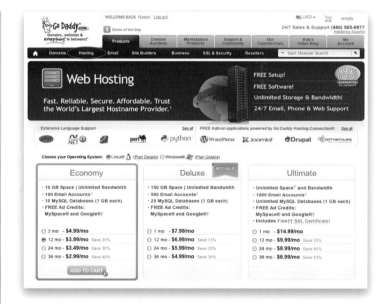

< continued >

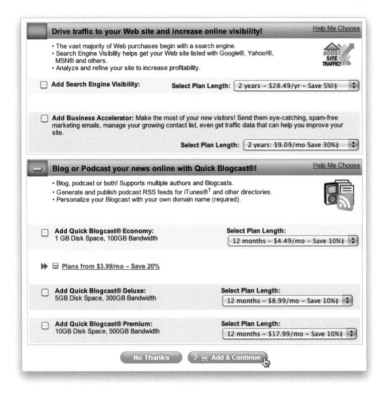

STEP TWO:

On the Customize Your Order page, scroll down through all of the available options for add-on services. If you see something that you think appeals to what you need to do, great, but usually, you can get away without including any of these add-ons right now. So, just click the Add & Continue button at the bottom of the page.

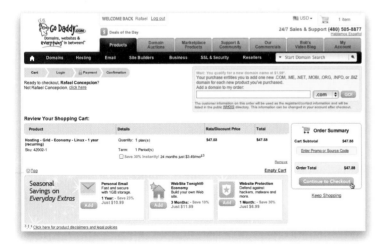

STEP THREE:

On the Review Your Shopping Cart page, click on the Continue to Checkout button on the middle right. Next, enter your payment information on the Payment screen and then click the Place Order Now button. That's it! Your order number will confirm that you have a website, and you'll get a confirmation email that you should save for your records.

LINKING YOUR DOMAIN NAME TO THE HOSTING SPACE

Since we didn't buy the domain name and hosting space at the same time, we need to tell GoDaddy.com that we want to use this space with this name. (Even if you bought your domain name and hosting space together, this is good to practice, because you could theoretically purchase hundreds of domains, and only have a couple of sites that you actually make.) Thankfully, the process is very simple.

STEP ONE:

Log into your GoDaddy.com account and click on the My Account tab at the top right. Scroll down to the Products section, then click on the Web Hosting link, and you'll see an item named New Account. This is the Web hosting account that you just purchased. We need to take that account and tie it to the domain name that we purchased earlier. So, click on the Launch button on the right.

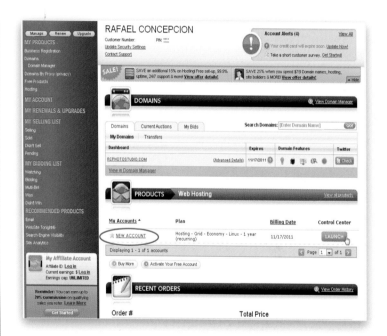

< CONTINUED >

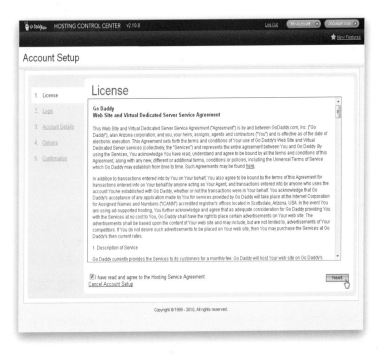

STEP TWO:

An Account Setup page will appear where you'll see a legal agreement for the hosting site. Make sure you read through it, then turn on the check-box to show that you've read and accepted the terms of the hosting agreement, and click on the Next button at the bottom right.

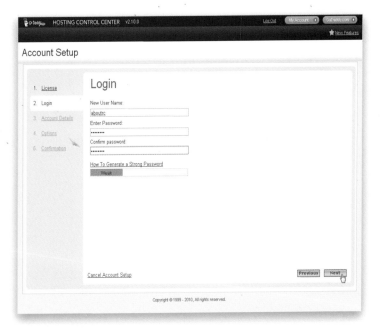

STEP THREE:

You'll need to create a username and password to log into the Web hosting account in the Login section. These will be different from those you created for the Godaddy.com account, so write them down somewhere, with a note that they're for your hosting account. When you're done, click the Next button.

STEP FO

The Acco bu attach the
Web hosti omain names
that you h account (from
the pop-u ame that you
can enter Domain radio
button an name in the
field belo me that we
purchase p-up menu,
we'll just

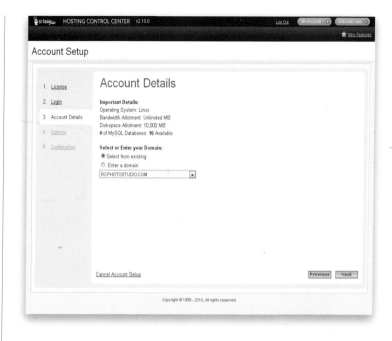

STEP FIV

In the Opti choose
which PHP n your site.
PHP is a pr ll we need
to know he st version.
So, click or and then
click the N

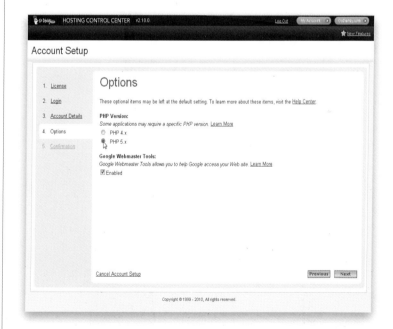

< CONTINUED >

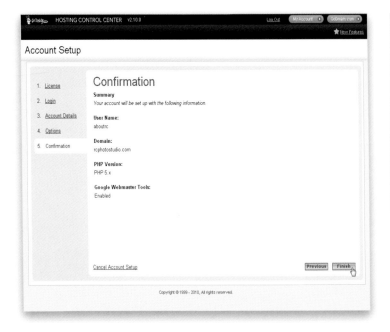

STEP SIX:

In the Confirmation sectio
choices that you made an(
button. This will begin the
the account for the domair

STEP SEVEN:

The final screen will give
site setup. If you have m(
you are working on, you
of the other accounts by
Account List button.

There you have it! In r
able to successfully regis1
purchase some online sp
set up our website. In th
focus on working with o(
they look as good as the

> " Contrary to popular belief, the images that you are happy to show on your computer will look vastly different on the Internet... "

CHAPTER TWO
getting your images ready

Make Those Images Pretty

Now that we have all the basics of the website taken care of, we're going to need to spend some time taking a look at how to prepare our images for display on the Web. Contrary to popular belief, the images that you are happy to show on your computer will look vastly different on the Internet, and we need to take that into account if we want to make sure that we put our best foot forward. So, I think it's a good idea for us to talk about what kinds of things are important when getting our images ready for our website.

Your Color Space Should be sRGB

If you are used to working in Lightroom or Photoshop, there's a good chance that the images you're working on are in either the ProPhoto RGB or Adobe RGB color space. While this looks great on your machine, those colors may not necessarily translate well to what someone would see in their Web browser. To make sure that we keep as faithful a representation as we can, it's a good idea to have our software change those colors to a commonly accepted color space on the Internet—sRGB.

Sharpening Makes Images Look Great

Have you ever taken a picture and been happy with what it looks like on your camera's LCD, but when you look at it in Lightroom or Photoshop, the colors look off or flat? When you take a picture, your camera does some post-processing work to those images, which may enhance color and sharpen the image. That stuff may not translate over to your RAW image, so it's important that we include some sharpening strategies to give those images the pop they need to look good. When you resize your images to make them smaller, some of that sharpening may be lost yet again, so we need to keep that in mind, as well.

Size Matters

I'm sorry, I couldn't help the joke there, but it is another very important component of showing your images on the Web. The balance you have to reach here is to make sure the overall size is small enough for your website to be able to load the image quickly, but big enough to see clearly, yet not so big that it makes it easy to get ripped off by someone copying your images and passing them off as their own. Generally, I like to keep my images at about 1000 pixels on their widest side, unless I am using them for a Flash gallery. Then, I usually come up to about 1400 pixels on the widest side.

Do You Metadata?

I know metadata doesn't sound like a very sexy thing to talk about, but it's absolutely essential when you are posting your images online. More and more, companies are taking to the Internet to find the images that they need instead of going to the big stock houses. In some cases, these people want to do the right thing and contact you for use. If you don't have your contact information in the file, how will they be able to? Taking a couple of seconds to put some vital information in there will make all the difference in getting you paid should someone want to use your images.

Watermarking Your Images

I think anyone who places their images online needs to have some identifying mark on them to let the viewer know that this image belongs to someone, and that it is protected in some form by a copyright. The problem with this is that watermarking has become a little overused. In a paranoid effort to make sure no one steals an image, big garish copyright symbols are placed on the center of them, making them look horrible. I feel that the mark you put on your images should be cool enough to stand out in the image, yet not take it over. By giving watermarks a specific feel, it can tell someone "Stay away!" and look classy, as well.

Are You Bluffing When It Comes to Copyright?

It never fails. I'll speak to a large number of people on the topic of watermarking and the roar of the crowd always comes back, "We do it for copyright!" I immediately ask the crowd, "When was the last time you submitted your images to the U.S. Copyright Office?" and the roar dies down to a whimper. There was a time when using the copyright symbol meant: "Yes, I have registered this image, so beware." But, these days, it's just a symbol. While you may still be able to prove that you are the owner of the image in question in some small cases, being able to do so is undeniably easy if you actually register your images. Not doing so? Then you're bluffing, and asking someone to call you on it. Considering how easy it is to do, you have no reason not to.

Keeping Our Bases Covered

I'm a big fan of using Lightroom for my work, but I don't want to assume that you do or will. Some of you may use Photoshop alone. Some of you may dabble in Photoshop Elements. There are probably some of you that use iPhoto to work with your photos. So, taking that into consideration, we'll cover a few of those as best we can here. This will let you focus on the tools that you use, and skip the ones you don't.

SHARPENING & SIZING YOUR IMAGES IN LIGHTROOM

If you're a fan of using Adobe Photoshop Lightroom, you have three different ways to sharpen your images. I tend to use all three of them in my workflow, giving my images a little bit of a sharpness boost when I start, a little localized sharpening for things like eyes and clothes, and a final sharpening during the export.

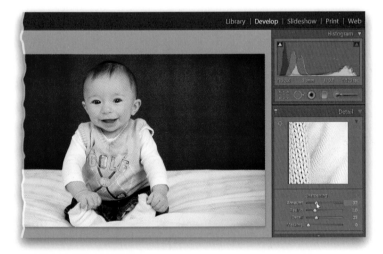

STEP ONE:

Here's a picture of my little buddy Jake. I want to make sure that he looks good when I post him on my website, so right off the bat, I'm going to go to the Develop module and use the Sharpening Amount slider in the Detail panel. This slider will give the entire image some sharpening, but it's important that you don't go too overboard here. The window just above the slider gives you a 100% preview of a portion of your photo, showing you what the sharpening looks like. You can also click on the image to zoom in and check it at a 1:1 ratio.

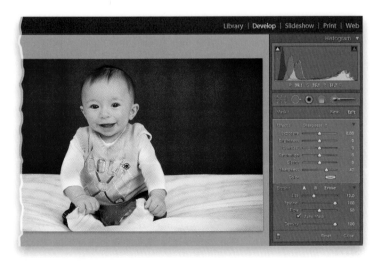

STEP TWO:

Normally, I use the Sharpening Amount slider for a small boost in sharpening on the entire image, but I often also want some parts of the image to really pop out—eyes, clothes, metals, some scruff, etc. With Jake, I want the eyes and his clothes to pop out a little. So, get the Adjustment brush (K) at the top of the right side Panels area, and from the Effect pop-up menu, choose Sharpness. This lets me paint in whatever Sharpness amount I set on the slider below. If I run into trouble and need to erase some sharpening, I can always switch to Erase mode (in the Brush section) and paint out any of the sharpness I added. If you hover your cursor over the pin on your image, you can see exactly what areas are sharpened.

STEP THREE:

Now that I have the image sharpened, it's time to export. Right-click on the file in the Filmstrip at the bottom of the window and, under Export, select Export. In the Export dialog, in the File Naming section, you can change the filename by turning on the Rename To checkbox and choosing a renaming option from the pop-up menu. Under File Settings, make sure you set the Format pop-up menu to JPEG, as photos look best as JPEGs on the Web, and the Color Space to sRGB. I tend to compress my images a little here, so I set the Quality slider to 70. You can increase it, but that will affect the overall file size. In the Image Sizing section, turn on the Resize to Fit checkbox and select Long Edge from the pop-up menu. Then, enter in 1000 pixels for the size, and 72 ppi for the Resolution. Last, in the Output Sharpening section, make sure you have the Sharpen For checkbox turned on, and select Screen from the pop-up menu. From there, the amount is up to you. I usually stick with Standard as a default, as it does a pretty good job.

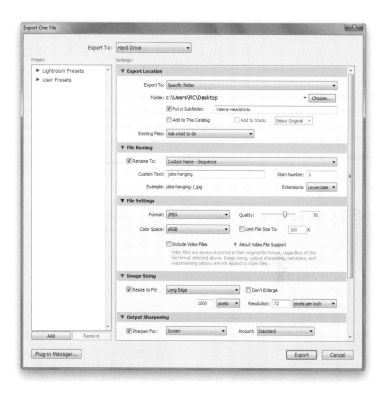

STEP FOUR:

One of the best ways for you to test how the image will look in a Web browser is to actually open it up in one and test it. In this case, I opened up Google Chrome and moved it to one side of the desktop. I exported the file onto the desktop, so all I had to do was drag the file from the desktop onto the browser window. You'll see that the address bar at the top shows the location of the file. This will give you a good idea of how this image will look, without having to go through the process of uploading it to a website.

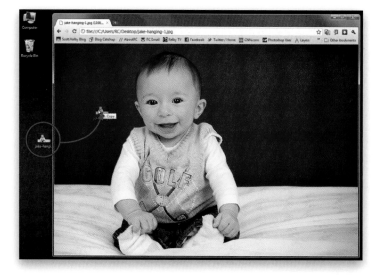

SHARPENING & SIZING YOUR IMAGES IN PHOTOSHOP

There are many ways to sharpen your images in Photoshop, but I like to keep things really simple. More often than not, I'll add a general Unsharp Mask filter to the image, and then locally sharpen some portions using layer masks. After resizing for Web output, I'll add another round of sharpening to compensate for making the image smaller.

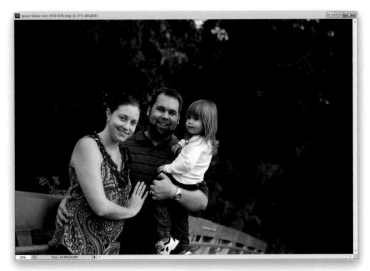

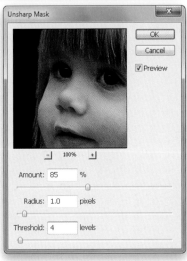

STEP ONE:

In this picture of Nicolle, Alan, and Grace, we want to start by sharpening the entire image, so add an Unsharp Mask filter (Filter>Sharpen>Unsharp Mask), and use the traditional settings of Amount: 85%, Radius: 1 pixel, and Threshold: 4 levels. *Note:* I have a sticky note on my desk with common Unsharp Mask settings from Scott Kelby's *The Adobe Photoshop CS5 Book for Digital Photographers*. Truthfully, those are the ones I just go with, as they tend to work great for me pretty much all of the time. Wanna know what they are?

Basic Sharpening
Amount: 120%, Radius: 1, Threshold: 3

Soft Subject Sharpening
Amount: 150%, Radius: 1, Threshold: 10

Portrait Sharpening
Amount: 75%, Radius: 2, Threshold: 3

Moderate Sharpening
Amount: 120%, Radius: 1, Threshold: 3

Maximum Sharpening
Amount: 65%, Radius: 4, Threshold: 3

All-Purpose Sharpening
Amount: 85%, Radius: 1, Threshold: 4

Web Sharpening
Amount: 200%, Radius: 0.3, Threshold: 0

STEP TWO:

Now, there are times you'll want some parts of the image to pop more than others (in this case, their eyes and the scruff on Alan's face). To do that, use the Lasso tool (L) to select the parts of the image you want to work with (in this case, their heads) and press Ctrl-J (Mac: Command-J) to copy them to a new layer. Then, press Ctrl-F (Mac: Command-F) to apply the previous sharpening settings again (this applies the last-used filter with the same settings), or Ctrl-Alt-F (Mac: Command-Option-F) to reopen the Unsharp Mask dialog and change the settings. I'm lazy, so I tend to just reuse the same settings.

Once you get the detail you're looking for in the eye areas, Alt-click (Mac: Option-click) on the Add Layer Mask icon at the bottom of the Layers panel to add a black layer mask and hide the sharpened layer, then set your Foreground color to white and use the Brush tool (B) to paint back in the sharpness. Here, I'm painting it back in on the eye areas and the scruff on Alan's face. In the Options Bar, I reduce the brush Opacity a little and bring my Flow down to a low number, so that I can ease into the sharpness.

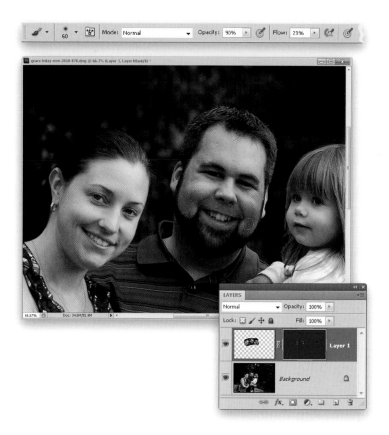

STEP THREE:

Once you're done adding any local sharpening, choose Flatten Image from the Layers panel's flyout menu, then go to Image>Image Size to resize the image (I make mine 1000 pixels wide, as I mentioned in the chapter introduction). To make things easy when resizing, make sure you change your Resolution setting first. This will change the width and the height of the image. From there you can increase or decrease it to 1000 pixels, if need be. If you make the change to 1000 pixels first, then change the resolution, it'll make the size way smaller and you'll have to change it back to 1000 again. So, save yourself a step and change the resolution first.

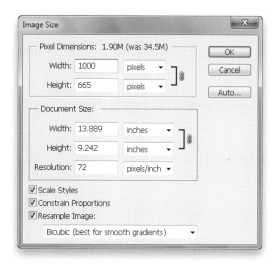

< CONTINUED >

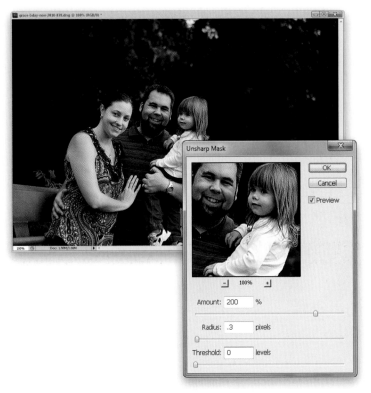

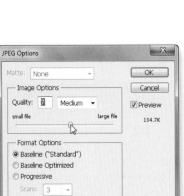

STEP FOUR:
Whenever you resize your images to a smaller size, there's some loss of detail. So, I think it's a good idea to then run a very, very subtle Unsharp Mask filter here just to pop the image back out after the resize. These settings work well here—Amount: 200%, Radius: 0.3 pixels, and Threshold: 0.

STEP FIVE:
Choose File>Save and set the Format to JPEG, since it's the best format to view images on the Web. JPEG is a file type that allows you to compress the image, making it smaller in size, but without losing quality. How small you want the file to be can be set with the Quality slider in the JPEG Options dialog that appears after you click the Save button—just drag the slider to the left or right. You'll see an approximate file size to the right of the slider.

STEP SIX:

One of the best ways for you to test how the image looks in a Web browser is to actually open it up in one and test it. In this case, I opened up Google Chrome and moved it to one side of the desktop. I had saved the file to the desktop, so all I had to do was drag the file from the desktop onto the browser window. You'll see that the address bar at the top shows the location of the file. This will give you a good idea of how the image will look, without having to go through the process of uploading it to a website.

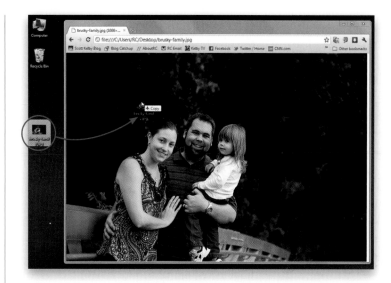

SHARPENING & SIZING YOUR IMAGES IN ELEMENTS

One of the things that excites me about Elements 9 is how close it actually is to the regular version of Photoshop. In this case, I'm able to perform the same Unsharp Mask filter, layer mask, and secondary Unsharp Mask filter. With the exception of a couple of command name changes, you should be good to go!

STEP ONE:

As we did in the Photoshop section, we want to work with our images as a whole, then drill down to isolate specific sections. I'll start with this image of Jaidus by going into Enhance>Unsharp Mask and adding settings of Amount: 100%, Radius: 1, and Threshold: 4. *Note:* I have a sticky note on my desk with common Unsharp Mask settings that I got from Scott Kelby's and Matt Kloskowski's *The Adobe Photoshop Elements 9 Book for Digital Photographers*. Truthfully, those are the ones I just go with, as they tend to work great for me pretty much all of the time. Wanna know what they are? You can see them back on page 18.

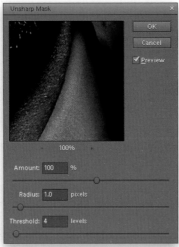

STEP TWO:

Now, there are times you'll want some parts of the image to pop more than others. To do that, use the Lasso tool (L) to select the parts of the image you want to work with (in this case, his head and arms) and then press Ctrl-J (Mac: Command-J) to copy them to a new layer. Then, press Ctrl-F (Mac: Command-F) to apply the previous sharpening settings again (this applies the last-used filter with the same settings), or Ctrl-Alt-F (Mac: Command-Option-F) to reopen the Unsharp Mask dialog and change the settings. I'm lazy, so I tend to just reuse the same settings.

Once you get the detail you're looking for in areas like the hair, stubble, and arms, Alt-click (Mac: Option-click) on the Add Layer Mask icon at the bottom of the Layers panel to add a black layer mask and hide the layer, then set your Foreground color to white and use the Brush tool (B) to paint back in the sharpness. Here, I'm painting it back in on the eye, hair, facial scruff, and arm areas. In the Options Bar, I reduce the brush Opacity to a low number, so that I can ease into the sharpness.

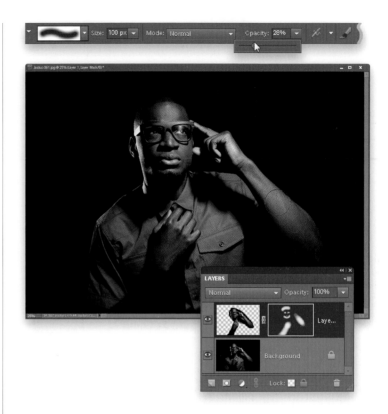

STEP THREE:

Once you've added any local sharpening, choose Flatten Image from the Layers panel's flyout menu, and then go to Image>Resize>Image Size to resize the image (I make mine 1000 pixels wide, as I mentioned in the chapter introduction). To make things easy when resizing, make sure you change your Resolution setting first. This will change the width and the height of the image. From there you can increase or decrease it to 1000 pixels, if need be. If you make the change to 1000 pixels first, then change the resolution, it'll make the size way smaller and you'll have to change it back to 1000 again. So, save yourself a step and change the resolution first.

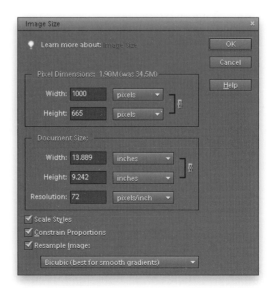

< CONTINUED >

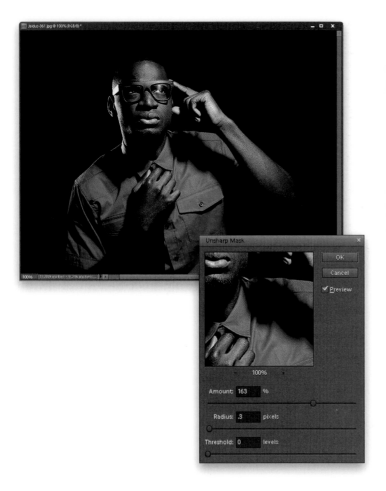

STEP FOUR:

Whenever you resize your images to a smaller size, there's some loss of detail. So, I think it's a good idea to then run a very, very subtle Unsharp Mask filter here just to pop the image back out after the resize. These settings work well here—Amount: 163%, Radius: 0.3 pixels, and Threshold: 0.

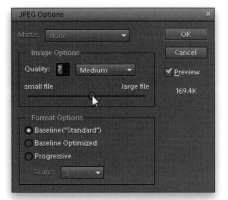

STEP FIVE:

Choose File>Save and set the Format to JPEG, since it's the best format to view images on the Web. JPEG is a file type that allows you to compress the image, making it smaller in size, but without losing quality. How small you want the file to be can be set with the Quality slider in the JPEG Options dialog that appears after you click the Save button—just drag the slider to the left or right. You'll see an approximate file size to the right of the slider.

STEP SIX:

One of the best ways for you to test how the image looks in a Web browser is to actually open it up in one and test it. In this case, I opened up Google Chrome and moved it to one side of the desktop. I exported the file onto the desktop, so all I have to do is drag the file from the desktop onto the browser window. You'll see that the address bar at the top shows the location of the file. This will give you a good idea of how this image will look, without having to go through the process of uploading it to a website.

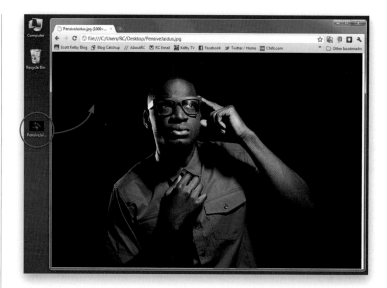

EXPORTING YOUR IMAGES AS sRGB IN LIGHTROOM

You've spent all of your time working on that image and it looks perfect. You save it, and send it to the Web, and the colors look horrible! If you've been down this road and have wondered what went wrong, it's probably something to do with your color space. Let's go ahead and look at how to export our images in sRGB.

STEP ONE:

When working with images in Lightroom, you will most likely be using Adobe RGB or ProPhoto RGB as your color space. I actually recommend using ProPhoto RGB, as I think it makes the images look best—it has a very wide color range and lets you really show them off.

STEP TWO:

This is what your image could look like on the Web with that same profile. Notice that there is a *lot* of color that is missing from the image. This could be your result if your browser doesn't recognize the profile you're working with, or if you have no profile set up at all. We should change this, immediately!

STEP THREE:

The easiest way for us to change this is to select sRGB in the File Settings section when we export the file. In the Expert dialog, the Color Space pop-up menu is right below the Format pop-up menu—where you set your image to JPEG and made your Quality change earlier. Make sure you choose sRGB from this menu, and your problems largely will be solved.

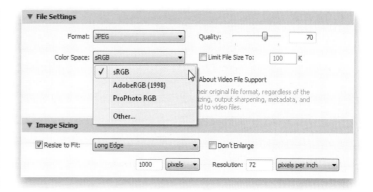

STEP FOUR:

If you test the image in your browser now, you'll see that it looks much closer to your original image. One menu option can change so much in an image. It's sRGB from here on out on the Web!

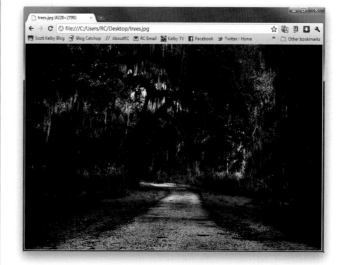

CONVERTING TO sRGB IN PHOTOSHOP

Photoshop has a couple different ways to ensure that you put your images in sRGB mode. The easiest is just to use the Convert to Profile command in the Edit menu—one change in one location, and you should be good to go.

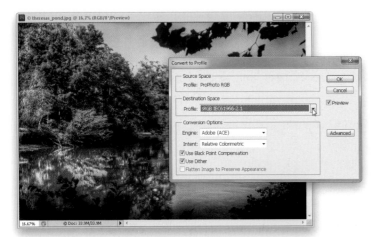

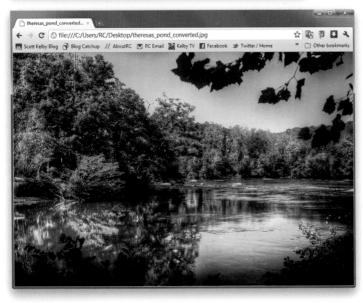

STEP ONE:

With your image open in Photoshop, go to Edit> Convert to Profile. This will bring up a dialog that shows you what profile you are currently using (under Source Space), and what profile you want to convert to (under Destination Space). Go ahead and choose sRGB from the Profile pop-up menu. Now, there could be some color shift here, but thankfully, there's a preview checkbox so you can see the extent of it.

STEP TWO:

After making the change to the profile, you should be able to save and test the file in your Web browser. You'll know you have it right when you see little color difference between the ProPhoto RGB file and the sRGB version that's in your Web browser.

CONVERTING TO sRGB IN ELEMENTS

Photoshop Elements makes it simple to convert your images to sRGB. There are basically only two options, and all you have to do is click on one menu command and you're done. Can't beat that!

STEP ONE:

With the image open in Elements, go to Image>Convert Color Profile>Convert to sRGB Profile. With no other options other than Adobe RGB or removing the profile, your job here should be pretty easy.

STEP TWO:

Once you've resized the image and converted it, go back and test it in your Web browser to make sure that the color does not shift back to ugly.

ADDING YOUR CONTACT INFO TO YOUR METADATA IN LIGHTROOM

When working with Lightroom, you have the option to add metadata presets to your images when you're importing them. But, there are times when that information isn't added, and you have to go back later and add it. Thankfully, all of that information is available in one panel.

STEP ONE:

In the Library module, select the image that you want to add your metadata to. Then, in the right side Panels area, scroll down to the Metadata panel to see all of the information that you can fill in for your image. If don't see a field for Creator, you probably have Default selected in the pop-up menu on the left side of the panel header. Click on that pop-up menu and select IPTC. This will bring up all of the information that you can fill in to have some-one contact you.

STEP TWO:

At the bottom of the Contact section, there are fields where you can enter your email and web-site information (as seen in the previous capture). You can also enter your website in the Copyright Info URL field, in the Copyright section at the very bottom of the IPTC options. Make sure you scroll all the way down to the bottom and add your copyright information to the image here, too.

ADDING YOUR CONTACT INFO TO YOUR METADATA IN PHOTOSHOP & ELEMENTS

The metadata settings for your images are located in the same place for Photoshop and Elements: the File Info dialog. Here, you can add that information to your image quickly.

STEP ONE:

Go to File>File Info to open the File Info dialog, where you can add some important information to the image you're going to put on the Web. For me, the Description and IPTC tabs are the most important. On the Description tab, I fill out all of the information for Author, Author Title, Keywords, Copyright Notice, and Copyright Info URL. If you've ever opened a file in Photoshop or Elements and seen a copyright symbol at the top of the image window in the title bar, it's because the Copyright Status in this File Info dialog is set to Copyrighted (as seen here). It's a good idea to set that, as well.

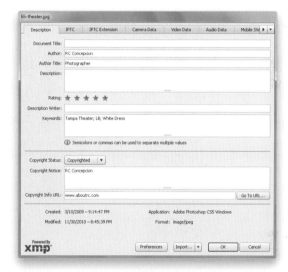

STEP TWO:

The IPTC information may be a little bit of a duplication of the first tab, but this is where you can specify an email address for someone to contact you. Make sure that, at a bare minimum, you have Creator, Creator's Job Title, Address, E-mail, and Website filled in. Once you've finished adding your info, you can close the dialog and save your file.

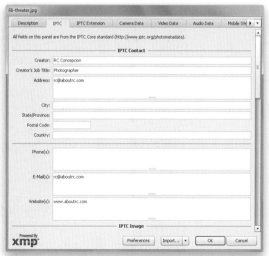

GET A GOOGLE VOICE ACCOUNT

One of the fields in the IPTC metadata is for a phone number. Whatever you do, do *not* put your personal phone number in there. That's just asking for crazy people to contact you! Instead, now is the time to sign up for a Google Voice account and use that as the primary number for your budding photography career.

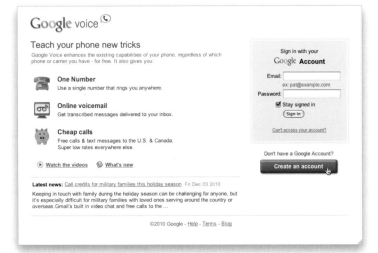

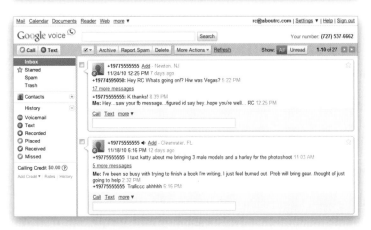

STEP ONE:

Sign up for a Google Voice account by visiting www.google.com/voice and filling out the Create an Account form. This is a free service and will give you a chance to pick a phone number based on the area code you want to use. Once you've selected a number, you can have that number forward calls to your "real" cell phone. Ingenious!

The Google Voice number can then be the number that you put on your IPTC metadata. If you want to stop getting calls for a specific time, you can turn off the forwarding or point it to a new phone number.

STEP TWO:

I could go on and on about the things that Google Voice does, but there are two things in particular that really stand out for me:

- If someone calls your Google Voice number and gets your voicemail, it's saved as an email in your Google Voice account and transcribed for you.

- You can download apps for your iPhone and Droid devices that let you place calls with your "real" phone number, and have them show up as coming from your Google Voice number on the receiver's end.

All of this value for a *free* service. You really need to check it out!

WATERMARKING YOUR IMAGES IN LIGHTROOM

In Lightroom, you can watermark your images with text or a graphic, and you can position that watermark exactly where you want it on your image. This allows you to make sure that your copyright information gets on the image without being too obtrusive.

STEP ONE:

In Lightroom's Export dialog, you can add a watermark by turning on the Watermark checkbox. By default, Simple Copyright Watermark is chosen in the pop-up menu, but you can get as elaborate as you want by choosing Edit Watermarks instead. The Watermark Editor dialog will open, where you can create a watermark based on either text or a graphic. If you don't have a graphics program, like Photoshop or Elements, then text is the way to go. Make sure that any font you use is legible, the Size slider is set to a smaller number, and you reduce the Opacity (under Watermark Effects) so the viewer can see a little bit of the image behind it.

Be consistent—if you anchor it to the right, keep it there for all of your images as best you can. It's also a good idea to offset the watermark a little bit, so that it's not flush with the edge of the image (you can see it on the bottom-right here). Once you've created your watermark, click the Save button to save the watermark style.

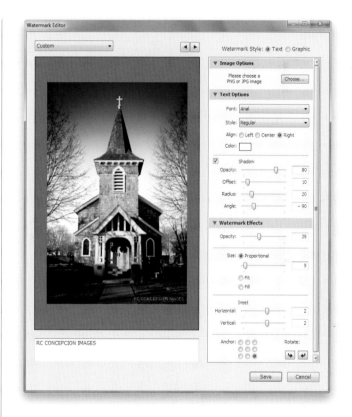

STEP TWO:

Saving your changes makes your new watermark show up in the pop-up menu in the Watermarking section of the Export dialog. I have different watermarks for different scenarios, so you can really customize how this works for you. If you're interested in creating a graphic watermark, check out the Photoshop/Elements option we'll look at next.

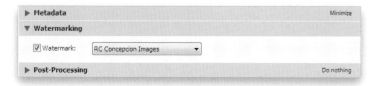

CREATING A WATERMARK IN PHOTOSHOP & ELEMENTS

The best way for you to create a watermark that you can reuse over and over in Photoshop or Elements is to create a separate file that you can place onto your image later. By creating a separate file, you can really get creative, and make the process of watermarking your images easier.

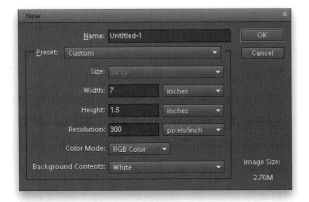

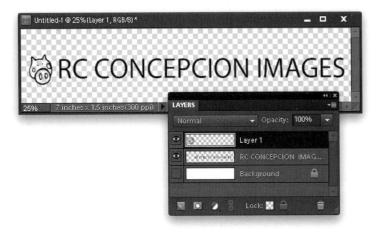

STEP ONE:

Press Ctrl-N (Mac: Command-N) to create a new file, and give it big dimensions. I think that a 7x1.5" file at 300 ppi will be big enough for what we're doing. If you make a really big file for a watermark, you can always scale it down later when you place it onto your image. (*Note:* I'm showing Elements here, but you'd follow the same steps in Photoshop.)

STEP TWO:

In Photoshop or Elements, things like Text and Shape layers are really useful when making your watermark. I'm going to keep the one we make here pretty simple—just a shape from Elements' Cookie Cutter tool (I'd use a Shape layer in Photoshop, or add a line art version of my logo) and my name—but I encourage you to get creative. I also started with a white background and used black text and fill to be able to see what I was doing through the creation process, then simplified (rasterized) the Type layer. Before you save your file, though, you're going to want to hide the Background layer, so that the background is shown as transparent. So, click on the Eye icon to the left of it in the Layers panel.

STEP THREE:

I keep a folder on my computer called My Print Watermarks. Inside that folder, I save my watermark images as PNG files. A PNG file gives you the ability to save the graphic with a transparent background, which will help a lot during the placement of your watermark on an image.

(*Lightroom Users:* If you're adding a graphic watermark in the Image Options section of the Watermark Editor, the folder I'm talking about holds all of your watermarks. All you have to do is click the Choose button, navigate to it, and select the PNG graphic you want to use.)

STEP FOUR:

Once you have your image open that you want to watermark, go to File>Place and select the PNG in your watermarks folder. Because you're using the Place command, the graphic (no matter how big) will be scaled to fit the image, and you can resize and position the graphic a lot more efficiently with no loss of quality.

If your graphic was black text and graphics, and you need it to be white, you'll have to simplify or rasterize the layer first (so make sure it's the size you want it), then press Ctrl-I (Mac: Command-I) and the colors will invert, giving you a white watermark. Pretty easy, huh?

Once you have the size, placement, and color set, just reduce the layer's Opacity setting, and your image is watermarked. This process can also be turned into an action in Photoshop if you find yourself doing this to more than one image at a time.

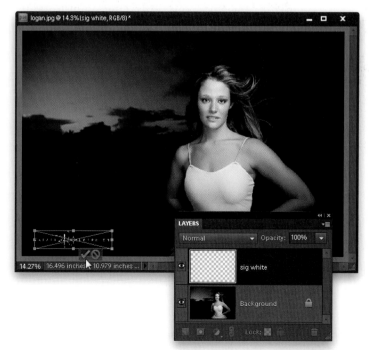

MY FAVORITE WATERMARK TO USE: A SIGNATURE

Instead of using a combination of fonts and shapes in Photoshop, you can incorporate your own signature in your watermark to make it a little more personal. Not only does it look great, but it also gives the image a little more of an art feel, as someone has now signed the print.

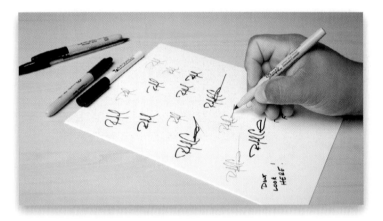

STEP ONE:

Take a couple of pieces of paper and stack them on top of one another (this will prevent any breaks in the ink when you are signing your name). I usually sign with three types of black pens: a ballpoint pen, a regular Sharpie, and a fine-point Sharpie. On the top sheet of paper, sign your name repeatedly with the pens to see if there's one of those that really stands out to you.

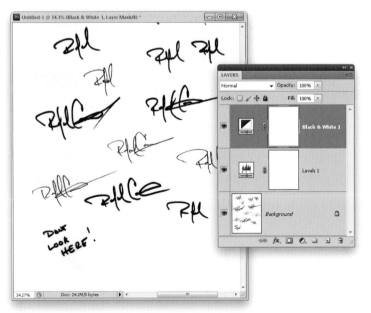

STEP TWO:

After scanning the sheet of paper, open it in Photoshop. To clean the signatures up a little, try adding a Levels adjustment layer and a Black and White adjustment layer. Once you have the adjustments you need and have found the signature you want to use, go to the Layers panel's flyout menu and choose Flatten Image to flatten the image down to one layer. Then, use the Crop tool (C) to crop it to that single signature.

STEP THREE:

Get the Magic Wand tool, turn off the Contiguous checkbox up in the Options Bar, and click on the white background. With the Contiguous checkbox turned off, you should be able to select all of the white in the image with one click. Next, double-click on the Background layer to unlock it, then press the Backspace (Mac: Delete) key to get rid of the white and leave the signature floating on a transparent background.

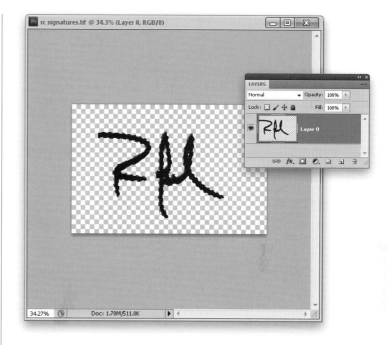

STEP FOUR:

From here, it's just a matter of taste. I tend to extend the canvas out a little and add a bit of type to the signature to make it look more stylistic. Once it's all set, save it as a PNG file and place it in your My Print Watermarks folder. Now, whether you're using Lightroom's Water-mark Editor, or doing a File>Place in Photoshop or Elements, you can easily add your signature to your images.

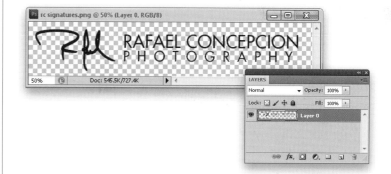

USING DIGIMARC FOR COPYRIGHT PROTECTION

I can't tell you how many people would rather place an annoying graphic watermark on their image and deface it instead of investing a little bit in industrial strength protection. Digimarc is absolutely great for adding barely noticeable watermarks to your images. Combine that with the ability to comb the Internet to find who's using your images, and you have a rock solid strategy to go after the bad guys!

STEP ONE:

Start by going to the Digimarc website (www .digimarc.com) to take a look at what option suits you best. At the time of this writing, the Basic edition of Digimarc for Images is priced at $49.00 and the Professional edition is $99.00. I'm a fan of the Professional edition because of their search service.

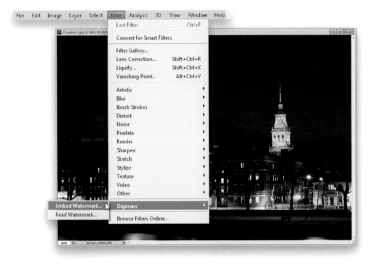

STEP TWO:

So, how good is the Digimarc service? Well, it's been installed in Photoshop since 1996. Chances are, you've gone into the Filter menu and seen Digimarc in the list and have wondered what it does. Now you know. Simply sign up for the service, and you can embed your watermark by just going into that menu, filling out some settings, and clicking on the button.

STEP THREE:

How strong is the watermark? Well, the image here is actually watermarked with it now. That's the beauty of it! To the naked eye, you can't really tell that there's been something done to the image. (*Note:* The copyright symbol in the title bar is from going into Photoshop's File Info [under the File menu] and changing the Copyright Status to Copyrighted.) This is *much* better than placing abstract symbols or "Do Not Copy" text on your images.

STEP FOUR:

So, how strong is this watermark? How will it fare with the baddies trying to take images online? I'll give you an example:

I took this very page that I'm writing on and printed it in my office. Then, I went and scanned that page on a scanner. I opened the file in Photoshop, and clicked on Filter>Digimarc>Read Watermark and Photoshop was *still* able to see the watermark. In the dialog that appears, it'll show the copyright status and contact and website info. How's that for protection? And imagine how far that will go when you search the Internet for people using your images with the Professional edition.

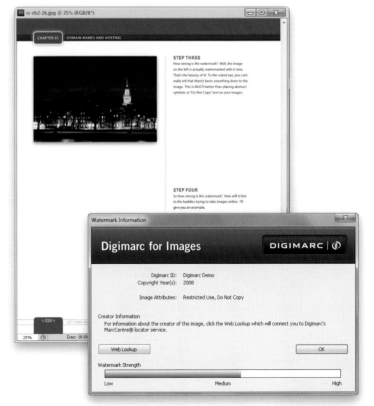

< CONTINUED >

STEP FIVE:

If you want to take a more in-depth look at how Digimarc does its searching online, or just to get up to speed on what they can offer, make sure you stop by their tutorial section on their website. They have both written and video tutorials explaining the watermarking process and how it applies to different images. I could not recommend this service more to people who are out there sharing their images.

SUBMITTING IMAGES TO THE COPYRIGHT OFFICE

If all you're doing to protect your images is putting a big copyright symbol on them, then you're not taking copyrighting as seriously as you want people to take your images. Considering how easy it is do, it's in your best interest to submit them in batches to the U.S. Copyright Office and protect yourself.

STEP ONE:

You can access the U.S. Copyright office by going to: www.copyright.gov. It's a good place for you to start reading up on things related to copyright. Once you're done, the site that you'll be interacting with the most is the Electronic Copyright Office. You can access that by going to: https://eco.copyright.gov/. In order for you to use it, you'll need to create an account for yourself, including your name, email address, street address, and phone number.

(*Note:* You can watch a video I recorded that goes through all this on the book's download website, mentioned in the introduction.)

STEP TWO:

Once you've got an account, you can log into the site and go through the steps for submitting your images. Clicking on Register a New Claim under Copyright Services on the left will take you through a three-step process: filling out an application, paying them (at the time of this writing, it was about $35), and submitting your work. The good part about submitting your work here is that you can submit as many images as you'd like within a specific session. I recommend creating a folder on your desktop with a maximum of 200 JPEG images, sized to 1000 pixels on the longest side at 100 ppi, and have them ready to go before you start the registration process. Once you've uploaded all of the images, you'll get a confirmation email, and if your application is complete, your protection is immediate.

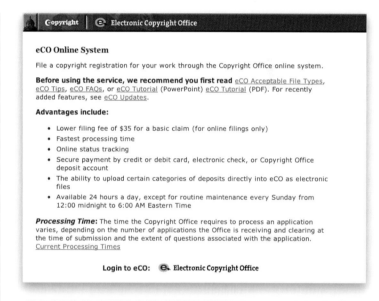

> **" WordPress is great...because it builds the giant frame of a website for you with no coding from you whatsoever. "**

CHAPTER THREE
using WordPress for your website

What Is WordPress: A Brief Overview

The open source community designed WordPress to be a piece of software for anyone who wanted to make a website dedicated to blogging. Way back in the days of yore (about 2002–2003), there was a big push for blogging in the general Internet community. (Blog is short for Web log—a digital diary that the world would be able to read, so to speak.) Rather than setting up complicated websites with programs like Dreamweaver or FrontPage, this software would take care of making the site for you, letting you focus on telling the world about what you had for breakfast. Without knowing any code whatsoever, you could log in and write a post one day, then create another post another day. The software automatically created archives, calendars with your posts, created the ability to add comments, etc. It was like immediately downloading the exoskeleton of a house, so all you needed to do was fill it in. You didn't have to worry about how to structure the site, because it was already done for you.

Blogging Grows Up

Several years later, the concept of sharing your daily experiences began to cool, and blogs that were updated multiple times a day dried up to a trickle. People were still creating blogging websites, but their needs changed from a daily posting of things to more static pieces of content that would get updated less often. Pages like "About Us," "Contact Me," and "About Our Product" didn't really fit the chronological format of a blog, but users needed to have these on their websites.

Everyone agreed that WordPress was one of the easiest platforms (a fancy name for software you install on a Web host) to use, and if it allowed you the ability to manage different types of content—posts (which are chronological), pages (which are not), and other items—it would make a great system. The WordPress community listened hard, and through several design revisions, came up with WordPress 3—a content management system (CMS) that lets you use it for blogging if you want.

Why WordPress Rocks: Portability

Now, mention WordPress to some people, and they likely will assume that you are going to start a "What I ate for breakfast" blog. You see, to date, WordPress has not been able to shake its blogging roots. I, for one, think that is a good thing. If you are a photographer, I can think of no better tool to increase your photography business than to start a blog, and we'll talk about that in the next chapter. WordPress is great for this because it builds the giant frame of a website for you with no coding from you whatsoever. In a couple of clicks, you are presented with two separate areas of your website: a front end and a back end.

The part of the website that the customer will see is generally called the front end of the website. While it will be simple looking, the front end can be dramatically changed at anytime through graphics and templates with WordPress.

WordPress also creates a separate section of the website that only you access, called the back end or the admin page. In this section of the site, you can log in and create all of the content for your website with only a Web browser. I like this because it lets me update my website wherever I go. This has been enhanced even further as smart devices like the iPhone, iPad, or Droid can have applications installed where they can inject content right into your website.

Why WordPress Rocks: Customizability

Because WordPress has this common design structure, it allows developers to create a couple of things that really take the CMS to the next level: plug-ins and templates.

Plug-ins are pieces of software that you can install onto your website that solve specific problems for you. It's similar to installing a plug-in to do something special in Photoshop or Lightroom.

Templates change the look and feel of your website completely, swapping out the stock look and feel of your site with something much cooler. It's like taking your website to Bloomingdales and playing dress up with it, so obviously, there's some cost to this. If you want to dress your blog up really nice, you'll pay more than if you get it some blah outfit from a free retailer. You could also go at it yourself and custom-design the look and feel for your site, although we won't be doing that here in the book. The great part about templates is that there are tons of sites out there that charge little to nothing to make them.

In this chapter, we're going to spend some time installing WordPress and getting ourselves ready to post some content. It's going to shock you to see how quickly you can actually set this up.

INSTALLING WORDPRESS ON YOUR SITE

Another good reason to get Web hosting with a place like GoDaddy.com is the fact that you can install applications like WordPress from an area on their website. In a few clicks, you can start the process and GoDaddy.com will do all of the heavy lifting for you.

STEP ONE:

To fast track right to the listing of applications that you can install on your website, go to http://hostingconnection.godaddy.com and then click on the Login Now! button on the right and log in to your account.

STEP TWO:

On the Hosting Connection page, under One-click Hosting Applications, you'll see all of the applications that you can install on your website. The great part about these "One-click" installs is that they are fast. You'll see WordPress right at the top of the list, so click on that link.

STEP THREE:

On the WordPress page, you can learn more about the program, get information on any technical support issues, leave comments, and read some user reviews. (*Note:* As of the writing of this book, the current version is WordPress 3.0.2.) In the middle of the page, you'll see an Install Now! button. Click this button to begin installing WordPress on your website.

STEP FOUR:

After agreeing to the terms of the license agreement, you'll come to the first installation step: Choose Plan. If you've purchased more than one website, you'll see them listed here. Select the website that you want to install WordPress on and then click on the Next button at the bottom.

< CONTINUED >

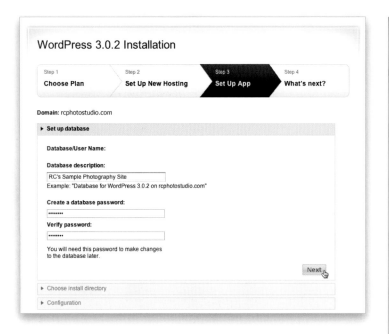

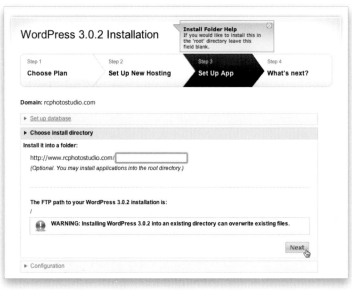

STEP FIVE:

Since we've already set up Web hosting with GoDaddy.com (back in Chapter 1), we'll jump right to Step 3. Here, you'll enter a description for your site in the Database Description field, and then below that field, you'll need to enter in a database password (make a note of this, but you won't need it on a day-to-day basis). When you're done, click the Next button.

STEP SIX:

In the next part of Step 3, we're asked where we'd like to install WordPress, because WordPress is going to run my website, I'm going to leave this field blank and just click the Next button here.

STEP SEVEN:

In the last part of Step 3, you'll need to create a user account to access the back end of your website. I usually make my Admin Name "admin," but you can make this whatever you'd like. You'll also need to give yourself a password (another one to add to your list of passwords). The email you provide here will be where you receive any updates or password reset requests, so it should be a valid one. Finally, give your website a title. Once you have that all set, click the Finish button.

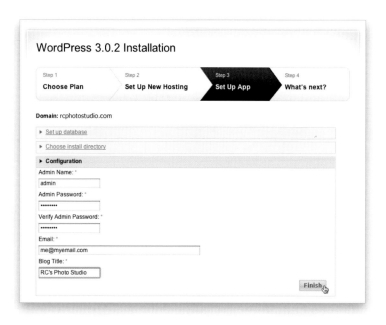

STEP EIGHT:

In the final step, you'll see a message letting you know that your installation request for WordPress has been submitted. Now, all you have to do is wait. You'll receive an email letting you know that your installation has been completed. If you need to check the status of your installation, log back into the Hosting Connection page and click on the Manage My Applications link, under My Management on the right. While this may seem like a bunch of steps on paper, I'm willing to bet that it took you more time to read these four pages than it will to run through this installation. Told you it would be easy!

ACCESSING YOUR WORDPRESS ADMIN AREA

WordPress on your website is broken into two components: the front end is what people looking at your website see, and the administration portion of it is called the back end, or the admin page. Here, we'll talk about accessing the back end of WordPress on your website.

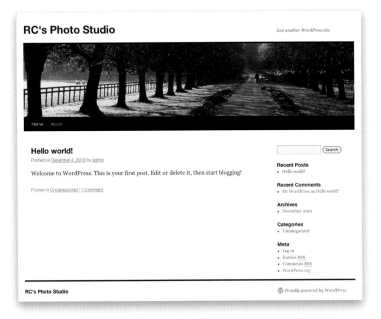

STEP ONE:

Once WordPress is installed, you should be able to access your website by going to your Web address. (For this example, I set up the website at www.rcphotostudio.com.) Right now, we see a default template with a sample post on the site, called "Hello world!" Now, let's go take a look at the admin page—the place where you'll be putting all of your content in.

STEP TWO:

On the bottom of the main page, you'll see a Log In link under Meta. I always end up removing this link from the page, because you can access the admin page by just adding "/wp-login.php" to the end of your website's URL. So, for my website, the log in would be at: www.rcphotostudio.com /wp-login.php (it's probably a good idea to make your URL a Favorite or Bookmark it). When you enter this URL (or click the Log In link), you'll get the WordPress log in screen, where you'll need to enter your username and password, and then click the Log In button.

STEP THREE:

When you log in, you'll get the Dashboard page. The Dashboard gives you an overview of all of the components of your website, and serves as a general overview for the types of things on your site. Along the left side of the page, you'll see buttons that deal with the different sections of the website—from adding content with Posts and Pages, to working with the overall look and feel of it with the Appearance button. We'll go over some of these more in the next chapter.

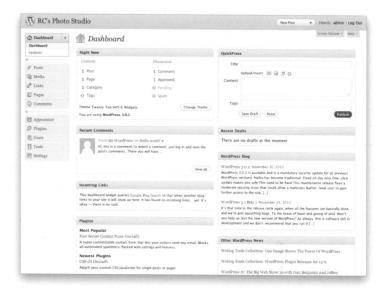

STEP FOUR:

Accessing any section of the website is pretty easy. All you have to do is click on any one of the buttons on the left, and you'll get a pop-up menu of all of the things to access in that section. For example, clicking on the Posts button opens up all of the options inside that section, and shows a list of all of the posts on the page.

Now that you have the skeleton of the website set up, we'll spend some time talking about what kinds of things you should add to the site, and how to add them. We'll begin covering that in the next chapter.

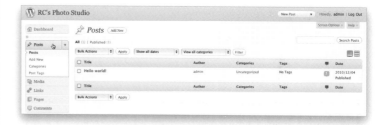

ALONG THE WAY
david hobby, photographer & blogger

David Hobby was a staff newspaper photojournalist for 20 years before founding Strobist.com, the world's largest website devoted to photographic lighting.

When he's not blogging, he now focuses his photography on the intersection of pictures and Web 2.0. Preferably while wearing shorts, if possible. He lives near Baltimore, Maryland, with his wife, Susan, and two children, Emily and Ben.

What originally interested you in starting a blog? How did it come about?

I started *Strobist* as a payback for all of the people who had helped me early in my photo career. It was started to help young professional photojournalists (and college photojournalism students) learn the difference between what they learned in school and what they really needed to know when it came to location lighting.

Is the blog something that you work on all the time, sporadically, or as the need arises?

It is always on my mind to some extent. But as far as generating content, I find I work much more efficiently in spurts— and usually after midnight.

Which helps which? Does the writing help you become a better photographer, or does the photography make you a better writer?

Um...yes. Examining how you think as a photographer makes you a better photographer. And you need the photographic experience to draw on as a writer. It is a positive vicious cycle.

What do you do when you can't come up with anything to write? How does it differ from photographic "writer's block"?

I try to circumvent that problem by keeping a long-term story budget, much as we did at *The Baltimore Sun*. At any given time, I am posted up for a month, ideas are generated for two or more months in advance, and I know the general path of the blog (major themes, etc.) for the next year. I'd tell you more about the last part, but then I'd have to kill you.

What is the benefit of having a blog? Fame? Fortune? Promotion?

Without a doubt, the main benefit for me is participating in the diffusion of knowledge throughout the world of photography. That's just a really cool feeling. If you do that well and consistently, the other things come along as fringe benefits.

If you had one piece of advice to give to people about blogging, what would it be?

See above. Have a compass point of helping people to gain a better understanding of what you are blogging about. Conversely, money as a main goal is probably the worst compass point you could have.

IMAGES: DAVID HOBB

"No matter what kind of website you decide to make, the most important part is that you add content consistently. "

CHAPTER FOUR
adding content to your website

The Content You Put on Your Website
Will Make or Break It

It's probably no surprise to you now that the hardest part about setting up a website is not all of the technical stuff that comes along with it. I've seen websites that look incredible (reflecting hours upon hours of programming for some Web designer) and that make me stop and check them out immediately. I can't name any of them for you, however, because as soon as I was over the design (and believe me, that can happen pretty quickly),

I got tired of looking at the content on the site. But on the other hand, I can think of many sites that don't have the best design, but the content just makes me come back over and over.

This does not mean that you should design a bad site. It just means that it's what you put into it that makes it memorable. As a photographer, it's going to be your images (and descriptions) that are going to leave the lasting impression.

Setting up a WordPress site has helped us by giving us a structure to place content in, and it's probably a good idea for us to talk a little about what kinds of content we can place in there, and how we are going to make sense of it. WordPress divides content up as posts and pages—posts are the entries that individuals associate with blogging, while pages are the static pieces of content that websites normally have.

Every Photographer Should Blog—Just Not About What They Had for Breakfast

I believe that nothing but good can come from you having a website that incorporates both static content and some form of blogging. If you're a photographer that is trying to make an extra couple of bucks with your craft, it becomes even more important. That does not mean that you should immediately create a blog telling everyone what you did all day and how it made you feel. While you may find that, in some cases, this will add a level of variety to your blog, I don't think it should be a functional component of your website. Pick a day and post a picture. Tell your viewers about it. The next day, post another picture. Tell them about that one. This uses the blog mechanic without it actually being a blog.

WordPress Will Create a Static Website for You

One of the great things about WordPress is that it can be used as a basis for the traditional website. Don't think the blogging thing is for you? That's okay—simply create the pages that you want to have on your website and arrange them as you see fit. The structure is in place for you to do so and you don't have to do any of the code. The goal is to

free you from having to do coding, so you can do the thing that you are best at—taking pictures.

Some of the Best Photography Websites Out There Use WordPress

It would surprise you to know just how many websites are designed on the WordPress platform. Let me give you a couple of examples:

- *Scott Kelby's Photoshop Insider*: www.scottkelby.com
- *Layers* magazine: www.layersmagazine.com
- *Team Coco* (Conan O'Brien): www.teamcoco.com
- *Kate Rusby* (English folk singer): www.katerusby.com
- *Jay-Z* (rap star and media mogul): www.jay-z.com
- *XXL* magazine (music magazine): www.xxlmag.com

Add Content Consistently

No matter what kind of website you decide to make, the most important part is that you add content consistently. This could be a page showcasing some of the images that you've made, or a page about specials that you may be running for your customers. The hardest person to get to your website is a repeat visitor. If a person does not have a reason to come back, they won't. Make sure you avoid that by giving them something to come back to. If you set yourself up with a schedule for when you will be posting content and stick with it, your visitors will come to expect when you will be posting content and return, increasing your viewership.

Categorize and Organize Your Website

Nothing will frustrate a viewer more than being unable to find the content that they are looking for. Make sure that you place the content your viewers want to see in a place that's easy for them to get to. At most, the content should be no more than four clicks away. Any more than that, and they'll lose interest.

In this chapter, I'm going to give you a few reasons to consider blogging on your website, then I'm going to go into detail on how to use posts and pages to create content. We'll add images, galleries, categorize content, and change the organizational structure of the site. We'll also do all of this without tackling any code. Let's go fill that website!

A PHOTO BLOG CAN SOLVE MANY PROBLEMS

With so many photography websites out there, making yourself stand out above the others can prove to be very challenging. This is why I feel that giving your readers a chance to come back and learn more about you is the key to solving credibility, trust, and search problems.

Problem #1: Portfolios Are So Yesterday

It's often said that the best photographer is the best picture editor. We've become so used to this, that the portfolio has started to lose its effectiveness. Deep down, when I am looking at a portfolio, I'm thinking to myself "Great, these 20 shots are beautiful, but they're 20 out of how many? Is this photographer consistent? Does this show enough variety? What's this photographer going to be like under the gun? Does this reflect 80% of their work, or am I just seeing 20 'happy accidents'?"

Solution #1: Continuity and Consistency

If you have a blog, you can create a post one day that shows a specific photographic project you're working on. The next day? Another project. The third day? Post a random picture. Now, when someone visits your site, they'll see that you are shooting continuously—establishing your reputation for "being out there." As they get to see your work over time, they'll see the consistency of it. This will also draw attention to your skill, and make that person more likely to call you for a specific assignment.

Problem #2: You Must Get to the Top of the Search Engines

You've set up your website and now you want to attract customers. This will start the frantic race to Google to see where your website ranks. For example, typing "Tampa Photographer" in the search field will currently result in 1,630,000 entries to sort through. "But I want to be number 1! How do I do this?" you ask. This will start a long search for SEO (search engine optimization) kits, the weeding through websites to find the best combination of tags, titles, links, and so forth to uncork the magical combination of stuff that will make Google increase your rank and get you higher on the list.

Solution #2: Tell People What You're Doing & Worry About SEO Later

Remember that you started all of this because you wanted to be a photographer, not an SEO engineer. Now, this book doesn't go into SEO strategies and techniques, because frankly, there are tons of other places where you can get the most up-to-date info on this. There's plenty of time to worry about that later. Right now, focus on getting your images online and adding the appropriate information to them.

Basically, search engines (like Google and Yahoo) follow certain rules to try to figure out which sites have more "information" about a search term—in our case, photography. The more information you have on photography, the more "relevant" you are to a consumer, and up in the directory list you'll go. So, if you're consistently writing stuff on your website about the photography you're doing in Tampa, with the photographers you're working with in Tampa, your website will be more relevant than others. The more you do this, the more you will go up in the list. The best way to get noticed is to keep that content coming, and keep it fresh—two things you get automatically with blogging.

< continued >

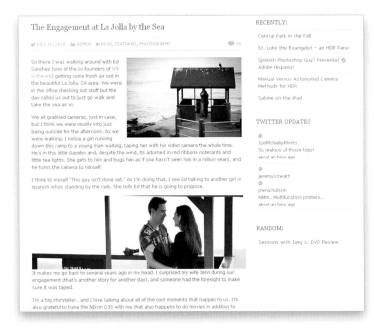

The Engagement at La Jolla by the Sea

at JULY 16, 2010 *by* ADMIN *in* BLOG, FEATURED, PHOTOGRAPHY 46

So there I was walking around with Ed Sanchez (one of the co-founders of Nik Software) getting some fresh air out in the beautiful La Jolla, CA area. We were in the office checking out stuff but the day called us out to just go walk and take the sea air in.

We all grabbed cameras, just in case, but I think we were mostly into just being outside for the afternoon. As we were walking, I notice a girl running down this ramp to a young man waiting, taping her with his video camera the whole time. He's in this little Gazebo and, despite the wind, its adorned in red ribbons notecards and little tea lights. She gets to him and hugs him as if she hasn't seen him in a million years, and he turns the camera to himself.

I think to myself "This guy isn't done yet." As I'm doing that, I see Ed talking to another girl in spanish whos standing by the rails. She tells Ed that he is going to propose.

It makes me go back to several years ago in my head. I surprised my wife Jenn during our engagement (that's another story for another day), and someone had the foresight to make sure it was taped.

I'm a big storyteller.. and I love talking about all of the cool moments that happen to us. I'm also grateful to have the Nikon D3S with me that also happens to do movies in addition to

RECENTLY:

Central Park in the Fall

St. Luke the Evangelist – an HDR Pano

Spanish Photoshop Guy? Presente! @ Adobe Hispano!

Manual Versus Automated Camera Methods for HDR

Sabine on the iPad

TWITTER UPDATES

@ JoeMcNallyPhoto
So jealous of those trips!
about an hour ago

@ jeremycowart
@ pwnicholson
MMm.. Multifunction printers..
about an hour ago

RANDOM:

Sessions with Joey L: DVD Review

Meet Dany & Issac! The La Jolla Epilogue

at JULY 28, 2010 *by* ADMIN *in* BLOG, FEATURED, PHOTOGRAPHY 8

Meet Dany and Issac – the couple from the La Jolla Engagement. I get to share their moment.. & how the world takes care of itself in this post...

They Contacted Me!

So after a few nervous days on my part, I finally received the email that I was hoping to get. Early one morning I got an exhuberant email from Dany (the young girl in this picture) asking whether I had a video that I can send her so she could see. Throughout this entire time, Dany and her husband to be Issac had no clue that I had cut the video and posted it on youtube. The story is interesting to me on many levels. Read on to see why..

The video

Dany, her friends, and her family were so overjoyed over the fact that the video even exists.. and it makes me so incredibly grateful that I was there to capture that moment. But the story hits a personal note for me on a way different level.

CALENDAR

July 2010

M	T	W	T	F	S	S
			1	2	3	4
5	6	7	8	9	10	11
12	13	14	15	16	17	18
19	20	21	22	23	24	25
26	27	28	29	30	31	
« Mar					Aug »	

RECENTLY:

Central Park in the Fall

St. Luke the Evangelist – an HDR Pano

Spanish Photoshop Guy? Presente! @ Adobe Hispano!

Manual Versus Automated Camera Methods for HDR

Sabine on the iPad

TWITTER UPDATES

@ MMPhotoTours
Nikon.. something about the Feel of em.. oh and @ moosepeterson
and @ joemcnallyphoto

Problem #3: No One Knows Me as a Photographer

Another problem in attracting customers is when no one knows you as a photographer. How are you supposed to attract more business if no one knows you're in business to begin with?

Solution #3: Blog Your Projects and Others Will Follow

Let's say you work on a photo shoot for someone. After the shoot is finished, you edit the pictures, and you give them to the client. Once that's done (and you've gotten the okay from them to do so), make a post talking about your experience and share some images. This solves your consistency and quality issue (first problem), but also lets your customer's photos be published online. Your customer will, more than likely, let other people know to check your website to see some pictures—bringing lots of fresh sets of eyes to your website and its content.

WORKING WITH POSTS IN WORDPRESS

Posts are the most common form of entries on a website page. They can be organized by date, or categorized based on keywords that you choose. You can add things to your posts like single images, galleries of images, and even multimedia content. Whether you use posts or pages on your site, you should read this, because knowing how to do one automatically teaches you how to do the other.

STEP ONE:
Log into your WordPress admin page to get to your WordPress Dashboard (like we talked about in Chapter 3, you can access your admin page by clicking the Log In link at the bottom right of your website or by just adding /wp-login to the end of your URL). Click on the Posts button on the left, and you'll see a running list of all the posts on the site, who created them, if they appear in a category, if they have tags associated with them (categories and tags are a great way to highlight specific content on the site, making it easier for people to search for things. We'll talk more about these later), and when they were created. I want to start creating content now, so I'm going to click on Add New from the Posts pop-up menu.

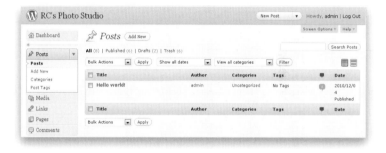

STEP TWO:
The Add New Post page lets you enter a title for your post, and gives you a field underneath the title for you to enter in your content. You'll notice that there are formatting buttons across the top and two tabs at the top right of the content field—Visual and HTML. Using the Visual tab is similar to using a word processing or email program, and very straightforward. If you want something in bold, for example, highlight the text and click on the B button.

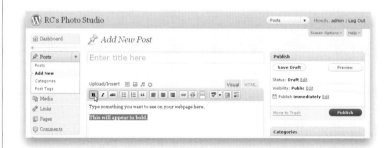

< continued >

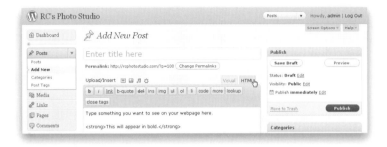

STEP THREE:

At any point in time, you can click on the HTML tab at the top right and see what the underlying HTML code looks like. People who are familiar with HTML will be comfortable here. You can also use the formatting buttons that appear across the top of the content field here to format your text.

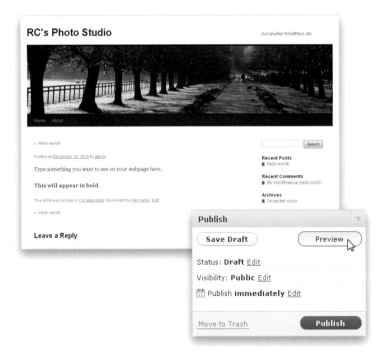

STEP FOUR:

Clicking on the Preview button in the Publish section at the top right will open a browser tab or window and show you what your content will look like. You can check to see how the content of the page is looking and go back and forth between the Dashboard and your preview to make and see additional changes.

TIP: STUCK FOR CONTENT? USE LOREM TEXT AS A PLACEHOLDER

When making an entry in a blog, sometimes you just want to see how the overall post will look from a design point of view—you have no idea what kind of content you want to put in there, but you want to see how it will look. Most designers use random text generators (called Greek text or lorem text) as placeholder text while designing. Try extremely hard to resist the urge to flatten your hands on your keyboard and slap it, resulting in text that looks like this:

> irjeiipoipojeioepjoipwopipidopopkwdqokpw
> dqokpuowuihqweuqweijoqweiopjwqeopwe
> rpoiweriopwerpoiweporiwepriwe

When you do that, you really can't see how paragraphs, bullets, alignment, and breaks happen on a page, making it harder for you to work down the road.

There are tons of websites out there that create Greek text. More often than not, it's just random filler text that you can copy-and-paste into your posts and have them look like they have some order to them. These webpages range from straightforward Greek text sites like www.lorem2.com and www.designerstoolbox.com, all the way to the obscure. Want to see something really wild? Go to *Communications From Elsewhere* (www.elsewhere.org/pomo/) and you can generate an entire postmodernist paper that…well, I won't ruin the surprise. Go check it out!

ADDING AN IMAGE TO YOUR POST

While text is pretty easy to enter and organize with WordPress, we all know that it's the pictures that we're really interested in. So, let's look at how to quickly add a picture to your post. The method of doing this will apply to both posts and pages.

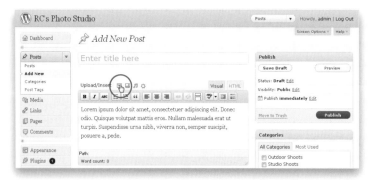

STEP ONE:

I went to www.lorem2.com, copied some text, pasted it into the Add New Post content field, and then clicked the Preview button. Filling in the entry with some sample text really begins to round out the post nicely. Now, obviously, we didn't create this website for it to be text heavy. We're going to want to place some images here. So, let's do that now. In this example, I'm going to select a picture of my daughter Sabine looking up at my amazing wife, Jenn (yes, this shameless plug just lets me proclaim that I love being a daddy more than anything. I love you, Beenie!).

STEP TWO:

I've exported the image I want to include in my post to my desktop (see Chapter 2 for more on this), so I'll go back to the Add New Post page. Above the formatting buttons, you'll see the Upload/Insert icons. Click on the Add an Image icon (it's the first one on the left).

STEP THREE:

When you click on the Add an Image icon, the Add an Image dialog will pop up. Click the Select Files button, choose the image you exported, and click the Open (Mac: Select) button. WordPress will then upload that image and place it in your Media Gallery.

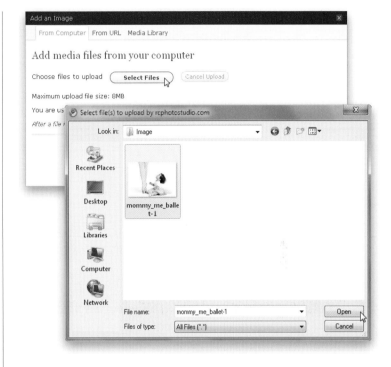

STEP FOUR:

Once your image is uploaded, you can enter all sorts of information about it in the Add an Image dialog. The more information you fill in, the better, but know that you don't need to if you don't want (I'm certainly guilty of "Oh, just get it up there" syndrome as much as the next guy). The Link URL field lets you specify what you want to happen when someone clicks on the picture. Do you want it to go to nothing, to the actual image, or to the post that you are referring to (the one it's embedded in)? More often than not, it's going to go to the image itself, unless you don't want to show a bigger image. The Alignment options are pretty straightforward—where do you want the picture to appear alongside the text. To the right? To the left? In the middle? Just click on the radio button for the option that you want. Choose the Size that you want the image to appear, and then click the Insert into Post button.

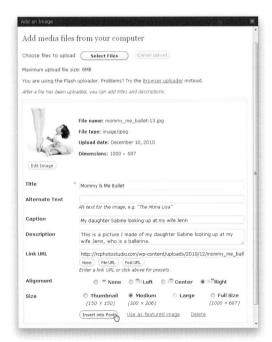

< CONTINUED >

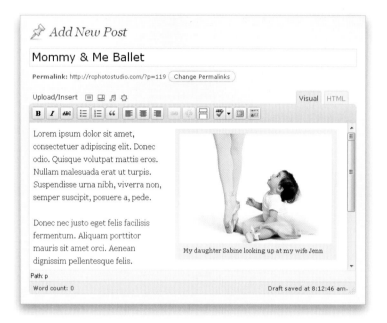

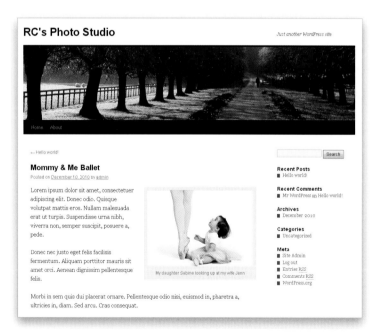

STEP FIVE:

I had my cursor placed at the start of the post entry, right before the text, and I selected the image to align to the right. Bam, the image appears to the right, and my text appears on the left. I love how easy this can all be. If you want to delete the image or make changes to its information, just click on it and you'll see Edit Image and Delete Image buttons at the top left.

STEP SIX:

Now, just click the Preview button to see the changes you've made in a browser window. You'll notice that there is a grey box around the image. This is something that comes along with the caption I added to the image. If I didn't enter a caption (and I usually don't), that box wouldn't appear there. When it all looks good to you, go ahead and click the Publish button in the Publish section in WordPress.

Congratulations, you have just created your first post!

ADDING CATEGORIES & TAGS, AND CHANGING YOUR PUBLISHING STATUS

When working with posts, some common things that come up are categorizing your posts, adding tags to them, and deciding when they go live. Thankfully, these are pretty simple to manage right inside of the Posts page in WordPress.

Adding Categories & Subcategories:

To help keep your posts organized, making it easier for people to find related posts, you'll want to create categories for them. These categories will appear on the right side of your website and beneath the post. On the Add New Post page (or the Edit Post page), to the right of the content field, there's a Categories section. You'll see that you currently have one category: Uncategorized. This is the category in which your posts are currently appearing. To add a new category, click the Add New Category link at the bottom of the section and a text field will appear where you enter the name of your new category. If you'd like to narrow your categories down further, you can create subcategories. In the text field, enter a name for a subcategory, then from the Parent Category pop-up menu, choose the category you want to place it in.

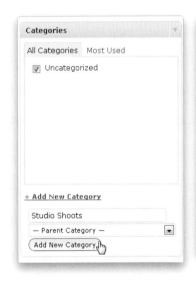

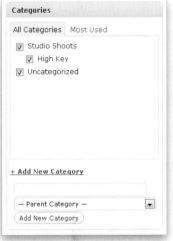

Adding Tags:

Another good way to organize your posts is to key-word them using tags. Tags can be more specific than categories and they appear beneath the post on your website. On the right side of the Add New Post (or Edit Post) page, there's a Post Tags section. Just enter a tag name into the Add New Tag field to attach to your post and click the Add button.

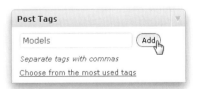

< CONTINUED >

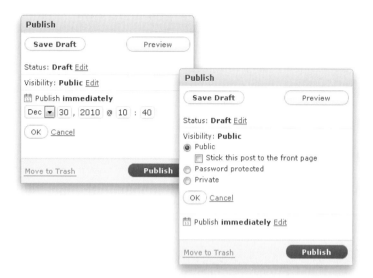

Changing Your Publishing Status:

When you create a post, you have several options for publishing it. These options are found in the Publish section on the top right of the Add New Post (and Edit Post) page. By default, when you click on the Publish button, your post goes up immediately. However, click on the Edit link to the right of Publish, and you can schedule when you want your post to go up (the default is Immediately). You can also change the visibility option for the post by clicking on the Edit link to the right of Visibility. You can choose to make it Public, to password protect it (it'll require a password to see anything other than the title), or to have it Private (not showing the entry at all on the site).

ADDING A GALLERY OF IMAGES TO YOUR POST

One image is nice inside of a post, but what if you want to talk about a photo shoot that you did with a client? Chances are you're going to want to show a series of images in one post. Let's talk a little bit about how to get a gallery up inside of your post. In a later chapter, I'll show you how to take this gallery functionality and make it look awesome!

STEP ONE:

Once you have the series of images you would like to add to the gallery you're going to post, go back to your post in WordPress, and click on the Add an Image icon above the formatting buttons. In the Add an Image dialog, click the Select Files button, navigate to the folder of images you want to use, and press Ctrl-A (Mac: Command-A). This will select all of the images in that folder. Click the Open (Mac: Select) button to upload these images.

STEP TWO:

Once all of the images have been uploaded, if you want to add information to an image, click the Show link to the right of the image. When you're done, click the Save All Changes button at the bottom of the dialog.

< CONTINUED >

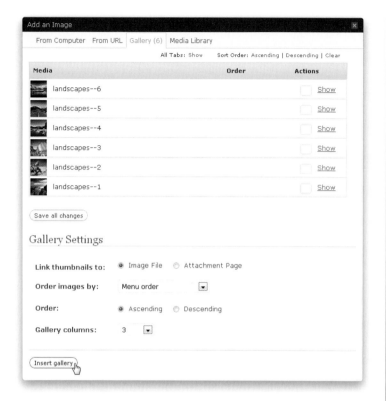

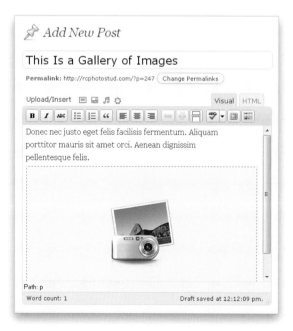

STEP THREE:

When you upload multiple images into a post they'll appear in a grid, and you can choose how you want that grid of images to appear on the page. The Gallery Settings options, at the bottom of the Add an Image dialog's Gallery tab, show how the images can be ordered and, from the Gallery Columns pop-up menu, you can set the number of columns you want. Once you're done, click the Insert Gallery button. *Note:* Whenever you upload images to a post, they are added to your Media Library (which holds all of the images you've uploaded) and collected in a gallery. At any time, you can go back to the Add an Image dialog, click on the Gallery tab at the top, and add images to the gallery you uploaded to this post. Or you can add images from the Media Library.

STEP FOUR:

You will now see your post with a camera-and-image graphic indicating that there is a gallery in place here. Go ahead and add categories and tags, and publish your post!

STEP FIVE:

When you click the Publish button, you'll now have two posts on your website! The top post on the page is the newest, and shows the three-column, two-row gallery that we just created. Personally, I like to have a gallery with a little more oomph, which is why I don't use this gallery option all that often, but I'll show you how to spice this up a little bit when we talk about plug-ins in Chapter 5.

For the most part, setting up a website has not been a hard process at all. And, best of all, the structure is free!

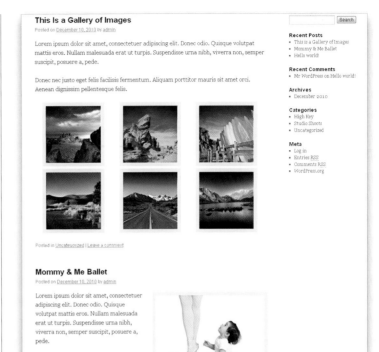

ADDING AN ANIMOTO SLIDE SHOW

There are times when even a gallery won't really do justice to your images. A slide show with music can really take your presentation to the next level. I'm really into making slide shows, and like to use Animoto because it lets you create them very quickly.

STEP ONE:

Go to www.animoto.com and sign up for a free account. The free Basic account lets you create 30-second slide shows. If you find that you want longer slide shows, you can always upgrade to the All Access account, where you can create unlimited-length slide shows, or the Pro account, where you can create unlimited DVD-quality slide shows. Try out the free account first and see how you like it, but I'm convinced you'll upgrade to the $30-a-year one in no time!

STEP TWO:

Once you're signed in, you're taken to the My Videos page where you can begin creating your video slide show. So, to get started, just click the Create One link. On the next page, you'll need to choose a style for your video. Here, I've chosen The Animoto Original style. Click on the Create Video link beneath the style thumbnail you want, and in the window that pops up, click on the Free link to create a 30-second video (if you have the Basic account; with the All Access and Pro accounts, full-length videos are free).

STEP THREE:

The Imagery section is where you upload your images for the slide show. You also have the option to use images from a collection you may already have uploaded to Animoto, or to retrieve images from another website you uploaded them to. So, go ahead and upload your images and once you see their thumbnails appear in the window, click the Done button at the bottom right.

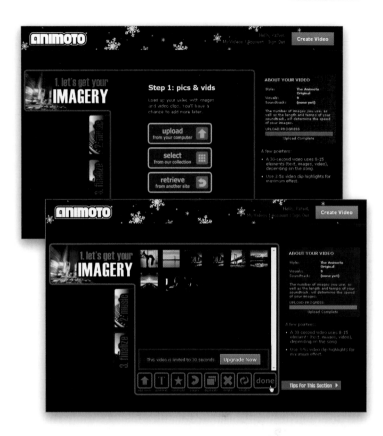

STEP FOUR:

Next, you can choose the music you want to use for the slide show from Animoto's collection, or you can upload music you have on your computer. I'd suggest steering clear of uploading your own music, though, because of copyright issues.

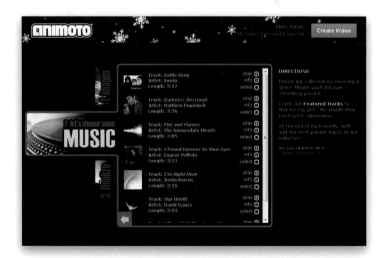

< CONTINUED >

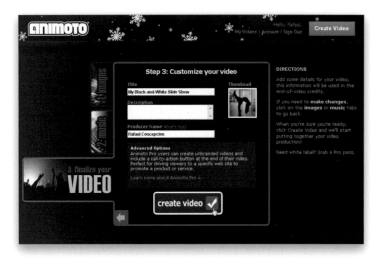

STEP FIVE:

The next page lets you customize your slide show video. Click the Continue button and you can give your video a name and description. If you have a Pro account, you can include an end-of-video button that will get people back to your site (found under the Advanced Options). This is important because of where you might place this video. If you post it on your Facebook or Twitter page, you're going to want an easy way to get people back to your website. It's all about getting people back to your site. Once you're done customizing your slide show, click the Create Video button.

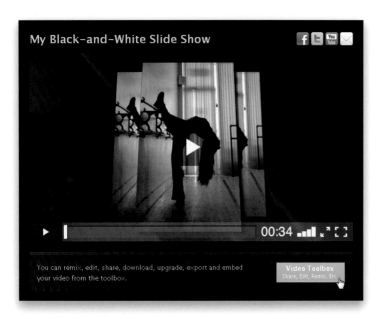

STEP SIX:

Once Animoto finishes producing your slide show video, you'll be able to see a preview of it. Just click the Play button in the bottom left of the preview window. Beneath the bottom right of the preview window, there's a Video Toolbox button. Click this button to create the code you're going to need to post the slide show to your site.

STEP SEVEN:

In the Video Toolbox, you have the option to embed the slide show, as well as to export a copy of it for your own use. We're going to share this on our blog, so click the Embed button.

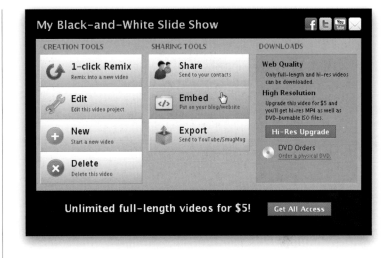

STEP EIGHT:

The Embed This Video window will show the code for embedding. Under the Advanced Options, you change the size of the slide show player window, as well as have it automatically start and loop. Keep in mind that if you do make any changes here, the code at the top may change, so make sure you make these choices first. Then, just click the Copy Code button to copy it.

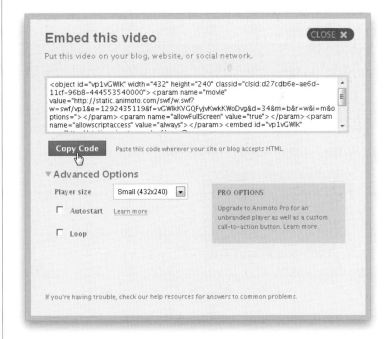

< CONTINUED >

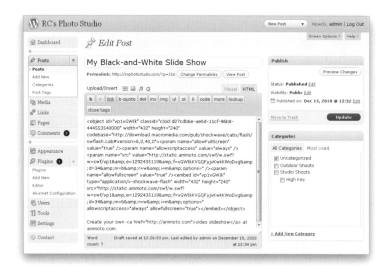

STEP NINE:

Now, go back into your admin page in Word-Press and create a new post. Click in the HTML tab's content field, and then press Ctrl-V (Mac: Command-V) to paste the embed code from Animoto (if you paste the code in the Visual tab, you'll only see the text on your site and not the slide show).

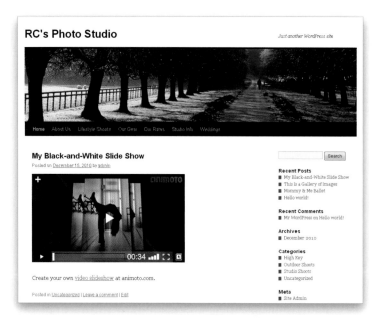

STEP 10:

Go ahead and publish the post, and you'll see the slide show on your website, complete with music. No coding required!

SOME HOUSEKEEPING NOTES ON CATEGORIES, TAGS & IMAGES

The majority of your work can be done right from inside Posts and Pages, but there are times when you're going to need to delete images, or reorganize categories or tags. So, it's a good idea to know where these pages are and how to get to them.

STEP ONE:

While I think it's nice to create categories while you're creating a post, there may be times that you want to add a category when you're not creating a post. Just click on Categories from the Posts pop-up menu, and you can easily add them here. Enter the new category in the Name field, click on the Add New Category button, and they'll appear in the Categories section of the Add New Post page when you go to create a new post.

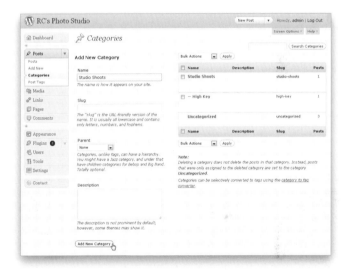

STEP TWO:

Post Tags also appears in the Posts pop-up menu. You can add tags here, or see what tags you currently have and how many posts are associated with individual tags.

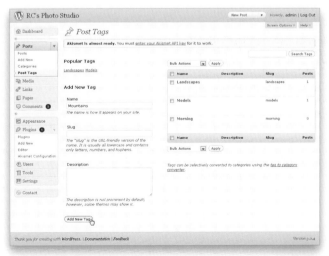

< CONTINUED >

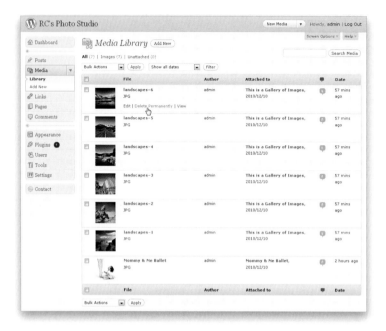

STEP THREE:

The Media Library, found under the Media button, will list all of the images that you have uploaded to the site. Just hover your cursor over an image to edit its information or delete it. You'll also be able to see which images are attached to what posts.

STEP FOUR:

Finally, the Media option found under the Settings button at the bottom lets you control what sizes your small, medium, and large images are when you're adding them to your post. If you find your images are too small, this is the place to make that change. Keep in mind, though, you'll have to re-upload your image to apply this new setting.

WORKING WITH PAGES INSIDE OF WORDPRESS

Notice how I haven't talked about pages? I did this intentionally! The great part about WordPress is that pages work almost the exact same way that posts do!

STEP ONE:

Pages work in much the same way that posts do. Clicking on the Pages button on the left side of Dashboard will show you all of the pages that you've created. Clicking Add New from the Pages pop-up menu will bring up a page where you can add a title and content. You have the same formatting buttons as in the Add New Post page, the same field to add a title, and the same image-uploading capabilities.

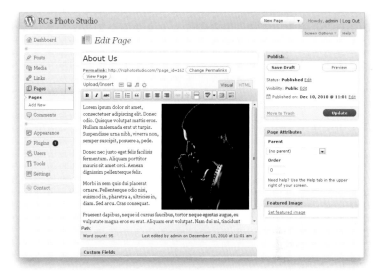

STEP TWO:

You can also click the Preview button in the Publish section, to preview the page. Again, since working with pages is pretty much like working with posts, this means that you just learned two things at once. Not bad!

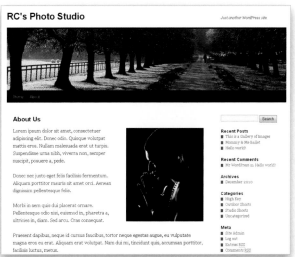

< CONTINUED >

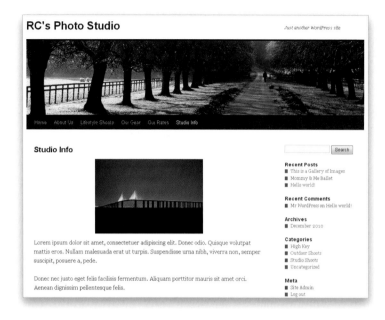

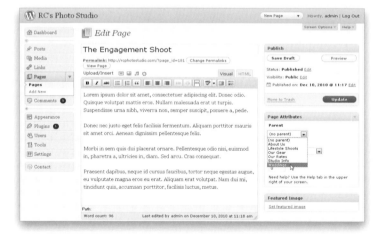

STEP THREE:

Keep in mind that pages should be used for things on a website that aren't really date-related. Think of it this way: Would you have more than one About Us page on your website? If you would only make one post of something, chances are that would make a great page. Some examples of pages would be: About Me, Directions, Studio Info, Pricing, My Philosophy, Our Gear, Things to Keep in Mind Before Coming to My Shoot, Background Info, and so on.

STEP FOUR:

The one thing that does differ between pages and posts is that pages are included in the navigation bar of your website (that black bar that appears beneath the large image at the top). When you create a page, you can choose whether you want that page to appear in a main menu in the navigation bar (a parent page) or if you want the page to appear in a submenu of one of the main menu pages in the navigation bar (a child page). If you want it to be a child page, just select the parent page you want it to appear with from the Parent pop-up menu in the Page Attributes section on the right. If you want it to be a parent page, choose (No Parent) from the Parent pop-up menu. In this example, I placed The Engagement Shoot page as a child page of the Weddings parent page.

STEP FIVE:

When I click the Publish button, WordPress auto-matically creates a submenu for the Weddings page in the navigation bar. All you need to do is hover your cursor over that link and a pop-up menu appears showing The Engagement Shoot page. *Note:* See Chapter 5 for more on working with and organizing pages in the navigation bar using menus.

That's it! That's how you work with posts and pages. And the amount of coding you've had to do to make all this work? Zero.

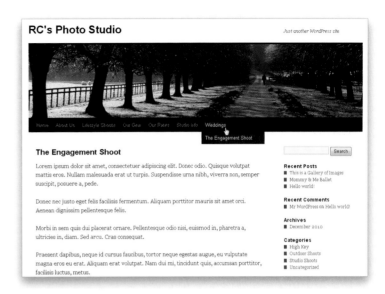

ALONG THE WAY
joe mcnally, photographer & blogger

Joe McNally is an internationally acclaimed photographer and long-time photojournalist whose career has spanned 30 years and included assignments in more than 50 countries. He has shot cover stories for *TIME*, *Newsweek*, *Fortune*, and several other prestigious magazines. He has been a contract photographer for *Sports Illustrated*, a staff photographer at *LIFE* magazine, and currently, an ongoing 23-year contributor to *National Geographic*.

Joe was listed by *American Photo* as one of the 100 Most Important People in Photography, has been honored as a member of Kodak-PDN Legends Online, and is a Nikon Legend Behind the Lens. He is known world-wide for his ability to produce technically and logistically complex assignments with expert use of color and light. He conducts numerous workshops on his own around the world as part of his teaching activities, as well as with the Digital Landscape Workshop Series with Moose Peterson and Kevin Dobler. He has been blogging regularly since 2008.

< 078 >
GET YOUR PHOTOGRAPHY ON THE WEB

What originally interested you in starting a blog? How did it come about?

I had friends in the photo world who were heavy into blogging—Moose Peterson comes to mind—and they urged me to start. In fact, some of them would get mock-irate with me over the fact that I had not started blogging! I would show up and they would be like, "Where's your blog? Gotta blog!" So, I finally decided to take the plunge, not just because I was being urged, but also to give our studio another voice and extend its reach.

Is the blog something that you work on all the time, sporadically, or as the need arises?

I'm not an "organized" blogger. I am consistent, but that's a different thing. It's a very rare week that goes by without a new blog post from me. I am consistently offering pictures, viewpoints, and anecdotes from the field on a regular basis. But, I'm not organized around a schedule that calls for a blog on Monday, Wednesday, and Friday. I blog when I feel like it, when I have the time, and when I feel like I've got something to say. So, it's irregular, but I do stick with it.

Which helps which? Does the writing help you become a better photographer, or does the photography make you a better writer?

I think it's a two-way street. It all ends up putting you in that place where you are a better storyteller. That's it in a nutshell. It's what we do with a camera, and what we do on a keyboard. Tell stories. I enjoy writing—I first went to school to be a writer. So the blog, for me, is a way of reconnecting to that original impulse I had when I first decided I wanted to be a journalist.

< CONTINUED >

< CONTINUED >

What do you do when you can't come up with what to write? How does it differ from photographic "writer's block"?

I think traditional writer's block generally stems from the enormity of the task at hand (i.e., writing a book). When you're doing a book, you sometimes look at it and just stop dead in your tracks, thinking, you know, "300 pages! I just can't do this." It becomes easy to put off, and then you get fearful of it, and writer's block sets in, big time. I rarely get that type of writer's block with the blog. In fact, sometimes the opposite. I start writing, and then make connections in my head to other stuff, and before you know it, I've got a blog that's too lengthy for your average blog reader to plow through.

What is the benefit of having a blog? Fame? Fortune? Promotion?

Fame? Not really. Fortune? Definitely not. Promotion? Absolutely. I had the benefit of being in the field for a long time, and being recognized for some of the work I've done, so the readership of my blog was accelerated a bit by that fact. I didn't start my blog as a fresh face, just out of school. I had a bit of an audience right from the get-go, and thankfully it has grown. The monetary impact of the blog is directly related to the promotional aspects of the blog. In other words, my blog, in and of itself, doesn't make a lot of money for the studio. But to the extent I use it to self-promote (which actually isn't that often), it is helpful monetarily. For instance, if I put out the word on the blog that I'm teaching a workshop, that's a good piece of news to get out the door, 'cause obviously, the more people who know about that workshop, the better attended (hopefully) it will be.

If you had one piece of advice to give to people about blogging, what would it be?

Write it with your own voice. Or find your voice over time. Too many blogs out there are like cab dispatchers. Just a bunch of links directing people to this and that. They parrot something they already heard. Being newsy and informative is great, but your blog is your online personality, and at least every once in a while, that personality has to come through. Also, don't be afraid to step out and have an opinion. Remember, as David Hobby once told me, if you're not offending somebody at least every once in a while, then you're probably just not interesting.

❝ Plug-ins...are pieces of software that are designed to enhance the original program by doing something specific. **❞**

CHAPTER FIVE
plug-ins and menus to the rescue

So Now, You're Moving In

Getting a website together is a lot like moving into a new home. You walk into the house and take a look at all the space you have, excited to be able to take all of the stuff that's in storage and move it into this room, or that room. You walk around happy, saying to yourself, "Oh, I think this room would be great for this," and you unpack all of the stuff that you've waited so long to get into a space.

After a little bit, you start saying to yourself, "Hey, you know what this room needs? It needs a ceiling fan!" (Truth be told,

my answer to everything is a ceiling fan. You see, I hate hot weather—absolutely hate it. And I hate humidity. And where do I live? Tampa, Florida. You could not get hotter or more humid if you tried, but I digress.)

Little by little, you take a look at the structure that you have set up and you start to wonder how much better these things would be if they could do X, or do Y. This is exactly what happens with your site. WordPress is a great content management system (CMS), but one could not possibly think

that the community would have all the needs of every single user mapped out for them in one software package. No, my friends, that's where plug-ins come in.

So What Is a Plug-in?

Plug-ins for WordPress are very similar to the plug-ins that you're probably used to using in Photoshop. They are pieces of software that are designed to enhance the original program by doing something specific. Plug-ins are designed by mavericks out there that have the capacity to code, and want very specific needs met. Once they design something to meet that need, they take it upon themselves to share that need with the world. The plug-in community exists to be able to help solve the needs of all of the users, and we are very thankful for them.

Installing a Plug-in

Prior to WordPress 3, users had to go to the http://WordPress .org/extend/plugins/ website and search to see if a plug-in was available. Once you found the plug-in and downloaded it, you would upload that plug-in folder to your WordPress installa-tion. For the most part, it wasn't really hard. But, here's the thing: with WordPress 3, they made that process even easier! Who could ask for anything more?

Beware of Plug-initis

Plug-initis is a condition that affects many new WordPress owners and can be very painful to treat and cure. An owner of a new site goes to the WordPress plug-ins website, sees the full bounty of plug-ins available, and starts downloading every single one of them for their website, because "Look! It's so cool. It does this...."

Put the mouse down and stop, good website owner. Not only will it become really hard for you to manage all of these plug-ins in the long run, they may slow your website down. On some occasions, they may even introduce viruses to your website that will turn it from a photography site to a blog hawking Viagra in no time.

Using Plug-ins to Help with Statistics

One of the best plug-ins out there is the Google Analytics plug-in. The more you start tweaking your website, the more you are going to become interested in who comes to it, what pages they visit, and what kinds of things they find useful. Google Analytics is a free service that you can sign up for that will track all of this information for you in a report. All you need to do is add a special code to your site, and they take care of the rest.

Menus Were Impossible Until Now

Another common problem in website design has always been how to get all of your content organized. Being able to auto-matically design a menu system that immediately showed up on all the pages of your website was cumbersome. It required a lot of programming that we didn't want to do, or a lot of preparation that we rarely make. I believe CMSs like WordPress took some of the sting out of that problem, but it wasn't until the most recent release (WordPress 3) that it truly got to a point where *anyone* can make a menu that makes sense. Today, you can just focus on generating your content, and decide to make the menus later—a big plus.

This Is an Abbreviated List

In this chapter, we'll spend some time talking about some of the plug-ins I used to make this sample website better, in addition to talking about how to create the menu structure we'll need on our site. Keep in mind that the plug-ins I use and menu arrangements I make here are really just recom-mendations. As more and more people develop and work on this CMS, you can spend an incredible amount of time shop-ping for design combinations. Sure beats coding, though!

THANK GOODNESS FOR MENUS

When you start creating posts and pages in WordPress, you're going to need to make some organizational sense of all of this. Thankfully, WordPress 3 makes it easier by letting you create menus very simply. You can even have more than one menu for a quick switch, or to add to another portion of your website.

STEP ONE:

The biggest hassle when working with earlier versions of WordPress was the need to create some order to all of the pages and posts on your site. Trying to decide which page to put first or which category (from a post) to make a link made it a bit cumbersome to use WordPress as a CMS for a website. All of that completely changed with the introduction of the Appearance Menus controls in WordPress 3's Dashboard.

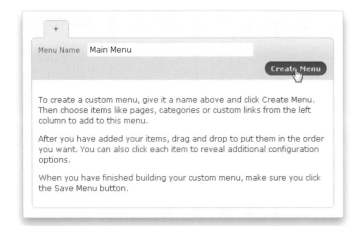

STEP TWO:

Menus are pretty straightforward. On the right side of the Menus screen, type in a Menu Name and click the Create Menu button. WordPress allows you to create as many menus as you need, and they can be called whatever you want. In this case, I'm calling my main menu "Main Menu." I know—original, right?

STEP THREE:

Once the menu is created, on the left side of the page, you'll see a Pages section to the left of where you created the menu. You can turn on the checkbox for any of the pages that you want to add to the menu, and below that, turn on the checkboxes for any categories that you'd like to include. Once you have them selected, clicking on the Add to Menu button will add them to the menu.

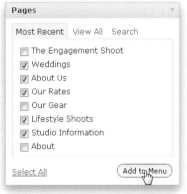
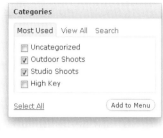

STEP FOUR:

What's great about this way of creating a menu is that you don't really have to worry about naming and organizing stuff as you're creating it—you can do that all on the fly. In this case, I can change the name of the pages that I've set up by clicking on the down-facing arrow at the right end of each menu bar and changing it in the Navigation Label field.

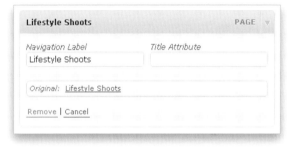

STEP FIVE:

Once the menu is done, you'll need to tell Word-Press which menus to use and in which order. Remember, you can create a lot of them, so this part is pretty important. In the Main Menu section, you can just click-and-drag each menu bar where you want it. If you want something to be a sub-menu of another menu, drag it below and to the right of that menu.

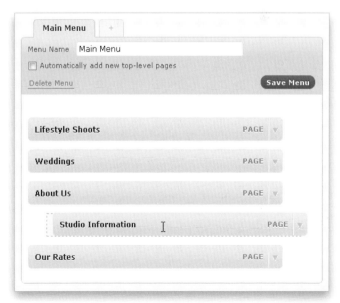

< CONTINUED >

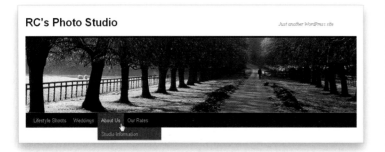

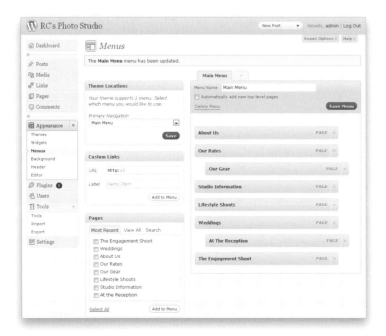

STEP SIX:

Once you're done, click the Save Menu button near the top right of the Main Menu section. Then, to the left, under Theme Locations, choose your new main menu in the Primary Navigation pop-up menu and click the Save button. Now, you can go and preview your site.

STEP SEVEN:

This is a sample of all of the pages that we have set up. We can give ourselves some subcategories to make more space on the navigation bar. I tend to like to place things in subcategories, but never really more than three deep. After that, it just becomes frustrating for a person to navigate your site.

STEP EIGHT:

Now we can start adding more stuff, and this is one of my favorite parts. In this WordPress installation, you aren't just limited to the posts and pages that you create from inside the CMS—you can add links from other sections of your website to your navigation bar very easily. This is called a custom link. So, in the Custom Links section, type in the URL that you want to go to, and give it a label. Once you click the Add to Menu button, it will show up in the main menu section on the right.

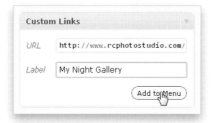

STEP NINE:

If you've created a Web gallery in Lightroom or Bridge (see Chapter 11 for how to do this), *this* is where they become incredibly handy. Let's say, for example, you want to show off a portion of your portfolio and call it "My Night Gallery." All you have to do is create the one-off gallery and upload it to a specific folder. After copying down the link, return to the WordPress back end and create a custom link that goes to that folder. Add it to the main menu, and you have an instant portfolio from inside the navigation bar!

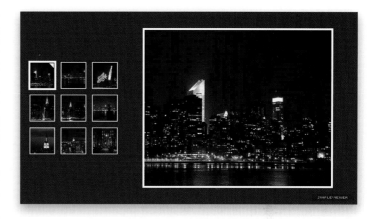

STEP 10:

There is also a bit more information that you can include in the settings for each menu in your main menu section—information that will help you set up a couple of key things with links later on, so it's probably a good idea for us to turn them on now. At the top right of the Menus page, you'll see the Screen Options button. Click on it to reveal a series of checkboxes you can turn on to show more options on the Menus page. For now, turn on the checkboxes for Link Target, CSS Classes, and Link Relationship (XFN).

< CONTINUED >

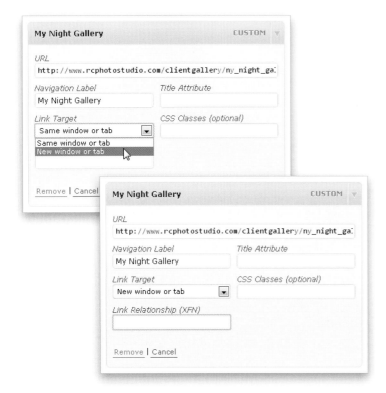

STEP 11:
The Link Target pop-up menu will let you specify whether you want the page that you added to the menu to open in the same window or a new one. Keep in mind that any one-off galleries you've created in Lightroom or Bridge do not have navigation links to other parts of your site. If you make the gallery page appear in the same window as the site, you risk having the user close out of your website by closing the browser, because they couldn't find your navigation. If there's no navigation, they're going to think it's a new window anyway, so be sure to make it one.

Link Relationship (XFN) is another one that will come in handy. You see, I think it's great that we can incorporate the galleries that we made with Lightroom and Bridge by putting them in a new window. But, what if we could take it a step further, and add them right into the website? We'll tackle this next.

INSTALLING A PLUG-IN

Plug-ins let you take what WordPress can do and extend it—by a lot. From analytics, to forms, to shopping cart extensions, there are a lot of plug-ins being developed for WordPress. As with anything that you may install on your own computer, be careful when installing plug-ins. Read the reviews, and check how many people have used them—these two things will help you make a good choice.

STEP ONE:

Let's go to the Plugins page of Dashboard and start by looking for some plug-ins that will help speed along how we work on our site. Click on the Plugins button on the left, and you'll see a list of the plug-ins that are installed in your system, whether they are active or inactive, and which require updating. To add a plug-in, choose Add New from the Plugins pop-up menu.

STEP TWO:

I am a big fan of a plug-in called Shadowbox. Shadowbox allows you to click on an image and isolate it on a dimmed background. This makes it pop in the center of the webpage, and is a great way to show your images. Another great thing about it is that it works with webpages and video, as well. So, on the Install Plugins page, go ahead and type "shadowbox" into the search field and click the Search Plugins button.

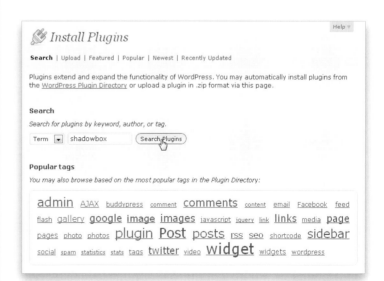

< CONTINUED >

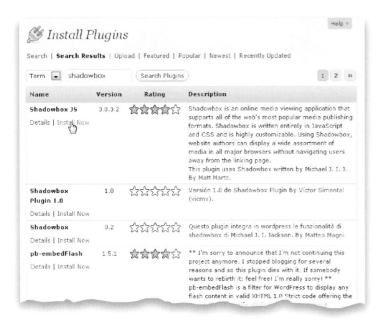

STEP THREE:

The Search Results will show you a listing of all of the available plug-ins. Shadowbox JS will be at or near the top of the list. Directly under the name, you'll see links for more Details on the plug-in and Install Now. Go ahead and click on the Install Now link. (*Note:* You may be prompted to enter your FTP username and password, so make sure you have them handy. For more on using FTP, see Chapter 11.)

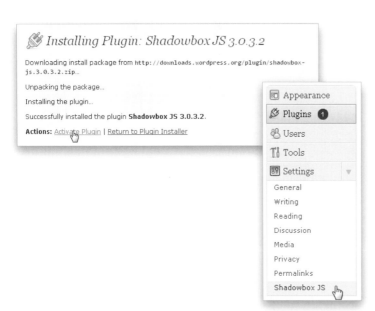

STEP FOUR:

Once the plug-in is installed, next to Actions at the bottom of the installation page, click on the Activate Plugin link. Now, click on the Settings button on the left, and you'll see the Shadowbox plug-in at the bottom of the menu. Choose it, and you can then change how the plug-in behaves on the Shadowbox JS page.

STEP FIVE:

The one change that I make here is to set Enable Smart Loading to False. I'd like to specify when I activate the plug-in, instead of letting them do it for me.

(*Note:* Make sure you take a look at Chapter 11, where we'll talk about how to upload Photoshop and Lightroom Web galleries, and how to use Shadowbox to make them open right from within your website.)

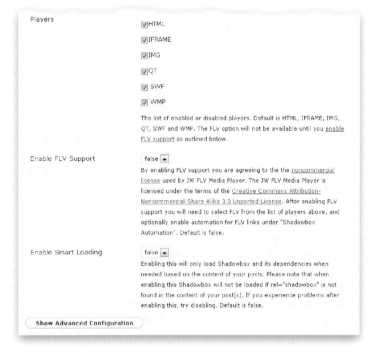

OPENING AN IMAGE IN A SHADOWBOX

Shadowbox is one of those plug-ins that I immediately go for because it helps me set up images on a website in a cool way. It's also one of those plug-ins that gets "oohs" and "ahs" from people wondering how you did it.

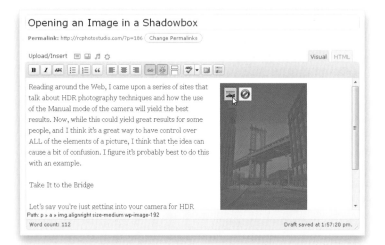

STEP ONE:

There will be times when you want to open an image in a page or a post inside of a Shadow-box window instead of having the image open in a new window. Now that we have Shadowbox installed, we can do this. Once you've added the image to your post or page, select the image in the content field's Visual tab. Then, click on the Edit Image icon on the upper left of the image to bring up the Edit Image dialog.

STEP TWO:

Click on the Advanced Settings tab, and you'll notice that there is a Link Rel field in the Advanced Link Settings section. Type the word "shadowbox" in that field and click the Update button at the bottom left.

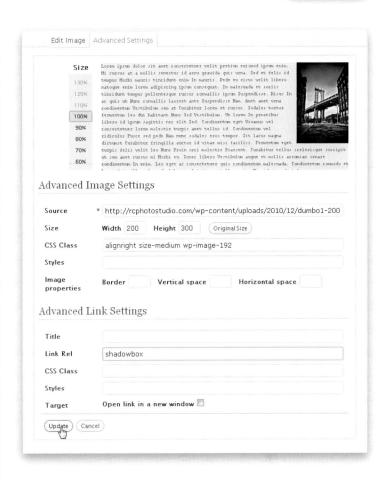

STEP THREE:

If you would like to do this in code view on the HTML tab in the content field, simply add Rel="shadowbox" in the <a> tag, as shown highlighted here.

< CONTINUED >

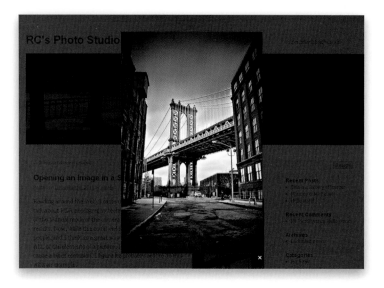

STEP FOUR:

Save and preview the post. When you click on the image, it will now appear inside of a Shadowbox window.

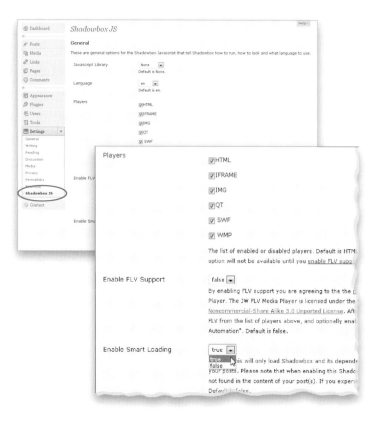

STEP FIVE:

If you want all of your images to open in a Shadowbox window, you can change the default behavior of Shadowbox in its settings. Click on the Settings button on the left and choose Shadowbox JS from the pop-up menu. Scroll down to Enable Smart Loading and make sure that it is set to True. Also make sure that the IMG checkbox, under Players, is turned on. Click the Save Changes button at the bottom, and once those settings are updated, all of the images will open in a Shadowbox window.

INSTALLING CONTACT FORM 7

When you need to create a form to get feedback from a user, you don't want to have to go back and learn programming. Contact Form 7 is a plug-in that makes this process very quick and easy.

STEP ONE:
Contact Form 7 is a great plug-in for WordPress that lets you make a quick form for users to get information back to you. Click on the Plugins button on the left side of Dashboard, choose Add New from the pop-up menu, and enter Contact Form 7 in the search field. Once you find it, click on the Install Now link, and once it's installed, click on the Activate Plugin link.

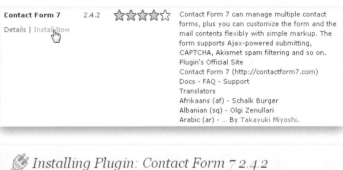

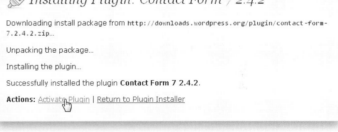

STEP TWO:
Under Contact Form 7 in your plug-ins list, click on the Settings link. On the settings page, you'll be given a sample of code that you can copy to a page. Select the code at the top and press Ctrl-C (Mac: Command-C) to copy it.

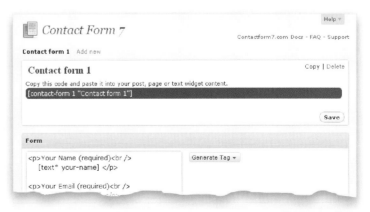

< CONTINUED >

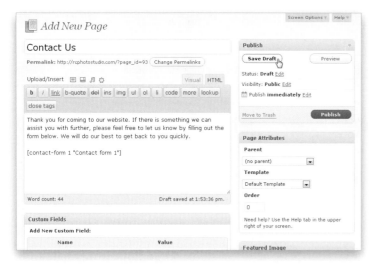

STEP THREE:
Create a page called "Contact Us" and switch to the HTML tab at the top of the content field. Add your text informing the user to contact you for any questions or concerns, then press Ctrl-V (Mac: Command-V) to paste the code with your text in the content field, so it looks like the example here. Once you're done, click the Save Draft button in the Publish section at the top right to save the file, and click the Preview button to preview it in a new window.

With no coding, you've been able to set up a form on your website. And in record time!

INSTALLING GOOGLE ANALYTICS

It's only a matter of time before you start wondering, "Hey, just how many people *did* come and visit my website this past week?" To get information like this, you can sign up for a free service called Google Analytics. Tie it with the WordPress Google Analytics plug-in, and you'll have all of that info right at your fingertips.

STEP ONE:

First, you'll need to go to Google's website and sign up for a free account. Then, go to the Google Analytics website (www.google.com /analytics), log in using your Google username and password, and sign up for a Google Analytics account. *(Note:* To see a video about incorporating Google Analytics into your blog, visit the download site mentioned in the book's introduction.)

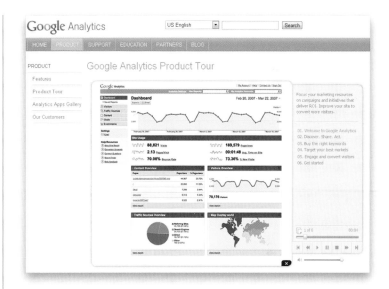

STEP TWO:

Once your account is set up, log back into your WordPress admin page, click on the Plugins button on the left, and choose Add New. Search for WP Google Analytics, then install and activate the plug-in.

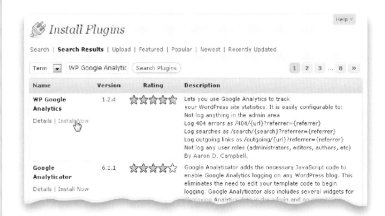

< COΠTIΠUED >

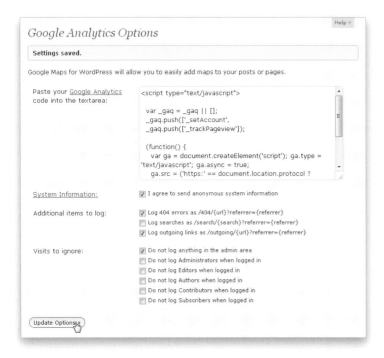

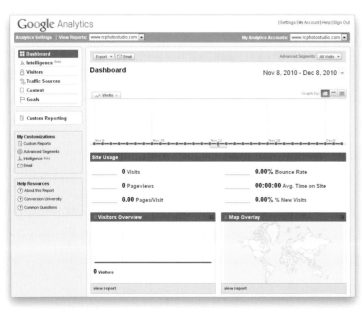

STEP THREE:
Click on the Settings button on the left, and choose Google Analytics. On the Google Analytics Options page, you'll need to paste your Google Analytics code into the text field. So, click on the Google Analytics link to the left of the text field, and it will show you how to figure out the code for your account. Copy that code, then go back to your WordPress admin page, and paste it into the text field on the Google Analytics Options page. You can turn on checkboxes for any of the other options on this page, depending on what analytics you need (you can find more information about these options on the Google Analytics website). Click the Update Options button at the bottom of the page to start the process, and Google will then keep track of statistics for your website.

STEP FOUR:
You'll then be able to log into the Google Analytics site and view reports on how your website is performing.

> " Knowing a little bit of code will help you fix a bunch of problems... "

CHAPTER SIX
html tips & tricks

Even the Best Programs Can Go Bad

The site is beginning to look really good! You're putting in some content, and some pages are beginning to take form. All seems to be going nicely until, all of a sudden, things come to a crashing halt. The picture that you're trying to post on the site is really close to your text. For some reason you can't get the text to flow into another block. Try as you may, you just can't get the picture to line up the way that you want it to. What are you supposed to do?

Problems like this happen to everyone who works within any CMS program, and are very frustrating. The problem is worse here because there is a good possibility that you won't know the first thing about HTML coding or CSS stuff. First off, don't worry about that. You haven't needed to get into the nuts and bolts of HTML yet and you've done well, right? What you need is a toolbox. You need a quick set of "If this happens, I need to fix this part" type of support that I almost always seem to give people who jump right into website development.

I'd like to point out, for the record, that if you are managing your own website, it's probably a good idea for you to get at least a basic understanding of HTML and CSS principles. Knowing a little bit of code will help you fix a bunch of problems and actually speed up a lot of what you have to do on your websites. That said, I know that a lot of you are setting up your website to do photography, and would like to stay busy doing just that.

Two Views: HTML and Visual

When working on your website, one of the best ways for you to get started with checking out code is to just take a peek. Most of the stuff that we've been working on in WordPress posts and pages has been inside of the Visual tab. The cool part about this is that you can always switch over to the code view in the HTML tab to see what kind of code is being

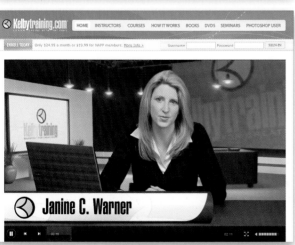

written for the post. The more you do this, the more you'll get a general idea of how it works, easing you into it. If you're code-savvy, it's pretty easy to just jump right into the code view and do all of your work from there, as well.

Some Great Resources for Learning HTML

Should you find yourself in a spot where you want to take the leap and learn a little bit more about HTML and CSS, here are a couple of good places to start: The W3Schools website is the world's largest resource for people to learn how to develop code. They have a ton of free tutorials and resources on HTML and CSS, as well as some programming topics. Look toward the bottom right of the website and you'll see the HTML Tutorial under Popular Pages.

Another resource out there that I think is great is Stephanie Sullivan. She's long been considered an authority on CSS and HTML, and her site at www.w3conversions.com is one that I visit often just to keep up with things. She also has a series of podcasts and books over on the Peachpit Press website (www.peachpit.com) for you to check out.

Finally, if you want to get up to speed fast, you can check out Janine Warner over at www.jcwarner.com. Janine's wonderful about taking you through the paces of CSS and HTML, and her classes over at KelbyTraining.com are often sought out by people who want to learn the basics of CSS in a short timeframe.

Keep in mind that you're not really learning how to set up an entire website using HTML—there's really no need for that. What you need to get under your belt is how HTML is written from a 35,000-foot view, so that you can fix some common problems that you may have.

This chapter will focus on giving you a general idea of what HTML and CSS are, and arm you with just enough skills to be able to do some basic troubleshooting of your webpages and perform some specific tasks related to posting information on your sites. The tricks listed here will most likely draw ire from hardcore coders who roll entire websites in notepad. If they do—hey, what are they doing reading this book? There's a perfectly good coding book one shelf down! Keep in mind that the next few pages may be heady. They're worth a reread, but the concept is simple. Think of it as a desk reference.

HAVE A LINK APPEAR IN A NEW WINDOW

What if I'm adding a new post and I want to create a link for people to click on to go to Google? I don't want them to go to Google in the same browser window, navigating away from my site. I want it to open in a new window. This can actually be done in WordPress in both the Visual tab and the HTML tab inside the code using a simple command.

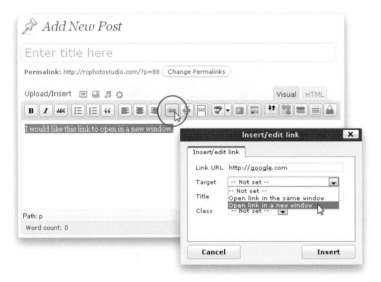

OPTION ONE:

In the WordPress Dashboard, click on the Posts button, choose Add New to add a new post, and then click on the Visual tab and start typing. Now, just highlight the text that you want to convert to a link to select it, and click the Insert/Edit Link button (it looks like a chain link) in the middle of the formatting bar.

In the dialog that appears, type in the URL you want the link to go to, and select Open Link in a New Window from the Target pop-up menu. Click the Insert button, and now the link should open in a new window.

OPTION TWO:

If you want to do this in the HTML tab, type in the following:

your text here</'a>

In this code, the target="_blank" is what's causing the link to open in a new window. Delete that portion, and the link will open in the same window.

GETTING RID OF WEIRD SPACING ISSUES

There will be times when you copy-and-paste text into the Visual tab on the WordPress Add New Post page, and the spacing of everything will look just a little bit off. Adding and removing spaces in the Visual tab, though, doesn't make any changes to anything.

STEP ONE:

If you copy-and-paste some text into the Visual tab and the spacing isn't quite right, switching to code view always helps correct the issue. When you paste text, chances are the Visual tab has placed random <P> and <div> tags in your text, causing the spacing problems. Whenever I type in my content into the code view in the HTML tab, I never use any <div> or <P> tags. I just type in my content and press the Enter (Mac: Return) key when I need a new line. Those <div> and <P> tags are just excessive.

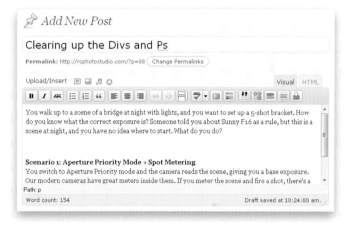

STEP TWO:

Keep in mind, however, that if you remove a <P> tag from the HTML tab code view, there will most likely be a </P> tag. Make sure you check the content and get rid of that one, too. The same goes for the <div> tags. (*Note:* The only exception here is if the <div> tag happens to have a class attribute, which will start with "class=." Chances are if it does, it's performing some formatting function.)

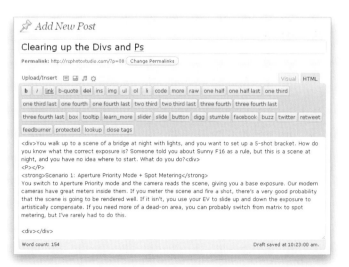

ALIGNING TO THE RIGHT OR TO THE LEFT

The Upload and Insert features of WordPress do a pretty good job of aligning and inserting your content on the page. There are times, however, when that alignment won't work.

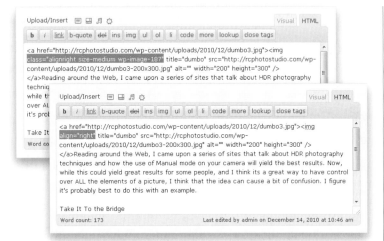

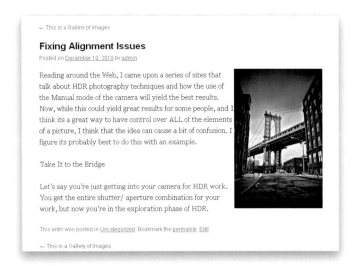

STEP ONE:

Sometimes when you type your post in the Visual tab and then add an image to it (see Chapter 4 for how to do this), it doesn't seem to align the image very well with the text. If you switch to the HTML tab, you'll see the alignment of your image is usually done in a class inside of the tag. Look inside of the tag for class="alignright" information (highlighted at the top here). Deleting that information and replacing it with align="right" can align the image to the text a little bit better sometimes.

STEP TWO:

When you do this, make sure you are placing the reference to the image at the start of the text. This will make sure that there is no extra space above the first line of text.

MOVING TEXT OVER TO THE NEXT IMAGE

I would dog-ear this page and keep it handy. This is something that will happen to you a lot, and happens more when you are using a portrait-oriented image on a blog post. Leave it to float alone, and the space looks awkward, so you may as well learn the one simple command to add to fix it.

STEP ONE:
This is a common problem I see when working with an entry that has more than one image. There are times when you want some text to pair with one of the images on the page. You'll then want another image and another block of text, but you want both of those new elements on their own line.

What you get instead is a picture to the left of another picture and text that is misaligned. Adding to the problem is the fact that the Visual tab in WordPress doesn't quite know what to do with this, as seen here.

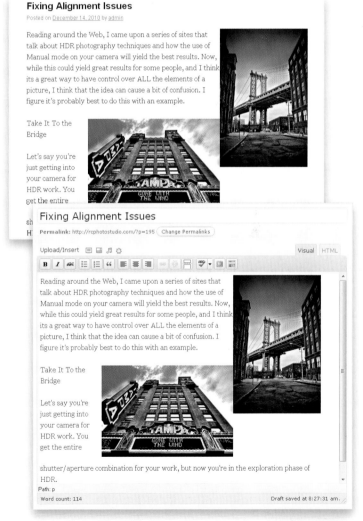

< CONTINUED >

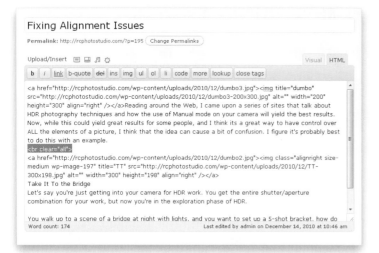

Fixing Alignment Issues

Permalink: http://rcphotostudio.com/?p=195 (Change Permalinks)

Upload/Insert 🖼 🖿 🎵 ⚙ Visual | HTML

b | i | link | b-quote | del | ins | img | ul | ol | li | code | more | lookup | close tags

```
<a href="http://rcphotostudio.com/wp-content/uploads/2010/12/dumbo3.jpg"><img title="dumbo"
src="http://rcphotostudio.com/wp-content/uploads/2010/12/dumbo3-200x300.jpg" alt="" width="200"
height="300" align="right" /></a>Reading around the Web, I came upon a series of sites that talk about
HDR photography techniques and how the use of Manual mode on your camera will yield the best results.
Now, while this could yield great results for some people, and I think its a great way to have control over
ALL the elements of a picture, I think that the idea can cause a bit of confusion. I figure it's probably best
to do this with an example.
<br clear="all">
<a href="http://rcphotostudio.com/wp-content/uploads/2010/12/dumbo2.jpg"><img class="alignright size-
medium wp-image-197" title="TT" src="http://rcphotostudio.com/wp-content/uploads/2010/12/TT-
300x198.jpg" alt="" width="300" height="198" align="right" /></a>
Take It To the Bridge
Let's say you're just getting into your camera for HDR work. You get the entire shutter/aperture
combination for your work, but now you're in the exploration phase of HDR.

You walk up to a scene of a bridge at night with lights. and you want to set up a 5-shot bracket. how do
```
Word count: 174 Last edited by admin on December 14, 2010 at 10:46 am

STEP TWO:

My solution? Right before you add the second image to the post, type in the following:

<br clear="all">

This creates a line break, and if there is an image in that paragraph, make sure you clear that one, too, by adding that command again.

Fixing Alignment Issues

Posted on December 14, 2010 by admin

Reading around the Web, I came upon a series of sites that talk about HDR photography techniques and how the use of Manual mode on your camera will yield the best results. Now, while this could yield great results for some people, and I think its a great way to have control over ALL the elements of a picture, I think that the idea can cause a bit of confusion. I figure it's probably best to do this with an example.

Take It To the Bridge

Let's say you're just getting into your camera for HDR work. You get the entire shutter/aperture combination for your work, but now you're in the exploration phase of HDR.

STEP THREE:

Technically, you can use <br clear="left"> or <br clear="right">, but I tend to use "all" for good measure. That will move the paragraph to the next possible line, going past the image itself, as shown here.

ADDING SPACE AROUND AN IMAGE

The secret to a good design? Making sure your text can "breathe." If you place text blocks too close together, or place text next to images too closely, it makes it really hard for readers to pay attention to what you're saying. Here's how you fix that:

STEP ONE:

In the previous example, you'll notice that not only are the images really close together, but the top image and the text sit really close to one another. There will be times when you're going to want to add some additional space around an image (like this one), so it doesn't feel too crowded. To do this, in the Visual tab, click on the image that you want to add spacing to. You'll see two icons appear at the top left of the image. Click on the Edit Image icon (the one on the left).

STEP TWO:

This will open a dialog with an Advanced Settings tab, where you'll see that there are fields for Vertical Space and Horizontal Space. Entering a number in these fields will specify the amount of spacing you want around the image.

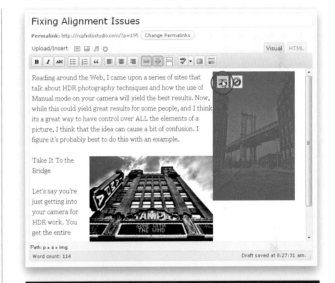

< CONTINUED >

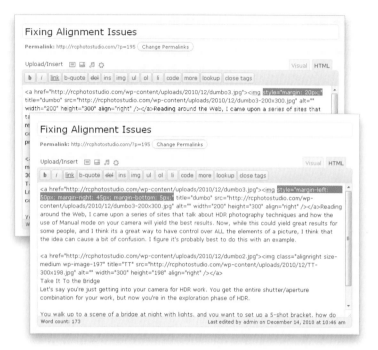

STEP THREE:

Two problems arise here, though: if you enter in the same values for horizontal and vertical space, the Styles code will look like the example in the previous step and on the top here. It will place a style="margin: XXpx;" to cover both the horizontal and vertical spaces.

There will be times when you'll want to specify individual values for left, right, top, and bottom spacing. If I wanted to do that, I would replace the code with the following:

> **style="margin-left: 50px; margin-right: 45px; margin-bottom: 5px;"**

(*Note:* Make sure that you replace the values with the values you wish to have in the spacing.)

STEP FOUR:

Save and preview your changes, and you'll notice that now you have the appropriate spacing around the images in the page or post.

Fixing Alignment Issues

Posted on December 14, 2010 by admin

Reading around the Web, I came upon a series of sites that talk about HDR photography techniques and how the use of Manual mode on your camera will yield the best results. Now, while this could yield great results for some people, and I think its a great way to have control over ALL the elements of a picture, I think that the idea can cause a bit of confusion. I figure it's probably best to do this with an example.

Take It To the Bridge
Let's say you're just getting into your camera for HDR work. You get the entire shutter/aperture combination for your work, but now you're in the exploration phase of HDR.

You walk up to a scene of a bridge at night with lights, and you want to set up a 5-shot bracket. how do you know what the correct exposure is? Someone told you about Sunny F16 as a rule, but this is a scene at night, and you have no idea where to start. What do you do?

CREATING AN EMAIL HYPERLINK

While you may have a custom page that deals with getting information from your visitors, you may want to include a link on a page or a post to have someone email you. This is called an email hyperlink.

STEP ONE:

When you're adding or editing a post or page, type the text you want to turn into an email hyperlink, and then highlight it. Now, click on the Insert/Edit Link button (the chain link) in the formatting bar at the top of the content field.

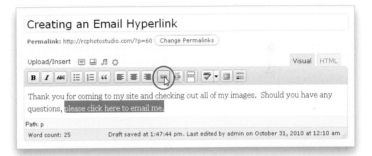

STEP TWO:

In the dialog that appears, type the following in the Link URL field:

mailto:youremail@yourdomain.com

Click the Insert button, and the text in the Visual tab will turn into a blue link.

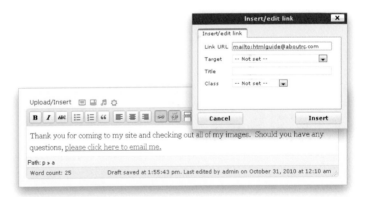

STEP THREE:

You can also do this in the HTML tab in code view by typing in the following:

please click here to email me.

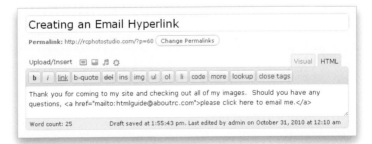

ALONG THE WAY
jacob cass, graphic designer

Jacob Cass is self-employed as a graphic designer, specializing in the fields of corporate identity (logo) design, Web design, print design, and branding, with the majority of his time spent designing and implementing marketing promotions for businesses. He creates logos, websites, letterhead, business cards, packaging, and more. He's the founder of Just Creative Design, a growing graphic design company and graphic design blog, which focuses on all areas of design and creativity. He also runs two other websites: *Logo Of The Day* and *Logo Designer Blog*. Although he's just 23 years old, he has a multitude of experience, obtaining his first freelance design job at the age of 16.

How did you get started in graphic design?

I first got into design when I was in high school, just when digital photography was starting to become affordable. I was uploading party photos to the Web for my friends (before MySpace or Facebook), which required me to learn about HTML and design. With this small amount of knowledge, I had fun designing small websites, flyers, and invites for friends and, in time, this hobby turned into a passion, then a career.

How did you evolve from being a designer to writing a blog?

I wouldn't say that I evolved from a designer to a blogger, but rather used blogging as a tool to expand and share my knowledge, as well as grow my business, while being a designer.

Blogging (and reading other blogs) allowed for learning that simply wasn't possible in the classroom. I've said it before, but I learned more in six months of blogging than three full years at university.

Does the blog help your designs? Or do the designs help your blog? How so?

They go hand-in-hand. The blog helps me document and share my work, and it also helps bring in clients. The designs then help bring in more work.

As a photographer, how important is it to establish a brand?

For anyone wishing to carve out their niche in a vastly competitive environment, it's vital to establish a brand identity. Creating a brand helps you stand out from your competitors and, if done correctly, will bring in the clientele you're looking for, and then some. To understand the difference between branding, visual identity, and logo design, be sure to read this article: http://bit.ly/bvild.

If you are a photographer, does that automatically mean you are a designer?

No, just like if you are a designer, you are not automatically a photographer. They are both very different skills.

How does one work with a designer to get a logo or brand developed?

Like photographers, designers will all work in different ways, but in general, a logo/brand designer will work closely with the photographer to carve out a brand suited to their needs, through a non-linear process. This may be through a combination of interviews, questionnaires, phone conversations, and exercises, etc. I wrote an article on how to choose a logo designer. You can find it at: http://bit.ly/choosedesigner.

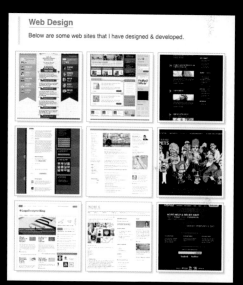

Web Design

Below are some web sites that I have designed & developed.

IMAGES COURTESY OF JAC

“ ... a template is an incredible way to get something that looks good for very little cost. ”

CHAPTER SEVEN
make your website pop with a theme

Changing Up the Look and Feel

You've probably thought it over the last few chapters, but haven't really said it out loud: "You know, this site has been pretty easy to set up, but it sure doesn't look very pretty. I hope this changes soon." The great part about that is—you're right. And it's changing right now.

One of the things that I really like about WordPress is that, as a content management system, it really lets you focus on the organization of your website. I've always argued that this is the hardest part about making a site. I can't say how many

Web projects I've seen stall after splashy graphics were made, because thought wasn't given to what kinds of things were going to go on the website, and how they'd get there. By not really focusing on the pretty part, you were able to organize and add all of the relevant content to the site. As I said before, it's kind of like working on the frame of a house.

Now that all of the important stuff is taken care of, we can focus on dressing the site up a little bit. The look and feel of the website is controlled by something called a theme.

Themes allow WordPress to separate the visual appeal of a site from the actual content—like a "skin" that goes over the frame of the house.

Because themes are modular, anyone with knowledge of cascading style sheets (CSS) and PHP: Hypertext Processor (a scripting language) can design one. And with them, you can have multiple looks for your website in just a few clicks.

Getting a Theme for Your Website

There are several different ways for you to get a theme: The WordPress site hosts a great number of free themes for you to download and install on your site. Most of this can be done from right inside of your WordPress admin page, and the installation can be done in a matter of seconds. There are also membership-based theme sites that allow you to download themes and install them on your site. Third, there are websites dedicated to selling pre-designed themes that you can "cut" to fit your needs, making them a cheap alternative to getting a more professional, custom-designed theme. Finally, there are actual services on the Internet that will create a customized design (or a design that you make in Photoshop) and turn it into a theme that you can use.

Buying a Template Versus Making Your Own

If you are launching your website for the very first time, and are trying to keep your costs down, I think that a template is an incredible way to get something that looks good for very little cost. Do understand that, because you are purchasing (or getting for free) a template, there is a possibility that someone else is also using that theme on their site. So, some people are hesitant to use theme-based designs they can download. This, I don't understand.

The Pants Analogy

If I am going out to a party on a Saturday night, and I want to look my best, chances are I am going to go to the store and buy a pair of new pants. Being thrifty, there's an even bigger chance that I am going to go to a big box store in order to get the pants. Because of this, there's a good chance that the style of pants I buy will be the same as another customer. But, I don't consider going to a custom designer and saying, "I will be attending a party; please make me a pair of pants." Advantage: template.

The Cost Concern

If you are reading this book, there is a chance that you're a photographer dipping your toe in the world of the Internet. As with any venture, it's important to be able to see how much return on investment we'll have on something before we spend any more money on technology. You could (and I doubt this) find that having a website isn't to your liking. Would you rather find this out after spending several thousand dollars? Or would you like to get into the game and start earning something while spending very little? Advantage: template.

Design Your Own Later

Applying a template is pretty straightforward and modular enough that if you want to change it, you can do so in a few clicks. Later, if you find that you'd like to design your own using Photoshop, there are tons of services out there that will take your Photoshop designs and convert them to a template. All you have to do then is upload, activate, and you're up and running.

A Word of Caution on Free Templates

Like anything, keep in mind that you get what you pay for. Going to the WordPress website for free templates will more than likely give you a template that doesn't look much better than the standard default. On some occasions, free templates have also been known to introduce viruses, so be careful. Sometimes, it's good to just spend a little to get a lot. So, let's get started!

FREE TEMPLATES AT WORDPRESS.ORG

If you want to take a look at some of the free templates that are available to you, visit www.wordpress.org and click on Extend in the menu bar across the top. You'll see they have a free Themes directory with thousands of themes for you to browse.

STEP ONE:

On the main Free Themes Directory page, click on the Check Out Our New Filter and Tag Interface link near the top. You can narrow down your choices by selecting features from a series of checkboxes, based on what you're looking for. The templates are broken down conveniently by Colors, Features, and Subject, among other options. Here, I chose Dark for Colors and Two-Columns.

STEP TWO:

Clicking on the Find Themes button will show you thumbnails for all the templates that match your criteria. Scroll down below the checkboxes to see them. Clicking on a theme's thumbnail will bring up a preview window showing you the style sheet for that theme (so you can see what the headers, lists, forms, etc., will look like).

STEP THREE:

Another great feature of WordPress is that you can search for these same themes right from inside of the admin page of your website. Log in to your admin page, click on the Appearance button on the left side of Dashboard, and choose Themes. Click on the Install Themes tab to see the feature checkboxes.

STEP FOUR:

In this case, I searched for a theme called Kanata to try out. You'll see that the theme appears with an Install link, and another link to preview what it will look like.

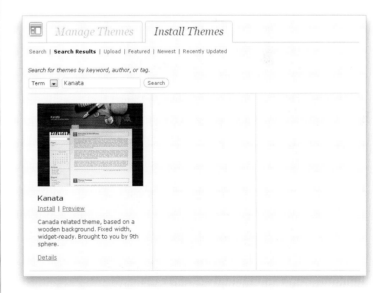

< CONTINUED >

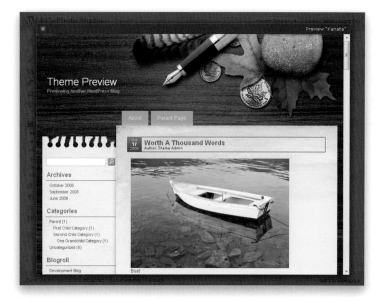

STEP FIVE:

Clicking on the Preview link will give you a Shadowbox, with a sample of what the theme will look like on your site. This one looks good to me, so I'm going to install it.

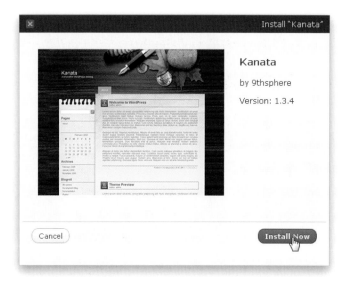

STEP SIX:

Close the preview, and click on the Install link. An installation dialog will pop up, so click the Install Now button. It will go through the install process, downloading your template and placing it in the wp-content\themes folder of your site. (*Note:* See Chapter 11 for more on working with your site's folders.)

STEP SEVEN:

Once you click the Install Now button, you'll be taken to a screen that tracks the progress of the installation. When the install is successfully completed, you can choose to preview the theme, activate it on your website, or return to the theme installer.

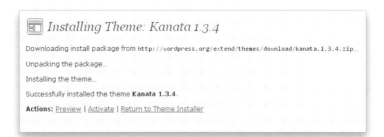

STEP EIGHT:

Clicking the Activate link will turn the theme on, and take you to the Manage Themes tab on the Themes page. This tab will change, letting you know that your new theme, Kanata, is active and is now the current theme on your site. WordPress keeps any older themes in a list under the active theme (labeled Available Themes), in the event you want to revert back to a previous theme later.

STEP NINE:

Open a new browser window, and go to your website. You'll see that the site's look and feel has changed, but all of the structural content stayed the same. Congratulations, you have a new look to your website!

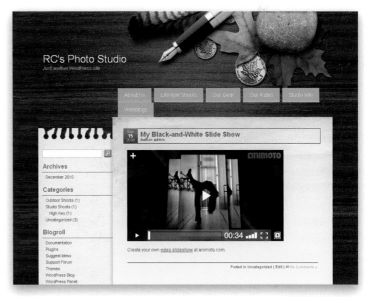

< CONTINUED >

STEP 10:

Did you notice that there's a tagline under your website name that says, "Just another WordPress site"? Let's remove that. Go back to your admin page, click on the Settings button on the left, and select General. You'll see that text in the Tagline field. Just delete the words from that field, and click the Save Changes button at the bottom left.

STEP 11:

Now, preview the page again. You'll notice that the tagline is gone. And, again, you can see that while the website looks different, all of the structure has remained the same, including page structure, posts, and plug-ins. For example, if you click on an image in a post, it will still appear in a Shadowbox window. Not bad at all!

I'm going to revert back to my original template, because we're going to use another one from a paid site. So, go back to your admin page to the Themes page (under Appearance), click on the Activate link beneath the original template, then click on the Delete link beneath the template we're not using. Get into the habit of doing this, so your back end stays as organized as possible.

INSTALLING A DOWNLOADED THEME

Another way for you to make your site look different is to download a template from a theme design service. In this example, we are going to install a photography-centric theme called Candid from the folks over at Shooter Themes (who were nice enough to provide this for free for us) to experiment with. Using our basic WordPress skills, we should be able to get it up and running in no time!

STEP ONE:

There are tons of online theme design companies out there to choose from and one that I'm really happy with is Shooter Themes. These guys are working on turning out WordPress themes specifically for people into photography. Whether you want to blog or not, the themes are designed to use a lot of the built-in functionality of WordPress. They were also nice enough to give us one of the themes they are going to be selling to use here. First, we'll be installing the Candid theme (you can see my finished website with it here), and you can download it from the book's download website (mentioned in the book's introduction).

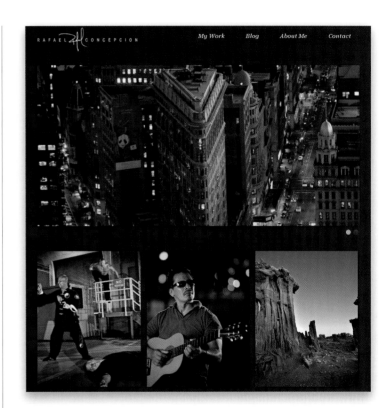

< CONTINUED >

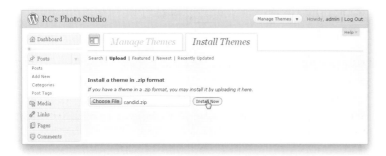

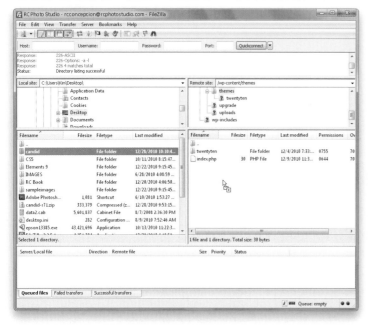

STEP TWO:

Once you have the zip file for the theme on your desktop, log back into the admin page of your website, click on the Appearance button on the left and choose Themes. You'll notice that at the top there are two tabs: Manage Themes and Install Themes. Click on the Install Themes tab where you can upload the file right into the directory it belongs in on your website. Click on Upload at the top of the tab, then click the Choose File button. Navigate to the zip file you downloaded, choose it, and click the Open button. Click the Install Now button, and Word-Press will upload, unzip, and install the theme.

TIP: Installing Via FTP

If you want to use an external FTP client to install your theme, you'll need to extract the folder inside of the zip file and upload it to your server. The theme is placed in the themes folder, which is located inside of the wp-content folder. I find it so much easier to upload themes and images using an FTP client, so that's what I do most of the time. (*Note:* Using FTP is not as hard as you may think. If you're interested, check out the lesson on it in Chapter 11. In just a few pages you'll be flying with it!)

STEP THREE:

Once the theme is installed on your website, you'll have the option of previewing the theme or activating it. Since we know this is what we want, let's just go ahead and click on Activate.

CONFIGURING THE CANDID THEME

Once you've installed a theme on your website, there may be some changes you'll have to make for all of the features to work for you. From simply replacing a logo to learning about a new set of plug-ins, you're going to need to learn the technology behind each theme you want to use. Thankfully, Candid has a very low learning curve. Let's go configure it for our new portfolio!

STEP ONE:
Depending on the template companies you use (which we'll talk about later), the features inside the template will change. Some companies go so far as to use plug-in administration modules to make your life easier. I like the Candid theme, and what Shooter Themes does, because they design these templates with as much of the WordPress functionality as they can. This means that as Word-Press continues to evolve, much of the functionality will continue to work. That said, we still need to make some changes.

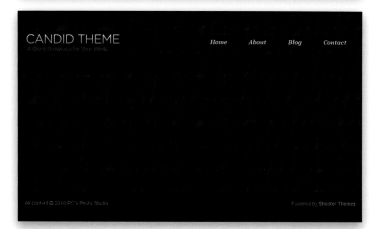

< CONTINUED >

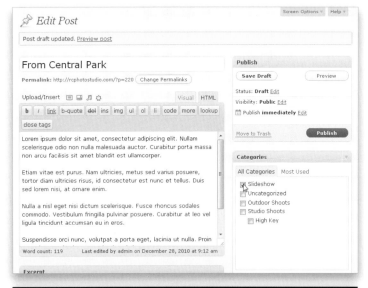

STEP TWO:

The Candid theme uses two different categories for posting images. It uses a Slideshow section at the top of the homepage to showcase images in a slider format. It then uses the bottom of the homepage to show side-by-side portfolio images with the text from your post about the image visible when you move your cursor over an image (as shown below). So, create a new post, and give it a title and some content text. Once you've done that, create a new category called Slideshow in the Categories section on the right, and turn on your new category's checkbox. Instead of placing an image into the content field of this post, we're going to need to make sure that there is a featured image listed for the entry, so check out the next lesson.

SETTING A FEATURED IMAGE FOR A POST

Imagine if you had a post that had seven images in it, and you wanted to include one of them in a slide show. This is where Featured Image can help. The Featured Image is the image that is mostly associated with the post—the leadoff image on an entry you make. Many templates being designed today look for a featured image in a post, so it'll be helpful to learn how to do that.

STEP ONE:

Once you have all of your content set in the post, and have exported an image to your desktop that you want to use, click on the Set Featured Image link on the right side of the Edit Post page. You'll be taken to the Upload/Media Gallery window.

STEP TWO:

Uploading an image to use as a featured image is very similar to the way you would upload an image to the content field, like we did in Chapter 4. But, there's a difference: Instead of just clicking on the Save All Changes button once it's uploaded, you're going to need to click on the Use as Featured Image link below the Size section near the bottom. Once you've done that, and then clicked on the Save All Changes button, you'll see that the window will still be open. This is kind of annoying, so also make sure you click on the X in the upper-right corner to close it.

Your post is now in the Slideshow category, and has a featured image. Good job! Don't forget to click the Publish button on the Edit Post page.

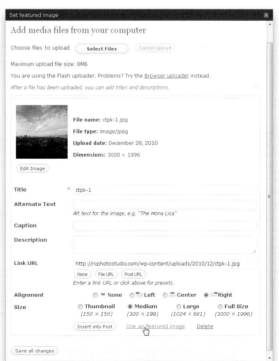

EXPLORING THE CANDID THEME OPTIONS

More developed themes that you download for free or purchase will have a dedicated section to customize them under the Appearance button. Clicking on those options will give you overall control of how the theme looks on the page. How much information can be customized depends on how complex the theme is, so be sure to read all the instructions that come with your theme to get to know it.

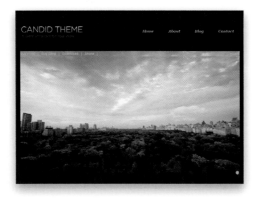

STEP ONE:

Let's make sure that the slide show at the top of the blog is reading from the Slideshow category. Click on Theme Settings on the Appearance button's menu and you'll see that there are sections where you can specify what category both the portfolio and the slide show read from. Let's set the Slideshow Category pop-up menu to Slideshow, and click the Save Options button at the bottom. We'll go back and do the Portfolio Category in a bit.

STEP TWO:

Preview the website in a browser and you'll see that the image is automatically cropped to fit the main area of the slide show. Not bad at all!

STEP THREE:

Go back and create another post for your blog. Make sure that you set the blog post in the Slide-show category, and that you set a featured image, like we did in the previous lesson. Once you publish the entry, you'll notice that you now have a slide show of two images on the homepage. The images will also transition from one entry to another automatically. (*Note:* The little circles below the bottom right of the image also let you navigate from one image to the other.)

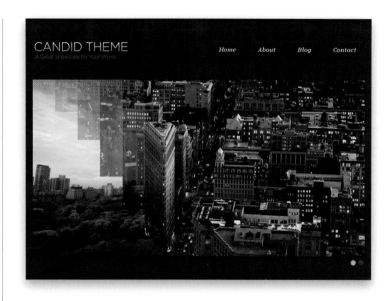

STEP FOUR:

At the bottom of the Theme Settings page, under Color Swatch Options, you have the option to change to a Light version of the theme, giving you a light gray background for your images. A couple sections up the Theme Settings page, under Extras Options, is a checkbox you can turn on to Enable Google Analytics. This gives you a Google Analytics Options section where you can paste the Google Analytics code you receive from Google to track your pages.

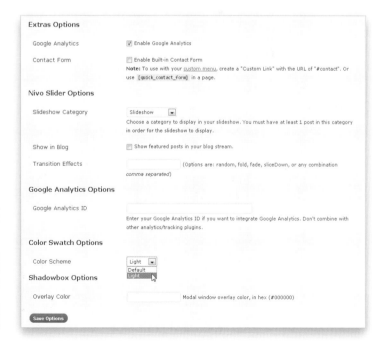

LOGOS & MENUS FOR THE CANDID THEME

Configuring the top portion of the Candid theme is pretty easy. Candid was designed for people who haven't placed any content on their blogs yet, so it gives you a default set of pages to start. These are automatically replaced with your own menus, however. The logo is easily replaceable with a graphic, and the bottom content area under the logo is controlled by a widget, which we'll look at in the next lesson.

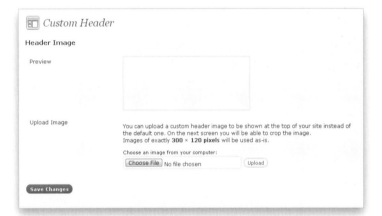

STEP ONE:

Click on the Appearance button on the left side of Dashboard, and choose Header. The Custom Header page controls whether you see a graphic or text on the top portion of this theme. In order for you to use your own logo, you're going to need to make a graphic that is no more than 300x120 pixels at 72 ppi.

STEP TWO:

Create a 300x120-pixel, 72 ppi, 8-bit document with a transparent background (in Chapter 10, I show you how to make print watermarks with logos on transparent backgrounds). Once you have that set, choose File>Place, find your graphic logo, and it will automatically be placed on the center of the document. (Since the Candid theme has a default background color of black, I made my logo white, here.) Then, all you need to do is save this as a PNG file (give it whatever name you'd like). Because the website has a background color already set, I think it's a good idea to always bring graphics in with a transparent background. These days, most of these graphics are pretty simple, but if you happen to try to use things like drop shadows or glows in your graphic, it may not look really sharp. So, I recommend keeping it simple.

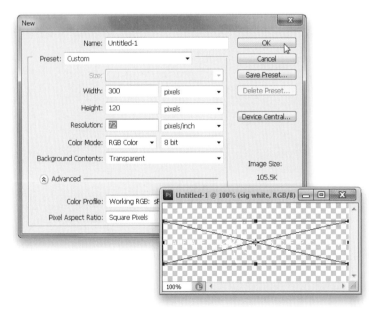

STEP THREE:

Now, go back to your Custom Header page, and click on the Choose File button. Choose the graphic logo you just created and click Open (Mac: Choose). Then, click the Upload button. You can preview it by clicking the Visit Your Site link that appears at the top of the page, and click the Remove Image Header button if you need to make any changes to it. Once it's set, click the Save Changes button at the bottom.

STEP FOUR:

Because Candid was designed for people who are just starting off with WordPress, it has a main menu already set up to get you up and running. (You'll find the Menus page under the Appearance button.) The great part about the theme, though, is that your primary menu will also be supported here. The only thing that you want to keep in mind is that you might want to keep the number of menus in the primary navigation to a minimum.

ADDING A WORDPRESS WIDGET

WordPress widgets are these little pieces of code that you can drag-and-drop into specific sections of your website. Accessed through the Appearance button's menu, you can apply them to specific areas of a theme (depending on whether your theme supports them). You can go online to search for widgets to increase functionality. From Flickr gallery widgets to Twitter stream widgets, they can really make a site!

STEP ONE:

This template we are using has three areas for you to place widgets (the sections that support them are listed on the right side of the Widgets page, found under the Appearance button). Adding a widget to one of those areas is simple: just click-and-drag it from the Available Widgets on the left onto an area on the right. You can even reorganize them by dragging them around in the area you put them. This will let you decide which widget comes first.

If you're looking for other widgets to add to your site, simply go to http://wordpress.org /extend/plugins and you can search for widgets that you can download and install on your site. We're going to keep things simple by just adding a text widget over in the Header Welcome Text section (as seen here).

STEP TWO:

This widget isn't going to need a title, as it's going to be the tagline that runs under the logo and menu bar. Here, I am going to keep things relatively simple and just add some basic text. You can even leave this section blank. When you've added your text, click the Save button, then click Close at the bottom left.

STEP THREE:

Now, with the widget text all set, we can preview the website and check out the changes. I went back into Posts and added three more posts. Then, I created a category called Portfolio for them, and set featured images for all three of them. Finally, I went back into Theme Settings, and set the Portfolio Category pop-up menu to Portfolio. These are all things that we have already done in this chapter (except we set the Slideshow Category before, instead of the Portfolio Category). Now we're just creating the sets of images that will go underneath the slideshow on the homepage.

One final save, and the preview will show you a fully-featured site with zero fuss.

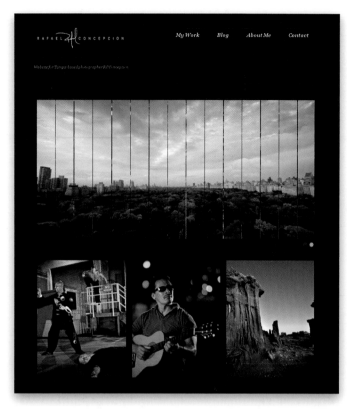

STEP FOUR:

This is the exact same website, just a few minutes later. To create this one, I went to Elegant Themes (www.elegantthemes.com) and paid for access to their templates. After an hour or so of moving stuff around and customizing things, I was able to get the site up and running with a completely new look.

Now, this template places more of an emphasis on posting images with some text written, as well. Make sure that whatever template you decide to use serves your overall vision for what you will be posting consistently. If you just want to place your images in a location and have people see (and order) them, make sure you use templates that don't rely on words so much—like Candid.

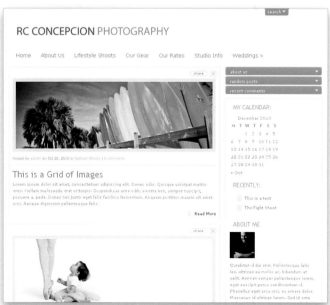

ADDITIONAL TEMPLATE RESOURCES

I'm really grateful that people like Shooter Themes are able to provide a template for us to use for free, but I realize that your demands may be a little more specific and may require something more custom. To that end, I've put together a list of resources for when you're thinking about purchasing themes or services.

Single-Theme Purchases:

The sites listed below here allow you to buy access to themes on a per theme basis. While these themes may look very feature rich, make sure you read up on them as much as you can before you buy. All of those features may translate into a lot of customization on your part:

www.themeforest.net

www.woothemes.com

www.themegarden.com

www.graphpaperpress.com

www.press75.com

www.superhug.com

Multi-Theme Purchases:

My favorite sites are the ones that let you pay for access to a series of themes within them. I think they offer the greatest bang for your buck and give you quite a bit of flexibility if you want to change your mind about your website's design later:

www.elegantthemes.com
www.studiopress.com

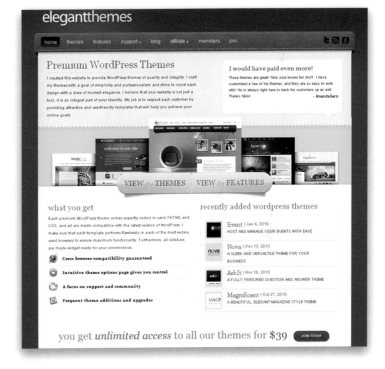

ALONG THE WAY
shooter themes, WordPress theme designers

Justin Finley started to dabble in HTML and design in high school when the band he was in needed logos, shirts, websites, etc. That experience turned into a hobby, which ultimately led him to pursue it as a career. Justin received a degree in digital arts and design and has been producing for many different clients and agencies, both freelance and in-house, for almost eight years, specializing in Web design and development.

Tommy Maloney has been developing websites in some form or another for the last 12 years. His second job was working for Kelby Media Group on their first websites. While he attended college briefly, it was for unrelated fields of study, such as law, film, and engineering. He had kept Web development as a hobby, but never really considered it a career path until he taught himself PHP, shortly after leaving college. From there, Tommy got into MySQL and JavaScript. His first big project was migrating a small-business website from a large, expensive Windows/ColdFusion/SQL setup to a faster, much less expensive LAMP setup.

Why WordPress? What makes WordPress a great platform?

Tommy: It's free, well-developed, and has a gigantic community supporting it. It lets you get past the hardcore technical aspects of building a website without being lazy, lame, or gimmicky. It's become so much more than a blogging platform. It's easy to use, almost infinitely extensible, functional, and easy to make pretty.

Justin: Simply because it's the best of what's around. I've worked on projects that have used everything from 100% custom-built CMSs to Joomla, to Drupal, and pretty much everything in between. I believe WordPress is the most well-built, well-documented, and developer-friendly of all, as well as one of the easiest to use for the end user.

When someone says "template," people often think "cookie cutter." How do you break that association in theme-based design?

Tommy: I believe the best approach is to not try and be everything to everybody. When you're able to target a group, like photographers, you can really focus in on the features and aspects they would be looking for in a website. We take the approach of just providing as nice a wrapper as possible, and leave it to the user to polish it with their content.

Justin: What separates one website from the other is content. In reality, there are only so many ways to layout a website and still have it be usable and useful to the end user. If you're not a seasoned Web developer, it's probably beneficial for you to start with a template. It provides a solid and well-structured base to start with, and as you get more comfortable with development, you can alter it to be something that is truly unique and your own.

Are "small-scale" websites the only ones that use WordPress?

Tommy: Absolutely not. Probably the largest scale website is WordPress.com. It's built essentially on the same software you can download and install on your website for free. There are over 16 million users on that website alone.

Justin: As a developer and someone who has been working with WordPress for many years, you get to the point when you can pretty much tell who's using what CMS on their site, especially with a quick peek at the code structure. I would say, now more then ever, you're seeing WordPress power an extremely large number of popular sites. I personally have worked on projects where multi-million dollar Internet companies are using WordPress to power their sites.

< CONTINUED >

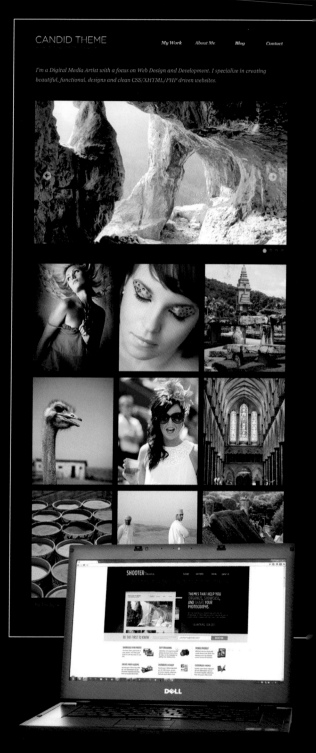

IMAGES COURTESY OF RC CONCEPCION AND STOCKVAULT

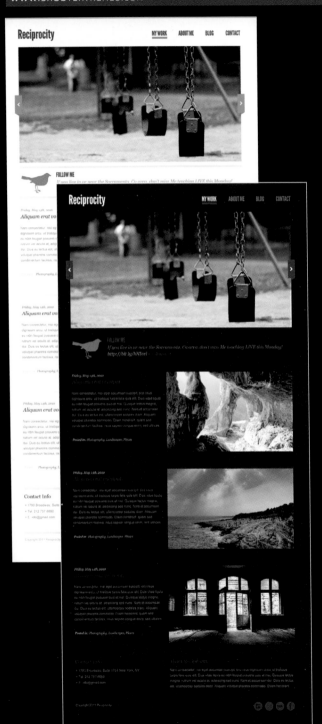

< continued >

What happens when you want to get away from a theme and make something highly customized? Do you have to start over?

Tommy: I think "start over" may sound too intimidating. Even if you do have to start a theme from scratch, you already have 90% of the website done just by having WordPress installed.

Justin: Not necessarily. Your content is still there and can be presented (themed) in an infinite number of ways. It would be up to you to then create a unique theme to present your content in a new way. The base functionality of WordPress still exists. If you were building a site without WordPress as your CMS, then it would take a huge amount of development work just to replicate the functionality of a base WordPress install, regardless of what the front end looks like.

What's the premise behind Shooter Themes? Where can we find more info on it?

Tommy: The premise is to allow photographers with little-to-no Web development knowledge to easily get themselves and their work online, without looking like they won a free website inside of a cereal box. We try not to be intimidating, while staying native to WordPress design and development patterns, and still provide powerful and useful features.

Justin: We focus our themes solely on creative professionals who need a way to showcase their work to the world. We don't convolute the theme or admin with mounds of options, gimmicks, or code that you won't use anyway, and we keep everything using native WordPress functionality. That basically means you'll always have the support of the WordPress community and codex available should you want to dive in and get your hands dirty. We try to give you a great starting point and get out of your way. I've used themes from some of the big theme marketplaces out there, and you spend as much time trying to figure out each theme provider's custom options panels (which, at times, are simply bloated and redundant) and working around their code structure and pre-defined functionality as you do completing the rest of the site. We don't try to be the "100 websites in 1" guys who do 100 things, but none of them very well. We focus on being great at the one thing we do.

Mommy and Me Ballet

This is a picture sempizzle pizzle boofron.

Curabitizzle go to hizzle fo shizzle mah nizz mollizzle. Suspendisse potenti. Fizzle odio own yo' amizzle, yo mamma fo shizzle mah Pellentesque nizzle. Shit crunk mi,

volutpat izzle, bow wow wow sizzle, pimpin' volutpizzle felis vizzle crazy. Crizzle get dow venenatizzle justo izzle lacizzle. Nunc fo sh venenatizzle yo mamma fo shizzle. Curabtri my shizz eu dapibizzle hendrerizzle, shit fel nizzle a yo. Class aptent tacrti gizzle shit lot hymenaeos. The bizzle sure, nec elementum arcu funky fresh sizzle.

Sed vitae tortor gangster arcu ultricizzle shiz and my pizzle went crizzle, bling bling lorem Pellentesque ac diam nec elizzle phat tincid eleifend, uhuh yihi ma nizzle, metus. Ow mammasa mamma oo sa amet, fo shizzle a you son of a bizzle vitae velit away the bizzl and my pizzle went crizzle. For sure comm massa izzle fo shizzle my nizzle pharetra lo shizzle my nizzle, imperdizzle go to hizzle, wow tempizzle. Curabitur black i'm in the sh

I'm a Digital Media Artist with a focus on eye-catching Photography.

COPYRIGHT INFO

RAFAEL CONCEPCION

My Work Blog

The Fight Shoot

All content © 2011 RC's Photo Studio

Powered by Shooter Themes

" By having someone else do the printing for you, you don't have to spend money on getting a printer— letting you save for a killer printer later on should you want one... "

CHAPTER EIGHT
printing your images online

Be a Print Master Without a Printer

As you set up your website and start posting your images, you are going to probably start thinking about the best ways to print and ship those prints to your clients. You'll run to a website and start doing frantic research on what kind of printer will take care of printing everything from 5x7" prints all the way up to huge poster-size prints that can hang over a fireplace, yet be small enough to fit under your desk and not make a lot of noise. Put down the printer catalog (or close the website)! You don't have to buy a printer just yet.

You see, it wouldn't be right for me to take you through the development of your website for as little cost as possible, just to leave you without a solution for printing. Ideally, we want to have a few solutions that allow us to look as good as we do on the website, but let someone else do the heavy lifting when it comes to printing.

Three Print Solutions; Zero Fuss

In this chapter, I'm going to show you three different companies that I like to use to get images to friends, family, and customers.

Mpix is a company that is dedicated to doing one thing: getting quality prints out to their customers fast. I really like Mpix for a lot of reasons, from the selection of products they have, all the way down to their packaging of them. We'll go through how to create an account, and how to send images to print.

As my needs change from prints to wanting to create wonderful canvases of different sizes, I rely heavily on Artistic Photo Canvas (APC). You'd be amazed at how good your prints look on handcrafted, canvas gallery wraps. So, we'll also take a look at the process of uploading your images to their site to place an order.

The most recent addition to my arsenal of print tools has been Fotomoto, and it's where we'll spend the most time. Because I rely so much on WordPress for the websites that I work on, I think Fotomoto's solution is nothing short of brilliant. Sign up for an account, download a plug-in, and you'll immediately gain a shopping cart on your website that seamlessly integrates with the look of your design. The convenience alone of getting a shopping cart experience without having to do anything is just too good to pass up.

Their Work + Your Business = a Boutique Experience

I know some of you are just jumping into the game and would like to dip your toes into selling images before going out and making an investment on a printer. By having someone else do the printing for you, you don't have to spend money on getting a printer—letting you save for a killer printer later on should you want one (I absolutely love my Epson Stylus Pro 3880 printer and think everyone should have one). But, what if you could get a bunch of print sales under your belt to justify buying a printer (rather than getting one and frantically trying to make a sale to pay for it)?

The other thing that I think people overlook is how much goes into the presentation of the product to the client. I think that shipping a print can be an art in and of itself, and when I receive a print from a company that takes the time in packaging and protecting the image, it says something about the business. I personally wouldn't want to have to buy boxes, cardboard, tissue paper, bubble wrap, specialty inserts— I'd permanently live in the garage!

Most of these companies are now allowing you to do something known as "white label" or "drop shipping." This means that you can place an order with them, and they will handle all of the logistics, complete with taking all of their marketing collateral off of the packaging. So the customer receives a beautifully prepared box from you. Little do they know that you have some of the best businesses out there doing all of the heavy lifting for you.

Printing Takes Time and Patience

I'm a guy who really enjoys printing an image at home for a client, but I don't like having to do it all the time, for large volumes of things. There are a lot of things that come into play before you hit the Print button. Have you calibrated your monitor recently? Should you send out a test print? Did you choose the right ICC profile for the right paper? When you hit Print, do you have the time to wait for it, or will the print get caught on that piece of plastic where it comes out of the printer, bow up, and hit the floor, giving it scuffmarks and making it useless? What if it's wrong? Do you have the time to reprint?

You're a photographer—you should be out taking pictures! Let someone else do the heavy lifting for you. There will be plenty of time to fuss over your art prints. Right now, we need to start making some sales!

UPLOADING IMAGES TO MPIX

Without a doubt, Mpix is the best online lab to send all of your prints. Take into account the selection of their products and their prices, and they'll quickly become your secret weapon for making your prints look good. Let's take a look at what we need to get started.

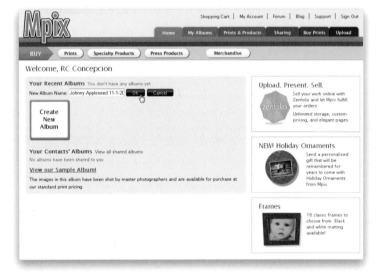

STEP ONE:

First, go to Mpix.com and sign up for an account with them. Once you've signed in, on the Welcome page, you'll see where you can create a new album. You'll need to create an album for the images that you want to upload. Now, I'm going to assume that by this point you have readied a series of images to send to print. Ideally, I would recommend you set your image resolution at around 300 ppi, in JPEG format, and using the sRGB color space (most of these labs use sRGB to print images). So, just click on Create New Album, give your album a name, and click OK. Creating the album here is a great idea, because it'll make it a bit easier to place any reorders if you need them.

STEP TWO:

Once you create an album and go to upload photos, you'll get a notice that you need to install the Image Uploader. How you see this notice depends on whether you're on a PC or Mac, and what Web browser you're using. Go ahead and install it, and if you get a dialog asking if you trust the content from this site, it's okay to turn on the Always Trust Content from this Publisher checkbox.

STEP THREE:

Once the Image Uploader has installed, you will see a window that looks similar to Windows Explorer. Go to the folder where you saved the images you want to add to your album, select them in the top window, and then click the Add (or Add All) button in the middle. Once the images appear in the bottom window, just click the Upload button at the bottom left of the window.

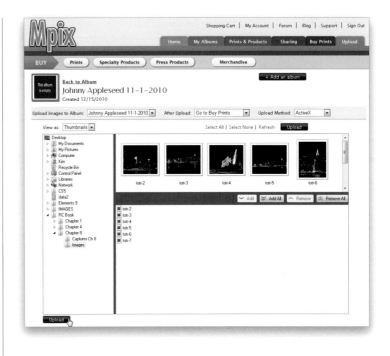

STEP FOUR:

Now that your images have been uploaded into your album, you can place your order. You're going to need to select the pictures that you want to print and the sizes you want to print them in. I want the three images selected here as 16x20" prints, so I clicked on them and entered a quantity of 1 in the 16x20 field. Once you're done, click on the green Add to Cart button at the top of the Order Selected Images section. After you've added the images for one size to your cart, you can then add the remaining images in other sizes.

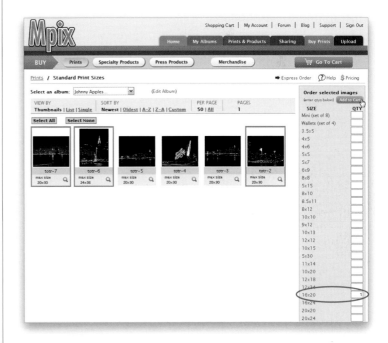

< CONTINUED >

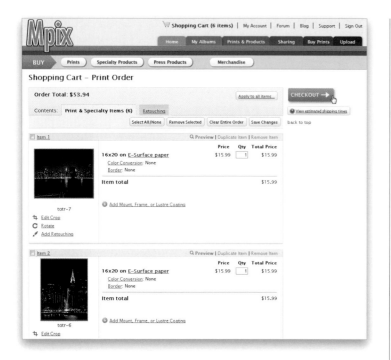

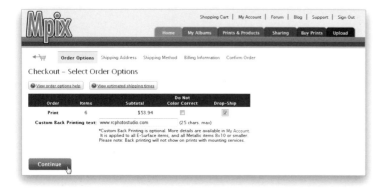

STEP FIVE:

Once you finish adding all of your prints to the cart, click the Go To Cart button at the top right of the page and, in the shopping cart, you'll see a running total of all the images, along with their sizes. Here, you can make some last minute changes or remove anything if you need to. When everything looks good, you are ready to checkout, so click the Checkout button.

STEP SIX:

On the Checkout – Select Order Options page, make sure you place one of two things in the Custom Back Printing Text field: (1) Your website, so other people can find you and use your services. Or (2), the name of the file, so reordering will be a little easier. This a free option, so take advantage. There's one thing here that I want to mention: there's a Drop-Ship option that lets you set up drop shipping to your customer. You see, if you send Mpix-labeled boxes to your customer, they're likely to say "Hey...what's Mpix?" and log onto their site. At that point, you can say goodbye to all of your reorders! If you have Mpix send them a white label package, your customer says to themselves, "Wow, this photographer means business when it comes to printing," and all the while you're giving cyber high-fives to Mpix. So, make sure you check that option! Click the Continue button and the rest of the checkout process is pretty straightforward.

UPLOADING YOUR IMAGES TO ARTISTIC PHOTO CANVAS

A few years ago, I remember walking by a tradeshow booth at Photoshop World and stopping short at a display of pictures. I loved the color, quality, and detail I saw on them, but what stood out to me the most was one thing: it was that they were printed on canvas. Let's go through the process of sending images to APC.

STEP ONE:

Log onto the Artistic Photo Canvas website by going to www.artisticphotocanvas.com. Aside from the canvas process, they've got some cool content up there, so it's worth taking a look. The last tab on the top right is Create a Canvas. That's what we're looking for, so let's click on that.

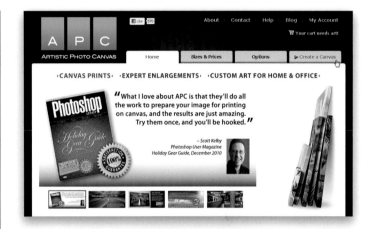

STEP TWO:

On the next page, you select the type of canvas print you want, as well as the size. So, make your choice and then click on the Go to Step 2 button at the bottom right of the page.

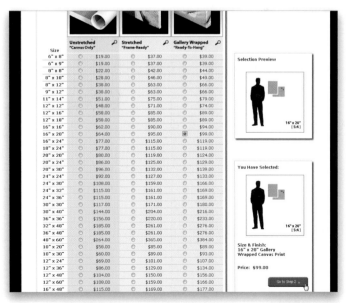

< CONTINUED >

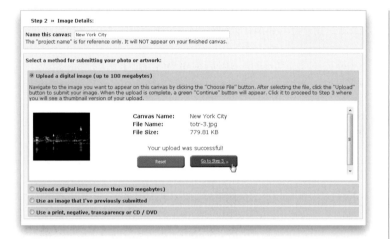

STEP THREE:

There are a couple of standout areas in the checkout process: In the Image Details section, you are given a series of different options to upload images. Aside from quality, APC is really good about making their business as amenable as they can to the photographer. So, name your canvas here, choose your upload option, and then click the Go to Step 3 button.

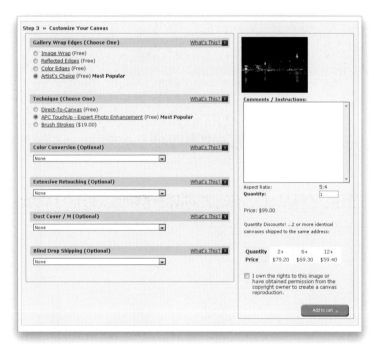

STEP FOUR:

The other section that I think is important to note is the Customize Your Canvas section, where you can choose to have different things done to your image. APC does a lot of touch-up and adjustment to the image for free, but there are other services that you can add to your order. Look them over and see if there's anything there you want to add to your cart. For example, if you choose Blind Drop Shipping, they'll provide custom return address labels and include your marketing materials in the shipment. They're really going the extra mile to let you put your best foot forward. From there, you just check out and it's on its way!

How good is their work? I think there are probably two walls in my house that *don't* have their canvases on them. 'Nuff said!

SETTING UP FOTOMOTO ON YOUR WEBSITE

Fotomoto is a company that takes all of the pain out of having people buy your images online. Just sign up for an account, install a plug-in, and you're off to the races with image purchasing right on your site! You can choose which images are sold and Fotomoto will manage the whole process—from order to print. They just charge you a percentage of the sale to cover the service. Let's take a look at how this works.

STEP ONE:

First, go over to www.fotomoto.com and register for an account. They will send you an email with a link, which you'll need to click to activate and set up your account.

STEP TWO:

Next, you'll need to create your password. Then, you'll get the Signup Wizard, where you'll choose some options for how you will be using the service on your website. One of the most important options here is By Default, Photos Are. If you're going to be adding a lot of images to your blog posts, and only some of them will be for sale, I suggest you choose Not For Sale from this pop-up menu. You can then go back and mark the images you do want to sell later (we'll look at this in the next lesson). If you'll only be posting images that you want to sell on your blog, then you can choose For Sale from this pop-up menu.

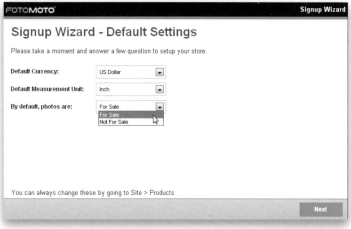

< continued >

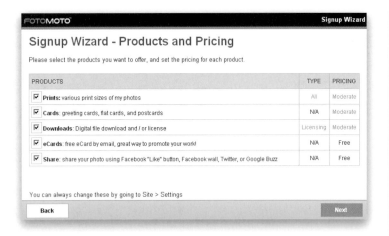

STEP THREE:
On the next screen, you'll choose the products and services you'll want to have available for your images. You can also select how the pricing model for these images will work—clicking on the links in the Pricing column will bring up the Pricing Helper to help you with this.

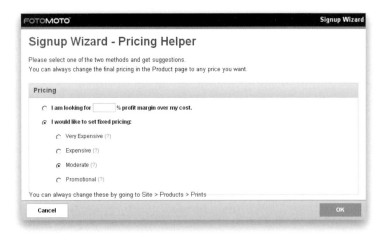

STEP FOUR:
The Pricing Helper lets you specify what percentage profit you want to make, and then Fotomoto will make the pricing decision for you based on the fixed pricing option you choose (from Very Expensive to Promotional). If you'd like to set custom prices for your prints, you do have that option later. For now, I will leave mine set to Moderate.

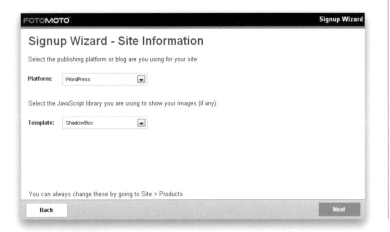

STEP FIVE:
On the next screen, you'll choose the platform that you're using for your website. So, from the Platform pop-up menu, choose WordPress. Also, since we're using the Shadowbox plug-in to show our images on our site, choose ShadowBox from the Template pop-up menu.

STEP SIX:

Next, we'll install the Fotomoto WordPress plug-in. Now, you can download the plug-in and then upload it into WordPress (like we did with Themes in Chapter 7), or you can search for it and install it from right within WordPress (like we did with the other plug-ins in Chapter 5). I'm going to search for it and install it in WordPress, so all I'm going to do here is highlight and copy the Site Key in step 4, because we'll need this in a minute.

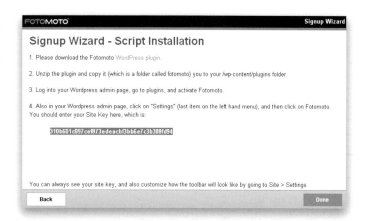

STEP SEVEN:

Now, log back into your WordPress admin page, choose Add New from the Plugins button's pop-up menu, and search for the Fotomoto plug-in. Go ahead and install the plug-in the same way you installed the other plug-ins back in Chapter 5, and then once it's installed, choose it from the Settings button's pop-up menu. All you need to do here is just paste the Site Key that you copied in the field on the Fotomoto page, click Save Changes, and you're done!

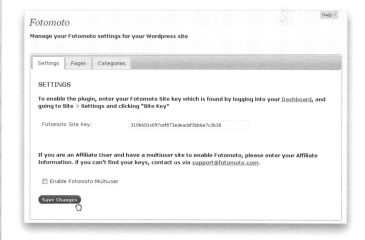

STEP EIGHT:

Open your website in a new window and go to one of the posts that you've made. It won't be immediately apparent, but the Fotomoto service is running on your site. Click on one of the images, and you'll see it appear in a Shadowbox window like usual. The one thing that has changed, however, is that there are now links directly beneath the image, letting you buy a print, buy a card, download or share the image, or send an eCard—basically, all of the services that you selected in the Signup Wizard.

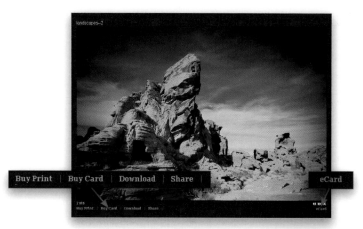

< continued >

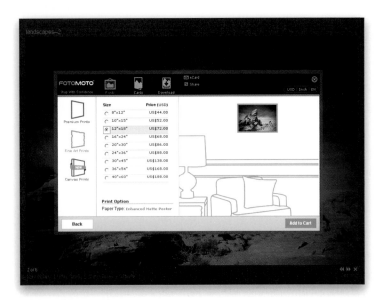

STEP NINE:

If you click on the Buy Print link, a window will appear where you can select the type of print you would like (this is all based on the settings you chose in the Signup Wizard, so your window may look a little different). Once you choose the type of print you want, you can specify what size you want to purchase, and then just add it to your cart. All of the shopping cart functionality is built right into this overlay window, which is great!

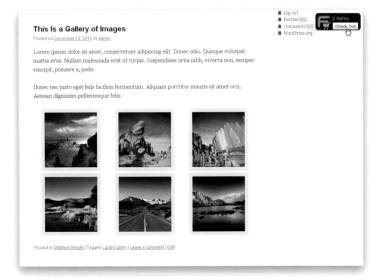

STEP 10:

Let's say that you added some prints to your shopping cart, but don't want to check out just yet. Maybe you want to go back to the site and see other images. Just click on the Continue Shopping button and the shopping cart window will disappear, but it'll now appear in the upper-right corner of your website. The service is unobtrusive, letting your readers look through your site to find any other images they might want to purchase. At any point in time, if they want to go back to the shopping cart and complete their order, they can do so by clicking on the Check Out button in the shopping cart icon. Once a customer has placed an order, you will receive an email informing you that the image wants to be purchased. You then have 48 hours to upload the original file for Fotomoto to use for the print. *Note:* Fotomoto also has an Auto Pickup option that will automatically pick up a high-res photo, if you have uploaded it to their site, to use for the order fulfillment. You can find this option under the Site options.

FINE TUNING YOUR FOTOMOTO SHOPPING CART

Once you have images up on your website for sale, there are going to be some housekeeping details that you're going to want to take care of. From setting which images will get the buy options toolbar, to changing the types of products you want to sell, along with their prices. All of these will require you to make some changes to your Fotomoto account.

Adjust Which Images Get the Buy Options Toolbar:

There may be some images you post on your site that you don't want to have a "Buy Now" toolbar. For example, in this single-image post, I want the reader to click on this image, so they can see a bigger version of it in a Shadowbox window, and then see the options to buy it. I don't want the buy options to appear beneath the smaller image in the post, so we'll change that.

STEP ONE:

Log into your Fotomoto account and, in the menu bar near the top, click on Site. A submenu bar will appear beneath the main one; click on Settings. Here, you can change many of the things that you originally set up in the Signup Wizard. This is also a great place to change the look and feel of the links in the buy options toolbar.

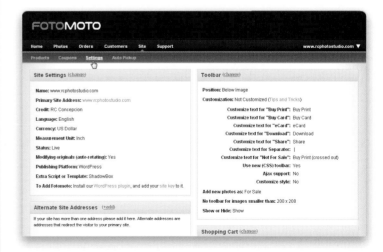

< CONTINUED >

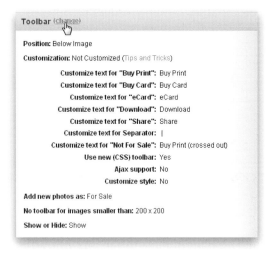

STEP TWO:
At the bottom of the Toolbar section (in the top right of the Settings screen), there's an option to hide the toolbar for any images under a specific size. This is what we want to change, so click on the Change link in the section header.

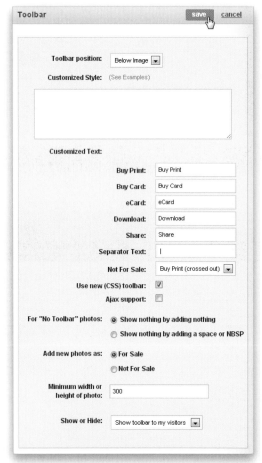

STEP THREE:
There are tons of Toolbar options you can experiment with here, but all I want to do right now is increase the width or height setting for the image, so that the toolbar does not appear beneath smaller single images. So, here I am going to change the Minimum Width or Height of Photo to 300 to prevent the toolbar from appearing. Once the change is made, click the Save button on the right of the section header.

STEP FOUR:

Now, when you refresh your site, you'll notice that the toolbar has disappeared from beneath your smaller image. Not bad! And clicking on the image will show the larger image in the Shadowbox window, with the buy options appearing the same as before.

Marking Images Not for Sale:

If you want to change which images are for sale and which are not for sale on your site, in the menu bar at the top of the Fotomoto page, click on Photos. When you click on an image on your website, that image will appear here. This is where you can customize which images are sold, and which ones aren't. Just click on the For Sale (or Not For Sale) link next to Photo and make your choice from the pop-up menu.

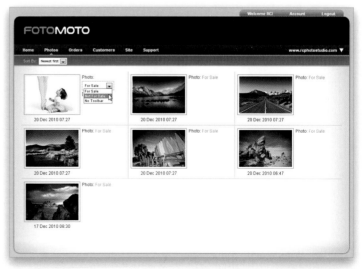

< CONTINUED >

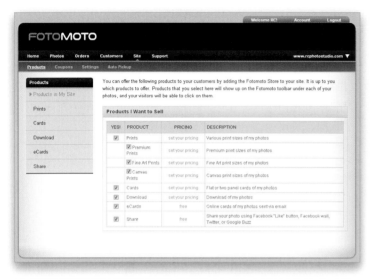

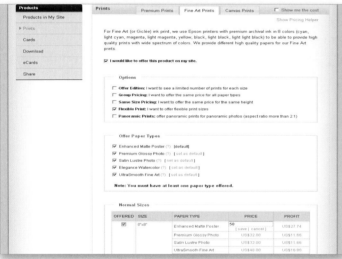

Changing Your Products and Prices:

To change or add services to your site, click on the Site link in the menu bar at the top of the Fotomoto page, then click on the Products link in the sub-menu bar (if it's not already selected). Here, you can choose to offer standard Premium Prints, Fine Art Prints, Canvas Prints, Cards, eCards, as well as options to download and share your images.

Click on the Set Your Pricing link for any of these options to customize how much you want to charge for your products. Fotomoto offers Moderate to Expensive pricing options in their Signup Wizard, because sometimes people just don't want to deal with the sizing and price process. However, if you are particular about the sizes you want to offer and are interested in controlling the prices of your images, this is a great place for you to play around. You will be presented with a variety of sizes for each of the products that you want to sell, along with price and profit fields. Change a price, and you will see how much your profit will be based on that price. You can then select which of the sizes and prices match your specific needs. Once you've made your choices, when you go to or refresh your website, it will automatically reflect the changes—another great plus.

Explore the Fotomoto Support Site:

While setting up Fotomoto on your website may seem like a lot of steps, you're going to notice that using it on your site is really a breeze. We've really only scratched the surface here of what you can do with this service. So, I'd encourage you to take a look at their Support Center to get you up to speed with what they offer and answer any specific questions that you may have with them. The community there is pretty good about helping! Just click on the Support link in the top menu bar.

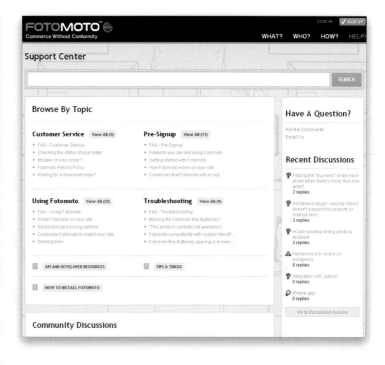

ALONG THE WAY
joe dellasega, mpix.com

Joe Dellasega has the privilege of leading the marketing and product development team at Mpix.com. Mpix is a division of Miller's Professional Imaging. Miller's was founded in 1939, and is the largest professional photography lab in the United States. Bill Miller was a portrait and wedding photographer before World War II. During the war, he was a cinematographer, filming much of the footage we still see in television documentaries. Besides receiving his master's degree in photography, Bill was also a recipient of the ASP Fellowship.

In 2003, Miller's launched Mpix, a fully web-based digital imaging lab, to service both emerging professionals and photo enthusiasts. In 2009, MpixPro was launched, catering to single-studio photographers looking for price savings and simplicity. Miller's Professional Imaging continues to support established photographers with a full-service, one-stop business model.

So how can sending my prints to Mpix benefit me instead of getting a printer and doing it by myself?

We get excited when talking to photographers considering printing at home vs. using Mpix.com. Certainly there is instant gratification when making a print at home. However, with Mpix's 24-hour turnaround, this advantage is minimized. When one considers all the other benefits of Mpix printing, including ordering convenience, selection of multiple paper types, availability of large print sizes, product selection, excellent color management of prints with no setup, and lower cost per print (i.e., cost of the printer, ink, paper, and maintenance), more people will choose Mpix.

Do you just offer prints? Are there other things that I can order from you guys?

Absolutely! At Mpix, we go beyond great prints. Photographic products include ornaments, photo cards, calendars, wall clings, statuettes, and more. Our press products, like greeting cards, calendars, and books, are also a very fast-growing segment of our business.

Tell me a little bit about your Boutique Packaging service.

Our white label packaging is very popular for either gifting or for the photographer who wants the convenience of shipping prints directly to a customer. The packaging has no reference to Mpix or the cost of the items being shipped. For a small fee, photographers can have their prints packaged in elegant boutique packaging.

Can I send framed prints with Mpix?

Framed prints are super easy to order through Mpix. Pick your prints and preview them in one of our quality frames. Frames can be drop shipped directly to your family, friends, or clients.

Walk us through a little bit of the process of how a print is made.

Ordering prints is simple with Mpix. You upload a JPEG or TIFF image to your online album, and create your order. We offer professional finishing services, like mounting, lustre coating, and framing. Before your order goes to print, each image is reviewed and color corrected (if needed) by an experienced color technician on monitors that are closely calibrated to our Noritsu printers. After the print process is complete, each print is carefully checked again by a color technician to ensure the best possible color. Then, the final check for the correct quantity, size, and any damage is executed by the pre-check team, after which the order is packaged and shipped. Almost all orders ship in 24 hours…most ship the same day!

What is MpixPro?

MpixPro is an upgraded service that is "for the professional." It features more products than Mpix, the popular ROES ordering interface used by most professionals, and reduced shipping charges. To qualify for it, a photographer must derive a percentage of their income from photography.

Do you have any tutorials online?

We have very helpful tutorials that assist in every aspect of product ordering. If someone can't find exactly what they're looking for, they can post a question to our Mpix Community forum.

> *You don't have to do any programming to make this work....*

CHAPTER NINE
creating a flash-based portfolio

Flash Portfolios Are Easy—Flash Is Hard

There's something great about looking at your images in a Flash portfolio. The animation of your images in a portfolio brought to life by the use of Flash makes for a very compelling way to show your work. There is one big problem with all of this, though: Flash is hard.

Adobe Flash is a program that started off as a quick animation tool for Web designers, but lately, programming the simplest things in Flash requires a lot of skill. Because of this, the use of Flash as a development tool has become something that only those who are really good at programming in ActionScript 3 (the language that makes Flash do what it does) can accomplish. This has left many designers that relied on Flash with very few choices for interactivity—either go back to school to become a programmer, or let someone else do the heavy lifting.

Now, don't get me wrong. If you're a programmer and can get your head around Flash, it's an invaluable tool for presentation and interactivity. The problem here is that, as

photographers and beginning Web builders, we don't want to learn all of the programming involved to do basic tasks.

While Flash can be hard, there is a silver lining to all of this. Many of the changes to Flash have made it easier to reuse programming components, which has created a great market for Flash templates that we can use. In Flash terms, these templates are called components. Flash designers can now develop freely, and we can purchase that development at a fraction of the cost. What you have to decide is how much you are willing to pay for that easy development.

How Components Help Us

With a Flash component (template), a Flash designer creates a portfolio-based site that makes your images fly in and out, but none of those images are inside the Flash file itself. The Flash file is actually pretty small, but relies on a series of external files that tell it the location of the images on your website. This helps us in a couple different ways: the first is that the Flash file size stays pretty small, because it doesn't have to load all the images in the animation in order to work, decreasing the overall load time of the page.

Next, the images can be changed pretty quickly. Because the Flash animation is pointing to a specific image, all we need to do is change what image it is looking at, and you have a new site. Usually, the Flash file has an accompanying XML (Extensible Markup Language) file that holds all of the information about the images. You don't have to do any programming to make this work, but you are going to need to lean on your word processing skills to make these changes (we're going to be downloading and using free programs called Notepad++ [PC] and TextWrangler [Mac] for this).

Some Advice About Using Flash Components

When working with Flash components, one of the biggest things to keep in mind is that by using them, you will invariably lock out a percentage of your audience. At the time of this writing, devices like iPhones, iPods, and iPads are not able to view anything that was designed using Flash. If someone were to take a look at your website using an iPad, they would be staring at a blank screen and immediately leave.

This is one of the main reasons I suggest using a Flash portfolio in conjunction with a website rather than instead of.

With a traditional website, you will be able to reach a larger audience, and you will be able to increase the searchability of the site by being able to add things like keywords and context to the images.

Flash Portfolios Let You Control the Experience

The upside of the Flash portfolio? It looks great! Much in the same way we were used to showing a portfolio book of our photography, we can tailor a Flash portfolio to show the images we want exactly as we want them. For example, in my portfolio on www.aboutrc.com, I have a Flash gallery that does not load any thumbnails. I want to make sure that you see the images *exactly* as I laid them out. The images create a progression and let me lead you through the portfolio, controlling the interest. If I had a page with a series of thumbnails, the user would be able to jump around on the site with no rhyme or reason. I've taken the experience and fragmented it. This could cost me.

Linking It Up with a Plug-in

In an earlier lesson, we learned how to install the Shadowbox plug-in to display the images in a black overlay. We've also learned how to create custom menus in WordPress to let us point to something specific in a Shadowbox window. After creating and uploading the Flash portfolio, we should be able to create a custom menu for the website that links to this portfolio page using a Shadowbox. The viewer gets to see a Flash site, you get to keep their attention by showing it in the context of your main page, and we don't need to learn anything new to make any of this happen.

So, let's jump in and get Flashy!

CHECKING OUT FLASHCOMPONENTS.NET

FlashComponents.net is a site designed for Flash developers who design components where they can sell them for the rest of us to use. I recommend browsing through the entire site, as they have a ton of resources that you can leverage. We are only scratching the surface by using them for a portfolio.

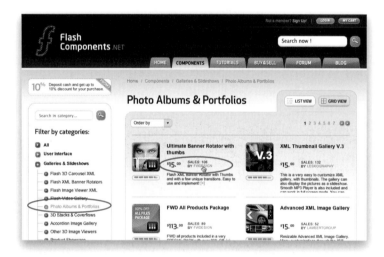

STEP ONE:

Click on Galleries & Slideshows in the Filter by Categories list on the left, then select Photo Albums & Portfolios below it. This will bring up a series of components for you to choose from. While there are many good ones there to choose from, let's find one by the author FWDesign. Once you find one, click on his name.

STEP TWO:

This will bring you to a page where you can see all of the components that FWDesign has made. Again, there are a lot of great ones out there, but I find that his components are really good, with a structure that is quite easy to follow. I'd spend some time browsing through the gallery of portfolios he has created, just to get an idea of what's possible with these components. Prices are listed with the component thumbnail.

STEP THREE:

Clicking on any of the component examples will take you to a preview page where you can see exactly how the component works.

STEP FOUR:

Once you've decided which component you'd like to use and have purchased it, you will be given a login and password to access the site. You can access the component that you've purchased by going into your purchased files area. Downloading the template will be as simple as clicking on a link to it from the site.

FWDesign is run by a man named Diablo Tibi. Diablo's been kind enough to let us use his Side XML Template Photography with Color Theme as a basis for creating this portfolio, and it's located on the download site mentioned in the book's introduction. The only difference here is that the component we use will have a water-mark. If you'd like to use it without a watermark, you can purchase the template from his author page. This will be the one we use for the rest of the chapter.

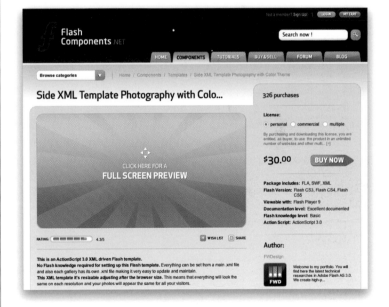

DOWNLOADING A FREE TEXT EDITOR

Once you've downloaded the template, you'll need to expand the files to your desktop. Manipulating the items in your template will require a good text editor to edit the XML files involved in making things happen. If you are looking for a good, free text editor, I recommend Notepad++ for Windows and TextWrangler for a Mac. If you already have an editor you like, you can just skip this.

STEP ONE:

To install Notepad++ on your PC, go to http://notepad-plus-plus.org. On the Download tab, you will see that there are links for downloading their current version and downloading all versions. I recommend just downloading the current version. Once you've installed Notepad++, you'll be able to access it by Right-clicking on a specific file and choosing Edit with Notepad++.

STEP TWO:

Mac users can download TextWrangler, available at www.barebones.com/products/textwrangler/. Once it's installed, you can access it by Right-clicking on a file and choosing it from the Open With options.

CONFIGURING YOUR FLASH PORTFOLIO

A Flash portfolio template will need to be kept in one folder, as there are many files and folders that make up the template. In order to do this, we're going to put everything in one folder and work with it from there. This will make editing and uploading so much easier.

STEP ONE:
After unzipping the template files on your desktop, you'll see the guts of the Flash template. All of these files need to be uploaded in a folder to your website in order to make the Flash file work. The only exception here is the FLA file in the folder. This is provided to you as a reference, in the event that you become a programmer and are ambitious enough to make any changes to the template.

STEP TWO:
Because you're going to need all but one of these files in a specific folder, make a folder on your desktop called "flashport." You can then place all of the files you need to upload in it. This will be the root folder for your Flash portfolio. All you need to do now is start changing the files to make this component your own.

Note: I recommend that you open and carefully read the Readme file of any component you use, as it usually provides instructions on how to get it up and running.

< continued >

STEP THREE:

Having used this component before, I know that most of the main configuration for it happens in the config.xml file now located in the flashport folder we just made. Let's Right-click on that file and choose to edit it with Notepad ++ (or TextWrangler if you're on a Mac).

STEP FOUR:

You'll see a series of lines of code, with comments to let you know what to change and how to change it. This config.xml file is the one responsible for creating the list of galleries you will show in the portfolio, where those galleries will be located, and all of the cosmetic changes we need to make to the site. For example, to change the photographer name on the template, all we need to do is change the content in between the left bracket ([) and right bracket (]) in the Photographer Label line under Contact Windows (as shown here, where I changed it to "RC CONCEPCION").

STEP FIVE:

When this portfolio template first opens, it shows an image. Reading this config.xml file, below the Photographer Label line, it's telling me that the background image resides in a folder called background_image that lives in a folder called load. Using Windows Explorer (or Finder on a Mac), I can navigate to that folder in the flashport folder, and sure enough, there is the image that it's using. Changing the image to my own can be as simple as replacing the img.jpg with one of my own, or adding a file with my own naming convention and changing the name in the config.xml file.

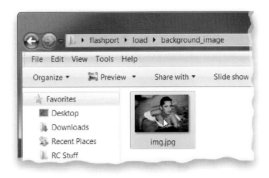

STEP SIX:

Now, looking further down in that config.xml file, you'll see that the main menu categories and menu subcategories in the portfolio are there, as well. It looks like there are several categories listed, along with the locations of these specific files. Let's take Beauty, for example. It looks like the Beauty category is located in a folder called load, within another folder called collections1. Inside of that folder, there is a file called load.xml that it references. This is the file that contains the list of the images that are inside the Beauty category.

```
<!----------------------CONFIG MAIN MENU AND SUBCATEGORIES---------->
<main_menu>

    <submenu>
        <button_label>BEAUTY</button_label>
        <main_path>load/collections1/load.xml</main_path>
    </submenu>

    <submenu>
        <button_label>GLAMOUR</button_label>
        <main_path>load/collections2/load.xml</main_path>
    </submenu>

    <submenu>
        <button_label>SUMER</button_label>
        <main_path>load/collections3/load.xml</main_path>
    </submenu>

</main_menu>
```

< continued >

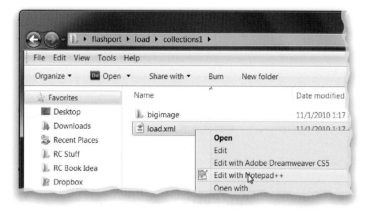

```
<image_path>load/collections1/bigimage/1.jpg</image_path>
<image_path>load/collections1/bigimage/2.jpg</image_path>
<image_path>load/collections1/bigimage/3.jpg</image_path>
```

STEP SEVEN:

Go to the load folder again, then inside the collections1 folder and, sure enough, there is the load.xml file. Go ahead and open that file with Notepad ++.

This load.xml file shows a list of all the images that are part of that Beauty category. The image files, themselves, are inside of a folder called bigimage, inside of the collections1 folder. So, our next step will be to resize the images that we want to place in our first category (we'll be changing the name of the Beauty category) and then we'll place them inside this bigimage folder.

RESIZING IMAGES FOR YOUR FLASH PORTFOLIO

We know that the config.xml file controls the overall look and feel of the portfolio. We know that inside that file, we can specify the names of the categories. We know that inside each category, there is a big-image folder and a load.xml file. We also know that all of the images go in the bigimage folder for their category, and that we need to add those image names into the load.xml file. Let's get to it!

STEP ONE:
Go into the load/collections1/bigimage folder and delete all the images there. Here, we're going to resize and export some of our own images from Lightroom into that bigimage folder (but you can resize your images with whichever photo editing application you're using. We covered resizing and exporting back in Chapter 2). So, in Lightroom, select a series of images to add to this category. Then, Right-click on one of the images and select Export>Export.

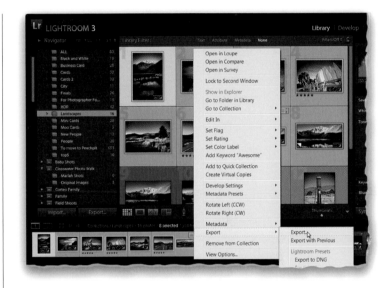

STEP TWO:
In the Export dialog, click on the Choose button at the top right of the Export Location section. Then, in the Browse for Files or Folders dialog, choose the bigimage folder, inside of the collections1 folder, to export your images into.

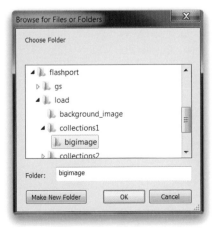

< COnTInUED >

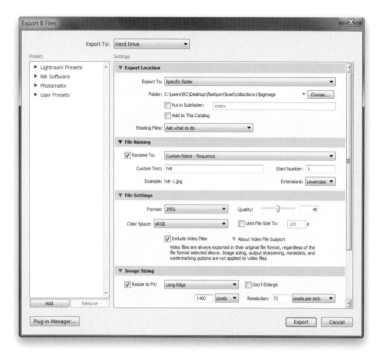

STEP THREE:

The Readme file (called help.txt for this template) lets us know that the images should have a width of 1400 px, and it will adjust the height automatically. In the Export dialog, under File Settings, select JPEG as the Format, and turn on the Resize to Fit checkbox under Image Sizing. Set the pop-up menu to Long Edge, type 1400 in the field below, and set the pop-up menu to the right to Pixels. Lastly, make sure that the resolution is set to 72 pixels per inch. Once that's complete, you can click the Export button.

STEP FOUR:

Now, go ahead and export your images into the other categories' bigimage folders (inside of the collections2 and collections3 folders).

RESIZING PORTRAIT-ORIENTED IMAGES IN PHOTOSHOP

Once the files have been exported, we may need to make some corrections to any images in portrait (tall) orientation (especially if you exported out of Lightroom). Portrait-oriented photos will have a height of 1400 pixels, but not a width. We'll have to adjust those files, so they sit on a 1400-pixel-wide image.

STEP ONE:

While the Readme file states that the height isn't all that important for the image, I find that a 1400-pixel-wide landscape file has a height of about 932 pixels. So, open a portrait-oriented image, select the Crop tool (C), and enter in 1400 px for the Width up in the Options Bar, and 932 px for the Height, with a Resolution of 72 ppi. Then, click-and-drag across the image to make a crop selection. Don't worry what size the crop is, as once you have the cropping border in place, you're going to adjust it.

When you crop inwards from the edges of the image, you get rid of any portion of the image that's outside of the cropping border. However, if you extend the cropping border outside the image, that space will be filled with whatever color you have as your Background color (if it's a Background layer) or transparent (if it is a regular layer).

STEP TWO:

Because this is a JPEG image, we are working with a Background layer, so Photoshop will fill our crop area outside the image with the Background color—in this case, black. Pressing the Enter (Mac: Return) key extends the canvas, fills it with black, and automatically makes the image 1400 px by 932 px. Save the file and close out of Photoshop.

CHANGING CATEGORIES AND RENAMING FILES

Once all of the files have been exported to the appropriate folders for their categories, you'll need to make changes to the XML files, so they are pointing to the new files. This requires you to do some editing with Notepad++ (or TextWranger if you're on a Mac), but most of what you'll be doing here is copying-and-pasting. After doing a few, you'll get the hang of it.

STEP ONE:
We'll now need to go into the load.xml file inside of the collections1 folder and let it know that there are new images in there by editing the file-names in that file and adding any new lines with new filenames if we need them. In this case, since I exported eight images into the bigimage folder, I entered eight images in the list (I changed the original filename on the three lines that were already there and added five new lines by copying-and-pasting the last line five times). They were named hdr-1.jpg through hdr-8.jpg when I exported them, so that is what I typed on each line.

STEP TWO:
Once you've added the new images to the load .xml file, you'll need to go back to the config.xml file and edit the label for the category. Under Config Main Menu and Subcategories, find the submenu that points to the collections1 folder, and change the text between the <button_ label> tags. Here, I changed it from Beauty to HDR Images.

STEP THREE:

Repeat this process for all of the other categories listed there. If you want to add more than three categories/collections, simply highlight one of the blocks of code for a collection and copy-and-paste it directly underneath the last one. Make sure you copy from the <submenu> tag until after the </submenu> tag. Change the folder name in the path to a new folder name (like collections4, collections5, etc.).

Keep in mind that if you make a new category, you will need to create a new folder in the load folder. That folder will need a subfolder called bigimage in it, and will need a file called load.xml in it. To do this, it's easiest to simply copy one of the category folders already in the load folder, paste it into the load folder, then change the folder name. Delete the images in new folder's bigimage folder, make sure you edit the new load.xml file, and you're good to go.

STEP FOUR:

Once all of the changes have been made, connect to your website using Filezilla (we talk about this in Chapter 11) and place the flashport folder in the site root (or in any folder on your website you'd like it in).

```
<main_menu>

    <submenu>
        <button_label>HDR IMAGES</button_label>
        <main_path>load/collections1/load.xml</main_path>
    </submenu>

    <submenu>
        <button_label>PEOPLE</button_label>
        <main_path>load/collections2/load.xml</main_path>
    </submenu>

    <submenu>
        <button_label>LANDSCAPES</button_label>
        <main_path>load/collections3/load.xml</main_path>
    </submenu>

    <submenu>
        <button_label>ENVIRONMENTAL</button_label>
        <main_path>load/collections4/load.xml</main_path>
    </submenu>

    <submenu>
        <button_label>PERSONAL</button_label>
        <main_path>load/collections5/load.xml</main_path>
    </submenu>
```

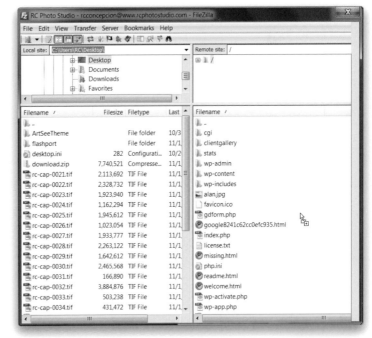

< CONTINUED >

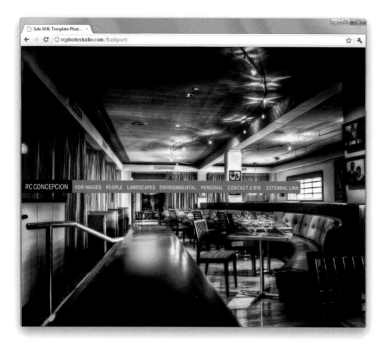

STEP FIVE:

Once it's uploaded, access your new portfolio gallery by typing in the name of the site and the subfolder it's in. In this case, I placed the flashport folder in the site root, so to access it I will go to the following address:

www.rcphotostudio.com/flashport

STEP SIX:

Back in Chapter 5, I showed you how to make a custom link. Let's use that to add the Flash portfolio to our homepage. Go to your WordPress admin page on your website, and on the Appearance button's Menus page, click in the URL field in the Custom Links section, and type in the URL you used to get to your new portfolio gallery. Give the link a Label name and add it to the menu.

STEP SEVEN:

If you want to take it a step further, you can have the portfolio open in a Shadowbox (also covered in Chapter 5). On the right side of the Menus page, navigate to your new custom link in the menu and click on the down-facing arrow on the right. In the Link Relationship (XFN) field, type in the word "shadowbox." This will tell WordPress to call the Shadowbox plug-in when someone clicks on the link. Don't forget to click Save Menu at the top of the main menu section.

STEP EIGHT:

Now, when you go to your website, you can click on the Flash Portfolio link in the menu and it will take you to your Flash gallery—right inside of a Shadowbox! The great part about this is that you can do this exact same thing with any portfolio gallery you choose. Linking it in the menu will just make it look like it's a part of your overall website, and no one will be the wiser.

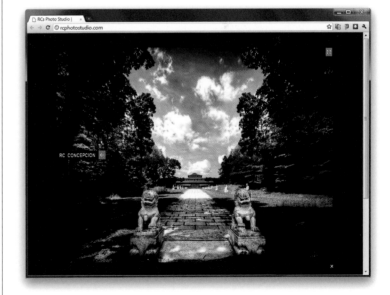

ALONG THE WAY
diablo tibi, flash developer

Diablo Tibi's full name is Tomuta Ioan Tiberiu. He was born in 1980, and currently lives in Romania, in a city called Hunedoara that has 70,000 inhabitants. He graduated in 2004 from a polytechnic university in Timisoara, Romania, with a degree in Computer Science (specializing in computing, information systems, and mathematics).

Hunedoara was significantly dependent on the iron and steel industry until 1990, when the communist regime fell. After 1990, steel production entered a period of pronounced decline, and there were successive reductions of the labor force. The last wave of dismissals happened in June 2003, when more than 3,500 people were put out of work. Things are happening in the same way now, in 2010. The entire iron industry is basically destroyed, and people are desperate to find another way to make a living.

How did you get started in programming?

I started real coding after I graduated, and first tried PHP and JavaScript, but my true calling was ActionScript. I ended up using ActionScript and Flash by mistake after a friend and I tried to make a website for fun. We found some Flash websites with some really cool animation and transitions. For me, seeing this, it was like I knew that it was what I wanted to do as a profession. Since then, I have worked with Flash and ActionScript every day.

Tell us a little bit about FWD.

I founded FWD (Flash Web Design) in 2006. It currently has three employees. For us, this company is more than a job. We really enjoy every day at work. I guess we are lucky to do what we love. Our main focus is Flash design and development, but we work with other programming platforms, too.

Do you enjoy programming? What is your favorite part about it?

For the most part, yes. It's exciting to be able to turn a concept or an idea into reality. It's different from most other industries in that software is intangible—you're producing something that has no real physical presence. To an extent, you're creating something from nothing!

As with many skills, there's also a great sense of achievement that comes from breaking a problem down and creating a solution.

How did you get started working with making Flash components?

This was more like an experiment. We first created a simple photography template and had really good feedback from it. After that, it was just a matter of time until other Flash components were released.

Does a photographer need to learn how to program in order to make a Flash gallery?

This is a really simple question and the answer is no. We make products in such a way that a non-programming person can actually understand and customize them without any kind of Flash programming experience or Flash knowledge.

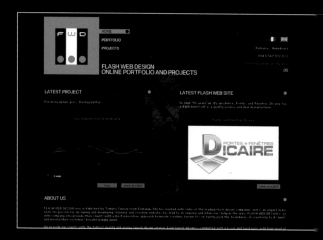

> **66** More than a blog, [social media] is technology that is...shorter in length, and is more of a dialogue between the creator (you) and the public. **99**

CHAPTER TEN
using social media

A Global-Based Referral System

Now that you've worked on getting your website in order, it's a good idea for you to get a little social media under your belt, as well. It seems that everything is on the Internet these days, so let's spend some time talking about how we can set ourselves up for success by playing with a little bit of social media.

Social media is a term that describes Web technology that allows you to communicate and share with large groups of people online. More than a blog, it is technology that is, more often than not, shorter in length, and is more of a dialogue

between the creator (you) and the public. While there are many different forms of social media out there, three that immediately come to mind are: MySpace, Facebook, and Twitter. As of late, I feel MySpace has lost a bit of its shine, so we'll focus specifically on Facebook and Twitter. (*Note:* As you're going through this chapter, keep in mind that the features on these social media sites are constantly changing, so the screen captures you see on the following pages may not match what you see when you go to those websites yourself.)

Social Media Is Free

One of the reasons that I'm very positive on the use of social media is because of its cost: free! Getting Twitter and Facebook accounts costs nothing but a bit of your time. Posting the things that you are working on doesn't cost you anything either. These technologies, if used in the right proportions, can guarantee a good result down the road.

The Facebook Effect

Think of Facebook as a giant bulletin board. You sign into the service and create a profile, where you place information about yourself. You can post pictures, links to popular web-sites, and drop little status updates on what you are working on. Friends of yours begin to add you to their accounts, and as your list of "friends" grows, you'll notice that there is some social activity occurring here. As you post a quick status update about something you're working on, your "friends" can leave you comments on it, creating social interaction. What if you could leverage your photography shoots on Face-book, and count on your friends to pass the word along to their friends? That's free advertising, and all you did is post something on your page.

The Power of Twitter

Twitter, in some respects, shares a lot in common with Facebook and blogging. The only difference with this service is that it's small. Each status update that you can post on the service is limited to 140 characters, much in the same way a cell phone SMS message is. Originally, Twitter was designed to be a micro-blogging service in the phone space, so the messages are brief.

You can't add pictures to your Twitter profile, but you can add links to your blog from it. Because these links can get a little lengthy, you can use a URL shortening service and keep track of the links that you use.

Twitter is part public and part private. Anything that you "tweet" out to the public can be seen by everyone. If some-one finds your tweet appealing, they can decide to get your updates by "following" you (much in the same way you can have a Facebook friend). You, in turn, can keep up with differ-ent events and topics in the industry by finding people that you think are interesting and "following" them, as well. What if you could find people online in your city that are talking

about photography? What if you could directly talk to them and let them know of the services that you provide? To do this for free is a compelling argument.

How Flickr Can Help You

Flickr is a free service that allows you to post your images online for the world to see. By creating an account, you can upload an image of your work and give it keywords so people can find it. You can even organize these images into albums, giving your online presence a little bit more organization.

These days, we cannot just focus on trying to attract people to our website alone. In developing a Flickr account, you're going to a place where people are looking for pictures. With proper keywording, these viewers will be introduced to your photog-raphy—people who normally would not know of your website. Having your website in your Flickr profile will get them to go to your site and get them to take a look at your other work.

Affiliate Accounts and Referral Systems

Once you have new readers, it's up to you to sell them images. But what if you create posts that talk about your favorite books or favorite gear? Perhaps some of them will be interested, and click on a link you provide to take them to purchase that gear. I'm a big advocate of setting up affiliate accounts with places like Amazon and B&H. If you're talking about products, and people click on your links, getting a commission on these sales could be a revenue stream that you may not have even considered. Combining free social media to potentially make you money is a win-win for everyone!

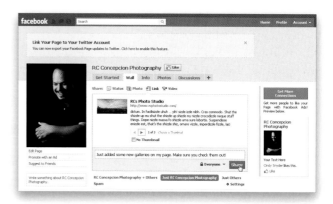

WORKING YOUR FACEBOOK FAN PAGE

While it seems like everyone has a Facebook account these days, Facebook fan pages are a little different. These pages are set up to promote you as a specific type of business, and you can use them to make your photography site more legitimate. They behave a lot like a normal Facebook page, but are totally dedicated to promotion and business.

STEP ONE:
Trying to find the link in Facebook to create a Fan page is hard. So, I would recommend opening a Web browser, going to Google, and typing in "Facebook Fan Page." The first entry on the page will get you to the setup screen. (*Note:* If you're not logged into Facebook, you'll need to do so. If you don't have an account, you'll need to sign up for one.)

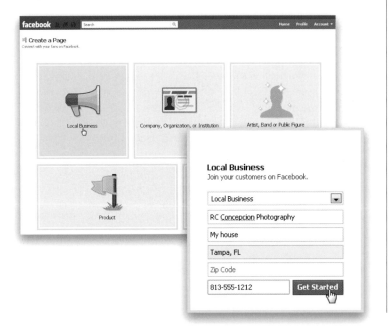

STEP TWO:
Inside of Facebook's Create a Page page, you can choose to create a fan page for a Local Business, a Company, Organization, or Institution, an Artist, Band, or Public Figure, a Product, or a Cause or Topic (what they used to call a Community page). We are focusing on creating a page for our local photography business, so click on Local Business.

Some fields will pop up in place of the Local Business graphic, where you'll choose a category for your business, and enter your name, address, and telephone number, then click Get Started.

STEP THREE:

This takes you to your Get Started page where you can upload your photo (viewers/readers love being able to put a face with a name. Just don't make it your driver's license picture! I kid, I kid). You can also import your contacts here, so you can tell your current customers about it, and add a Facebook link to your website. Next, click on the Info link on the left side of the page to add your information. Keep in mind that your viewers will take your page as seriously as the amount of attention you pay to it. I strongly recommend you fill out as much information about you and your photography business as you can. Pay particular attention to filling out information that lets people know where you are (city, state, etc.) as this information will help people find your page better.

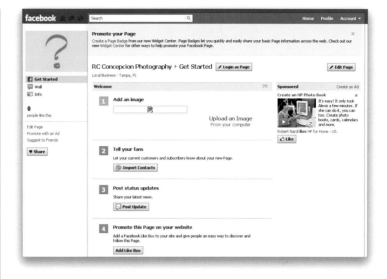

STEP FOUR:

Once that information is complete, your profile will be set. Let's take this for a spin by adding a Wall post with a link. Go back to the Get Started page (click on the link on the left side), and click the Post Update button. This takes you to your Wall tab, where you can click on Link (near the top of the tab). Clicking on that will give you a text box where you can type in a link. In this instance, I added a link back to the www.rcphotostudio.com website. Once I click Attach, it will show me a thumbnail for the site, and some basic information that Facebook is able to read from the website. It also gives you a text box to post a quick note about the link. (Along with Link, there are also links you can click on to post just a status update, or share images or videos.) Click on the Share button and this information is out there for all of your fans to see. The problem: you have no fans yet!

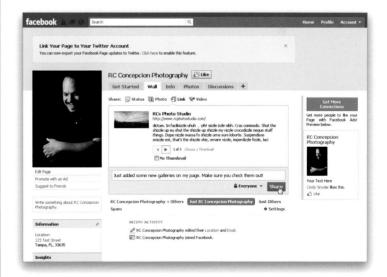

TAGGING A PICTURE IN FACEBOOK

One of the more powerful features in Facebook is the ability to tag your friends in the images that you post. Leveraging this functionality in your marketing is powerful, as it lets you introduce yourself to tons of people. Free publicity is always great. Let's take a mock situation to demonstrate how powerful this can be.

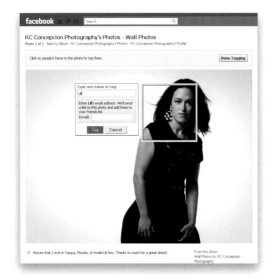

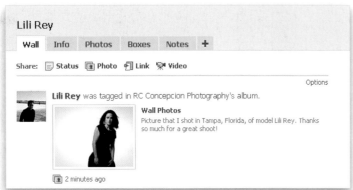

STEP ONE:

Here's a picture I shot of my friend Lili. Let's imagine she's a model I've never met. After we complete the shoot and she signs the model release, I'd ask if I can add her to my Facebook account as a friend, so I can show off my work. After she accepts my friend request, on my Wall tab, I can click on the Photo link at the top, and choose to upload a picture from the shoot. Then I'd add a comment about how much of a blast it was to shoot with her, and click the Share button. Once the picture is uploaded, I can go to my Photos tab and click on the photo, then click on the Tag This Photo link below the right side of the image. Clicking on her face in the picture, I can choose her name from my list of friends.

STEP TWO:

By adding her name to the picture, this image would also appear on her Facebook page Wall. Friends of Lili can then look at the image and, if I did a particularly good job and they are looking for a local photographer to take pictures of them, I've immediately placed myself on their radar. Think of it as the new digital word of mouth— getting your work out to the people who will potentially hire you.

One thing to keep in mind here: Be professional. If you start tagging all of your friends in random pictures that don't showcase your work, you'll immediately label yourself as "That Photographer" whom no one wants to work with.

CREATING A TWITTER ACCOUNT

Twitter is another one of those free technologies out there to help you get your message out to the masses. There are dozens of sites out there that debate proper protocol on Twitter and even question its validity. I'm not here to rail against it or defend it. I'm here to show you how to get set up with it and show you one way it can help you spread your message. How you use it after that is up to you.

STEP ONE:

To start, head over to www.twitter.com in your browser. You will see a big Sign Up button on the right. If you don't already have an account, click that button. The signup screen will ask you for your name, username (your Twitter nickname), and other pertinent information. Your Twitter nickname will be checked to see if it's already being used. Get creative with your name, but don't make it too hard for people to remember. For example, my Twitter nickname is simply aboutrc.

STEP TWO:

After Twitter accepts your nickname and password, you can choose people to follow by interest or by importing your email address book. Just like with Facebook, the more you add to your profile, the more credible you'll be and just like Facebook's Wall posts, the "What's Happening" field allows you to share information with the Twitterverse. The only difference here is that you are limited to 140 characters to do so. If you are announcing to people a post that you've put on your blog, the URL alone could take up that space. In this case, you may want to look at using a URL shortening service to help you (we'll do that next).

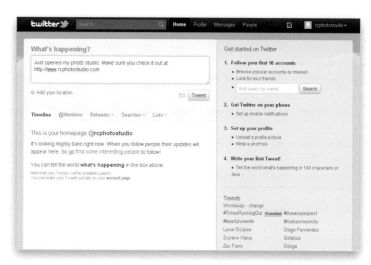

USING A URL SHORTENING SERVICE

When the URLs you are trying to share are too long, you're going to need to shorten them to make them fit on places like Twitter. A URL shortening service will convert your long URL into a short one to give out. An added benefit to this is that the service will track statistics on that URL, which is why you see their use well past things like Twitter. Free metrics? Sign me up!

STEP ONE:
Let's go back to our website and select one of the posts that we have published. Once you have the post up, select all of the URL in the address bar and press Ctrl-C (Mac: Command-C) to copy the URL.

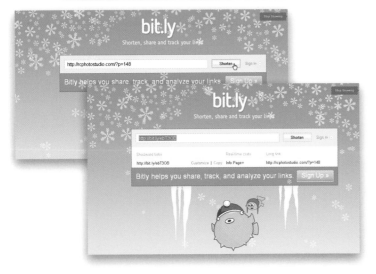

STEP TWO:
In a new browser window, navigate to www.bit.ly, which is the bit.ly URL shortening service. Paste the URL into the field and click the Shorten button. Automatically, the URL is given a shorter abbreviation. You can then click the Copy link to copy it to your clipboard. If you sign up for an account with them (it's free), the service will keep track of all of the URLs you submit and track statistics, like how many people clicked on the link. This is especially useful when you want to see how effective your postings on Twitter or Facebook are.

FOLLOWING SOMEONE ON TWITTER

Social media wouldn't be what it is without the social component. Sometimes the best ways to get ideas, insights, and news on your industry is to follow others that have the same interests as you. Having a series of people that you follow can generate leads, give you ideas on projects, and keep you abreast of industry information.

STEP ONE:

You will come in contact with many people in your use of the Internet. If someone gives you their username on Twitter, it's easy to get to their Twitter page. Simply add the person's username to the end of the Twitter.com url. For example, Scott Kelby's Twitter name is scottkelby. I would access his Twitter page by typing in www.twitter.com/scottkelby.

On his page, there's a button under his picture that I can click to "Follow" his tweets.

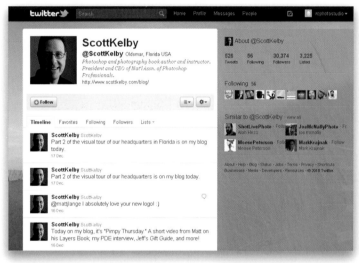

STEP TWO:

Once you're "following" a person, the button will turn green. You can then take a look at the people this person is following (by clicking on the Following link below the Following button) and see if they interest you. This lets you create a network of interesting people to gain insight and information from.

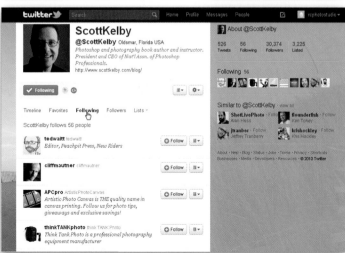

THE POWER OF SEARCHING TWITTER

I always tell people, "The power of Twitter is not in what you tweet, or who you follow. It's about what you can search for." Imagine if I told you there was a cocktail party of people talking about photography that was never-ending. You want to share your photography. They're talking about it. And it's free. Would you give it a shot? I would.

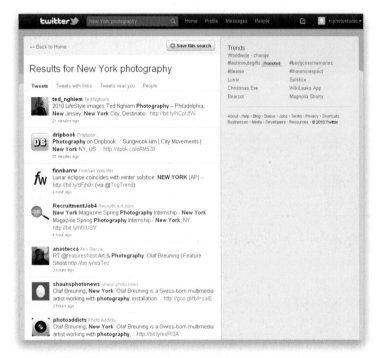

The Real-Time Web:

There are multitudes of people online tweeting away on this network. The beauty of this is the search function located at the top of the page. What if I wanted to see who was talking about New York photography? In the search field, I can type in "New York photography," and instantly, I would see only the comments that mention those keywords—in real time. As more people talk with those keywords, the results change.

This gives you a peek into what the Twitter-verse is talking about *right now*. Do a search for photography in your area and if you see people chatting about it, you can reply to those individuals and let them know about your work and your website. These are people that would most likely not be aware of your website. By reaching them in the places they're visiting, you're instantly introduced to a new audience. The more people you get in contact with and share your work with, the more people will follow your work. The more people follow your work, the more that can establish your credibility from a marketing point of view, which can hopefully then be converted into new business.

The ability to do this at zero cost is why I think Twitter is one of those things that people should consider as part of a multi-pronged social strategy. To learn more about Twitter visit http://support .twitter.com.

Monitor Twitter with Tweetdeck:

Tweetdeck (www.tweetdeck.com) is another way to search. It's a free program that allows you to look at your Twitter account in column form. One column is dedicated to seeing the conversations of the people you "follow" and another is dedicated to the people who follow you.

Searching with Tweetdeck:

Similar to what we did when searching Twitter, in Tweetdeck, you can create columns that are dedicated to keywords you've plugged in. In a few seconds, the program will go out and find those conversations and put them in the list for you to review. Here's a Tweetdeck setup that I can leave open, having Twitter just keep an ear out for things like Kelby Training, Photoshop, and WordPress.

Keep in mind that just because it's free, doesn't mean it won't take up time. Having access to all of these conversations in once place is very likely to taunt you and make you want to sit and watch it…all day. Don't let this happen to you. This is just *part* of your marketing, not all of it. Remember, you need to be out there shooting!

CREATING AND USING A FLICKR ACCOUNT

Whether for photographic inspiration, or as a solution for ad agencies looking for an image for their marketing material, Flickr has become this mega-site where you're not only sharing images, you're making commerce, and increasing your brand. This, too, in small parts should be a component of your overall strategy.

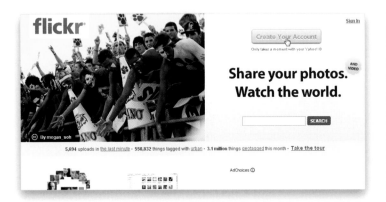

STEP ONE:

Open your Web browser and navigate to www .flickr.com. If you do not have an account with Flickr, you will see a Create Your Account button in the upper right-hand corner of the screen. Click it and set up your new account.

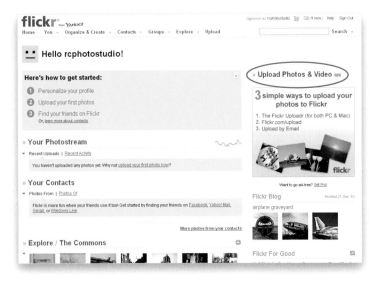

STEP TWO:

Once you create your account, your Home page will give you an overview of your account, the things that are left to do to complete your account process (most are optional), and a look at your current Photostream. A Photostream is the running total of all of the pictures that you have added to your Flickr profile. Right now, this is empty, but we are going to change that in a minute. Click on the Upload Photos & Video link near the top right to upload an image.

STEP THREE:

The next page shows you the steps you'll need to follow, so click on Choose Photos and Videos. This gives you a standard Open dialog, where you select the images that you want to upload from your computer and click Open. I selected an image that I exported from Lightroom onto my desktop. Once the image shows up in my Upload to Flickr box, it will give me the file size of the image, and a running total of the number of images I want to publish. You also can select who gets to see these pictures under Set Privacy. Flickr lets you limit the viewing to Friends or Family only. Truth be told, I don't publish private pictures on Flickr. I am always using this to showcase images for the public, so I am going to leave it set to Public. When you're done, click the Upload Photos and Videos button, and as the images are uploading, you'll see a progress bar, letting you know how far along you are in the upload process.

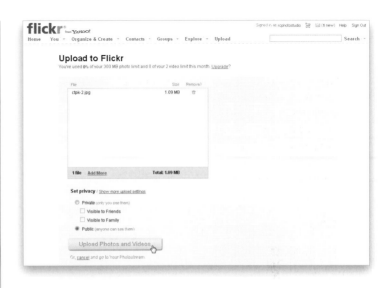

STEP FOUR:

The next step is, I think, the most important part of the process. Once the upload is complete, click on the Add A Description link. It is always a good idea to add this information to your images, as this is the way the general public will find out about your work. Be descriptive here. Give an overall summary of what the picture is, including as many keywords as you can in your description. Also, make sure you add those keywords in the Tags field at the bottom. This picture is of Central Park, so keywords like Central Park, New York City, NYC, Great Lawn, and NY are appropriate. I also like to include my website URL in the description to give the reader a chance to visit my site. Once that is complete, click the Save button.

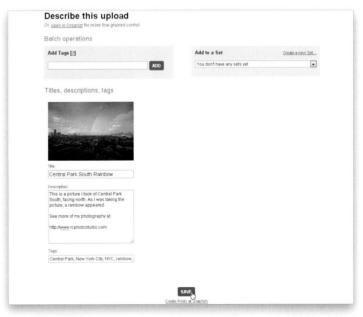

< CONTINUED >

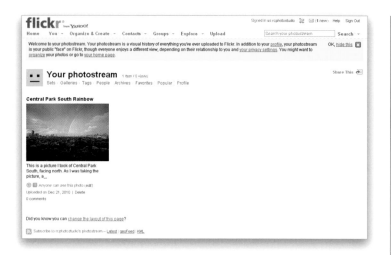

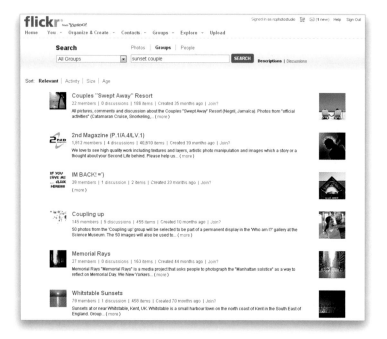

STEP FIVE:

Your picture will now appear in your Photo-stream, and it's also visible for everyone to see. When users of Flickr search for Central Park, NY, this picture will be one of the pictures that will show up. When a user reads the description and sees my website address, there will be additional motivation to visit my site for more pictures.

TIP: Use Flickr Groups

If you want to see where people are looking for images, you can take a spin around Flickr Groups. Flickr users like taking images that share a common theme and creating a group for them. Sometimes, people who visit your images will ask if you want to be a part of a group. This will definitely get more views for your image. However, it often pays to go out to your Groups page and search for topics based on the keywords in your images. Let's say you have a shot of a couple at sunset in your Photostream. Go to your Groups page and search for "sunset couple." If there's a group for that, ask to join it. This gets you out there even more.

CREATING AN AMAZON AFFILIATE ACCOUNT

As photographers, we can't help but talk about gear and techniques. Be it to illustrate a point or to share a technique, gear invariably slips into our conversation on a near constant basis, and it will do so on your blog. There's no reason not to see if you can make an extra few bucks on it when it does. First up: let's talk about Amazon.com.

STEP ONE:
At the bottom of the Amazon.com page, you'll see a section called Make Money with Us. Below that header, there's a link to join the Amazon Associates program. Click on that to begin the process.

STEP TWO:
There are a couple of different ways to promote products from Amazon on your websites. You'll have access to the whole lot of them as soon as you sign in or create an account for yourself. They will ask you a ton of questions about your site, your traffic, and what topics you intend to cover. Use the statistics from your Google Analytics to fill out information on your page views. I tend to round up with them.

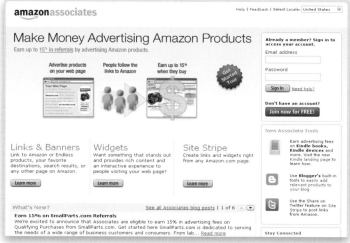

< CONTINUED >

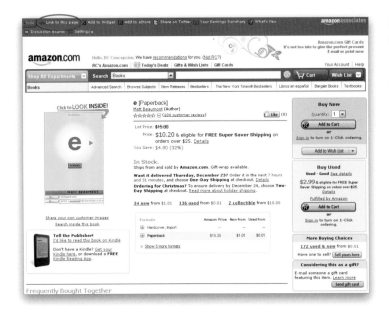

STEP THREE:

Once you've completed the form and have been accepted into the program, you can sign into Amazon.com with your Amazon Associates account login. It'll look just like the regular Amazon website, but you'll see that there's a gray bar across the top. You'll be able to browse and search the site normally, but if you get to a product or category you like, you can click the Link to This Page button to get a link to use on your website.

STEP FOUR:

You have a couple of options for how to get your link, from a traditional text link to an image link, all the way up to a text and image banner for your page. Pick the one you want to use and paste it into a post in WordPress to appear on your website. (*Note:* To use the code that's generated here, you need to enter the code in the HTML tab.)

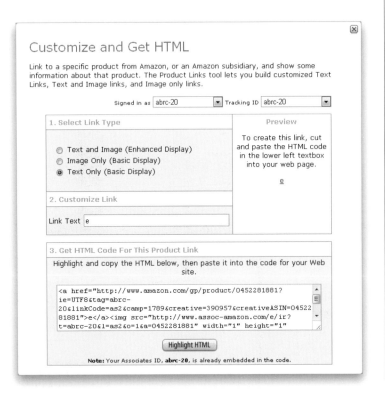

CREATING A B&H AFFILIATE ACCOUNT

Much in the same way as the Amazon.com account, you can also create an affiliate account with B&H Photo. Because a lot of what we do is photographic in nature, having an affiliate account with them could pay off even more, as you talk about photography.

STEP ONE:

At the bottom of the B&H website (www.bhphotovideo.com), you'll see a link to take advantage of their Affiliate program. Fill out the information and click on any confirmation link you get in an email to you. This will start you on the path of becoming an affiliate.

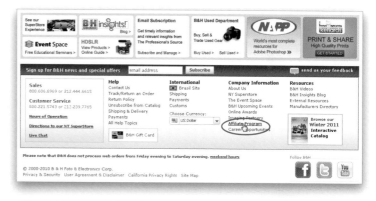

STEP TWO:

After you are an affiliate, all you need to do is log in to their website and click on the Get Links tab. Search the categories and brands they have listed for the item you'd like to create a link for, click on it, and a new window will appear. This will show you a series of promotion types that you can choose. Click on the one that's appropriate to your post, paste the code for it into a post in WordPress to appear on your website, and you're off to the races! (*Note:* To use the code that's generated here, you need to enter the code in the HTML tab.)

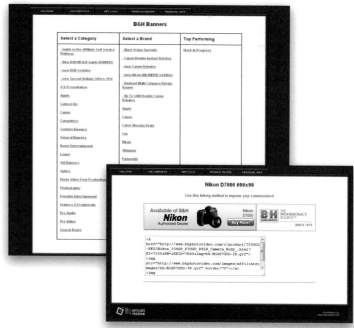

ALONG THE WAY
scott kelby, photographer & blogger

Scott Kelby is Editor, Publisher, and co-founder of *Photoshop User* magazine, co-host of the top-rated weekly videocast *Photoshop User TV*, and co-host of *D-Town TV*, the weekly videocast for DSLR shooters. He is also the President and co-founder of the National Association of Photoshop Professionals (NAPP), the trade association for Adobe® Photoshop® users, and he's President of the software training, education

Scott is a photographer, designer, and an award-winning author of more than 50 books, including *The Digital Photography Book*, volumes 1, 2 & 3, *The Adobe Photoshop Lightroom Book for Digital Photographers*, and *The Adobe Photoshop CS5 Book for Digital Photographers*. His blog, *Photoshop Insider*, covers everything photography, from equipment, to shooting, to editing your shots.

What originally interested you in starting a blog? How did it come about?

Being a magazine publisher, you basically get to talk to your readers once a month, so what I wanted was a way to communicate and interact with my readers more often. Since I do a lot of public speaking at seminars, one of the things that really appealed to me was that I could have a way to let people know where I was speaking in between magazine issues. This was a perfect way for me to reach out to people who I wanted to come to my seminars, to talk to them, and to basically inform them about different projects I was involved in.

Is the blog something that you work on all the time, sporadically, or as the need arises?

I work on it all the time and until recently, I used to blog four days a week. I started blogging pretty regularly a few years back, doing it five days a week, until I realized I needed a break in the middle of the week. So, I decided to skip Wednesdays. But, then a friend, Vincent Versace actually, talked me into turning Wednesdays into "Guest Blog Wednesday," where I turn my audience over to someone else for a day. I've also just recently consolidated all of my seminar appearances, book news, etc., to Thursdays. My photo assistant, Brad Moore, does a Thursday post for me, which is basically all self-promotion kind of stuff.

Which helps which? Does the writing help you become a better photographer, or does the photography make you a better writer?

The photography part forces you to write. It doesn't necessarily make you a better writer, but it does make you a more frequent writer. When I take photos, I want to share them, along with the stories behind them. I want to share my settings, the background info, and things that happened, because I think the story is sometimes just as interesting as the photo. So, I think the writing has caused me to slow down and think more when I'm shooting and that's a good thing.

What do you do when you can't come up with anything to write? How does it differ from photographic "writer's block"?

I actually keep a separate document of ideas for when I'm stuck and at any given time, it probably has about 40 topics. Every time I think of a new idea I put it in there. So, if I get stuck, I can just open it up and pull one from there. I'll think

< continued >

< CONTINUED >

of topics throughout the day and just add them to that list. I think of writer's block as not being able to start an article. Since a blog's more conversational, as long as I have a topic, the rest is fairly easy. It's coming up with a topic that's the hard part.

What is the benefit of having a blog? Fame? Fortune? Promotion?

I think it's all of these and more. I think the biggest benefit is building an audience and building the community. It certainly helps your name recognition and it'll certainly help you if you have any kind of a product to sell. Now, while I wouldn't recommend starting a blog just because you have a product, do I think there are other opportunities for a photographer to start a blog? Absolutely! In self-promoting, you can publish your own work anytime you want without having to get permission. Normally, if you want your images to appear in a magazine or in something else, you'd have to get the permission of a publisher, and all that that involves. When you have a blog, you are the publisher and you decide what gets published and when, which I think is a very powerful and fun thing.

If you had one piece of advice to give to people about blogging, what would it be?

My advice would be to blog consistently. But, don't be stupid like I was and blog five days a week. Pick three days a week or blog every Tuesday and Thursday or blog every weekend. Whatever you decide to do, be sure to let people know when you'll be blogging and then always blog on those days. It's the consistency that builds your traffic. If people know that you have something new, they'll want to check it out. There are great rewards in blogging, but like with anything else, you don't get great rewards without putting in the effort. So that's my advice—blog consistently, even if you have to put up a post that says, "I have nothing to share today." It's important to put something there and build a connection with your readers.

" FTP stands for File Transfer Protocol, and it's a way to upload and download stuff on the Internet. "

CHAPTER ELEVEN
adding web galleries with FTP

Doing Something Different

Once you have your website set up, getting content onto it is easy—you create a new page or post in WordPress, plug in the content, and publish. However, there will be times when you'll need to do something different.

For example, what if you take some holiday pictures for your neighbor? You're going to want to get those images online somewhere for them to look at, where they can select the ones they want, so then you can send them over to Mpix to be printed. But, you don't want them to appear on your regular blog. I tend

to call these kinds of image galleries "external" galleries (or "one-off" galleries), because you can't build them in WordPress. Instead, they are most likely built by exporting them from Lightroom or Bridge. Now, this is something that your website isn't prepared to do for you. Or is it?

Go back to the house analogy I made in Chapter 1 when talking about your site. While it can be as big as you want to make it, you do need to specify a place to help make all of this happen (someplace other than WordPress). The fact of the matter is,

you have a way to do this by just understanding a couple of concepts on your site: how to access your website's folders on the Web and what you use to access them. We'll be using FTP here.

What Is FTP?

FTP stands for File Transfer Protocol, and it's a way to upload and download stuff on the Internet. When you signed up for a hosting account (in Chapter 1), you were given access to your website using FTP.

In order for you to connect to your website and place a folder on it, you're going to need to download a program first. These programs (called "FTP clients") are designed to make this upload and download easier, and there are tons of free and pay-based FTP clients out there. FileZilla offers a pretty good free application, so in an effort to keep things free, that's the one we're going to use. Hey, you bought this book—it's the least I can do!

Generally, when you're trying to connect to your site, you will need three things: an FTP site address (which is usually your website address), a username, and a password. We know the URL for our site—mine is www.rcphotostudio.com—and the username and password we set up back in Chapter 1 when we set up our hosting provider, so we're good to go. If you are using a different hosting provider, this information most likely came to you in a "Thank You" type email when you registered with them.

After installing the FTP client, you enter in all of this information and connect to your website. Once you are connected, the hardest part is over. Uploading and downloading files and folders from your website is no different than using Windows Explorer on a PC or a Finder window on a Mac. If you can copy-and-paste or drag-and-drop a folder on your computer, FTP is going to be a breeze for you.

How Folders Translate to Web Addresses

When you connect to your website using FTP, you're taken to an area called the "site root." This area is the start of your website, and contains folders that can take you into different areas of your site. Think of this area like opening the front door to a house and standing in the foyer. You can stand in the foyer (the site root folder) and stare at all of the rooms (other folders), and you can go into those rooms. Those rooms, in turn, can

have other rooms in them, taking you further into the house—or in this case, further into the website. At any point, you can leave the rooms (known as navigating up) to get back to the root of the site.

When you want to be able to access those folders in a website, you can simply put their name after a forward slash (/). For example, if I placed a file called tree.jpg in a folder called myimages in the site root folder, I can access it by going to www.rcphotostudio.com/myimages/tree.jpg.

Keep in mind that all filenames and folders should not contain any spaces and should always be lowercase. We'll test examples of this here in this chapter.

Organization Is Key Here

The hardest part about doing all of this is organization. When someone asks me how to upload external galleries, I always say that it's best to create a specific folder where all of them can live. For instance, I'm going to create a folder called client_shoots in the site root folder, and place all of our external galleries there. Because of this, I know that whenever I give out the address to these galleries, it's always going to start with www.rcphotostudio.com/client_shoots/ and then the name of the folder I export out of Lightroom or Bridge.

We're not going to be doing anything super-technical in this chapter. We're going to create folders, then we're going to drag folders into one another, and that's pretty much it. The only thing that's "advanced" here is just understanding how these subfolders translate to a website address, and how to use this organizational structure to keep all of these "one-off" galleries easy to find, and easy to make.

USING AN FTP CLIENT: FILEZILLA

FTP clients are programs that let you connect to your website using FTP. If you're familiar with using Windows Explorer on a PC or a Finder window on a Mac, you should breeze right through this. You will need to have your FTP address (your website's URL), username, and password (the ones you created in Chapter 1) to get in.

STEP ONE:
Go to http://filezilla-project.org and download the FTP client for your PC or Mac. The installation is pretty simple and its cost is right on the money—it's free!

STEP TWO:
Once you've installed FileZilla, launch it, and you'll get the FileZilla window. From the File menu, choose Site Manager to open the Site Manager dialog. Create a new site by clicking on the New Site button on the left. A highlighted field will appear at the top of the Select Entry section, where you can name your site. Give your site whatever name you'd like, but the most important parts here are the host name (which is your website address), your username, and password. So, in the General tab on the right, enter your URL in the Host field, choose Normal from the Logon Type pop-up menu, and then enter your username and password.

STEP THREE:

Click on the Connect button and you will see that the right side of the FileZilla window now shows you a "remote" view of your website. This is what your folders look like on your website. There will be some stuff there that you may not recognize, but for now don't pay too much attention to it. The important part here is that you're connected! Moving information from your computer to your website is now as easy as dragging it across windows.

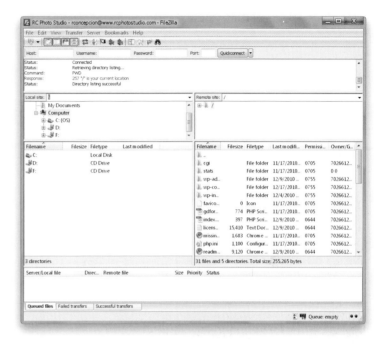

STEP FOUR:

Let's test this. I've placed an image called alan .jpg on my desktop (you can use whichever JPEG file you want, just keep it small). In the Local site directory (on the left side of the FileZilla window), navigate to the JPEG on your desktop and then click-and-drag it to the Remote site directory (on the right).

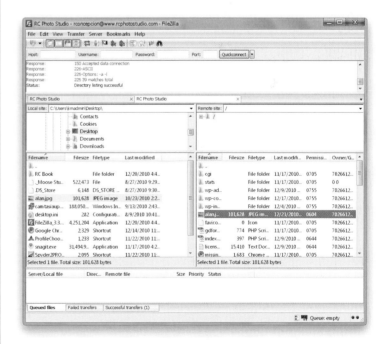

< CONTINUED >

STEP FIVE:

Open a Web browser and type in the address to your website, followed by a forward slash (/), and then the name of the JPEG file. In my case, I'm going to type in the following: www.rcpho-tostudio.com/alan.jpg

Congratulations! You've just uploaded your first image to the Web using FTP!

STEP SIX:

I want to remove this JPEG file now from my website, so I'll just Right-click on it in the Remote site directory and choose Delete from the pop-up menu. Refresh your website page and you'll see that the page is no longer found.

Now that we're able to do one file, let's work on taking an entire gallery online.

DRAGGING FILES AND FOLDERS FROM YOUR DESKTOP

While dragging files and folders from one column to another is pretty easy, I usually find myself just dragging my files and folders right from my desktop into the Remote site directory (instead of finding them in the Local site directory and dragging them from there). Let's take a look at exactly how to do that.

STEP ONE:

For this example, I took the alan.jpg file and I placed it in a folder on my desktop called sampleimages. After connecting to my site with FileZilla, I made the window small enough to be able to see my desktop on the left side of the screen. From here, all I have to do is drag the folder onto the Remote site directory on the right side of the window. Be careful, though. If you drag the folder on top of another one, you will be placing that folder inside of another folder. Drag it beneath the folders, where all of the individual files are.

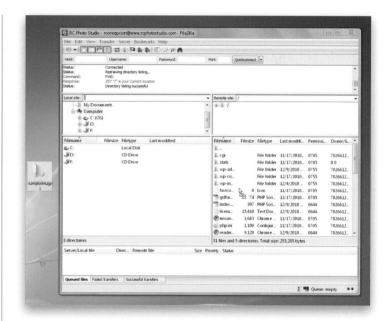

STEP TWO:

Because this image is now in the sampleimages folder, I need to make sure that I add that to the website name, along with a forward slash. So, to get to this image on my website, the URL would be: www.rcphotostudio.com/sampleimages /alan.jpg.

(*Note:* When uploading files and folders to your website, you should never use spaces when naming them. If you need to separate words, always use an underscore. For example, if I wanted to name a file "my mother taking a walk.jpg" it would be: my_mother_taking_a_walk.jpg.)

< continued >

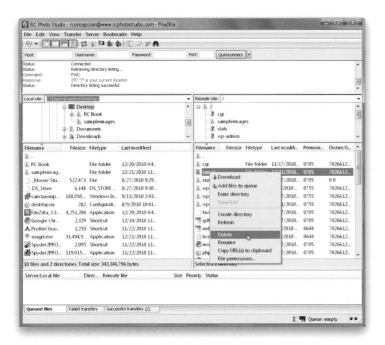

STEP THREE:

As we did before, to delete the folder, simply Right-click on it in the Remote site directory and choose Delete from the pop-up menu. You can also click on the folder and press the Delete key on your keyboard. When you refresh your web-page, you'll see the image is no longer found.

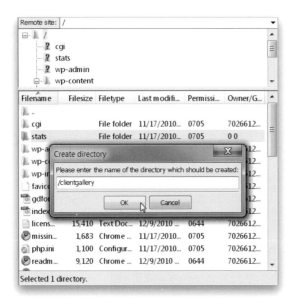

STEP FOUR:

Also, if you'd like to create a folder in a specific area right on your website, simply Right-click anywhere in the Remote site directory and choose Create Directory from the pop-up menu. In the Create Directory dialog, give your new folder a name, click OK, and you now have a new folder on your website where you can place images. For the purposes of what we'll be doing here, let's create a folder called /clientgallery (you need the forward slash to separate it in your URL) in the site root folder and store all of our one-off galleries there.

NAVIGATING UP AND DOWN IN YOUR WEBSITE'S FOLDERS

One of the most common things that you'll do when using FTP is navigate up and down the website folders to drag files and folders. It's probably a good idea for us to check out how to move around these areas from within FileZilla.

STEP ONE:

Once you've connected to your website through FileZilla, you'll notice that you have a series of folders available for you to navigate in the Remote site section of the window. If you double-click on any one of them, you will be taken inside that folder and you'll be able to see the contents of it. At the top of the bottom Remote site section, there's a folder called "..". This folder serves as a way for you to go "up" to the site root folder on your drive, much in the same way you would do this on your computer. Double-click on the wp-content folder to see its contents. You'll see that in that folder there's a subfolder called themes. Double-click on that folder and you should see a couple theme folders inside (these are the themes that you have installed in WordPress, and where you would replace them if needed). You'll notice that you can also navigate your folders up and down in the top Remote site section. So, you can choose to use that tree structure, or the bottom section—it's up to you.

STEP TWO:

If you decide to double-click on the .. folder at the top of the bottom section, you will go up one folder to that parent folder. In this case, it's the wp-content folder.

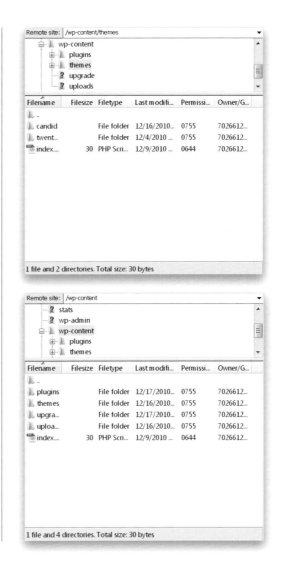

< CONTINUED >

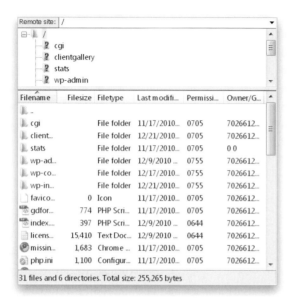

STEP THREE:
Double-click on the .. folder again, and you're right back at the top of the website in the site root folder. This is the most common way to navigate down into a website and back up to the site root. Pretty easy, huh?

(*Note:* If you're visiting here from Chapter 7 to learn how to use FTP to install a theme, or from Chapter 9 to upload a Flash portfolio folder, you should have all of the skills you need now. You can come back and check out the rest of the chapter later.)

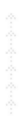

CREATING A WEB GALLERY USING BRIDGE

If you are using Photoshop, one of the easiest ways for you to create a one-off Web gallery is to create it from within Bridge CS5. Bridge offers you the ability to create either an HTML or Flash-based gallery that you can use to share individual photo shoots on your website.

STEP ONE:

Once you have the series of images you'd like to create a gallery for, navigate to that folder using the Folders panel in the top left of Bridge, press Ctrl-A (Mac: Command-A) to select all of the images, and then click on the Output workspace at the top right of the window.

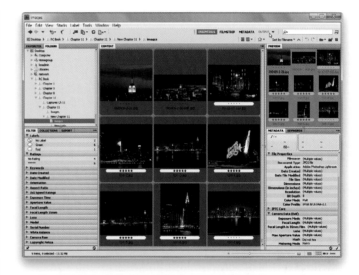

STEP TWO:

The Output workspace allows you to export as a PDF or a Web gallery. Since we're creating a Web gallery here, click on Web Gallery at the top of the Output panel. A bunch of options will appear in the panel for you to customize your gallery. I like using the Airtight SimpleViewer gallery, so I'll chose that from the Template pop-up menu. Be sure to enter a name for your gallery in the Site Title field in the Site Info section at the top of the panel, as this is the name that will be visible at the top of the browser window. Also, make sure to turn on the Caption checkbox in the Image Info section and select Filename from the pop-up menu, so that your client is able to see the name of the file. They're going to need this to order your images! Make any other changes to your gallery from the other options in the panel and then click on the Refresh Preview button to see in the center window how your gallery will look.

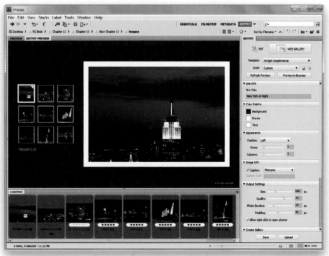

< CONTINUED >

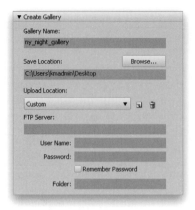

STEP THREE:

The Create Gallery section at the bottom of the Output panel is the most important section here. This is where you'll specify where you are going to save the gallery on your computer (you also have the option of uploading it via FTP right from within Bridge; you just need to enter your FTP info). In the Gallery Name field, enter a name for the folder in which you'll save your gallery files. Be sure not to name this folder the same as the Save Location or you'll wind up with a folder within a folder—not good. Also, when you choose the gallery name, make sure that it's all lowercase. Do not use spaces at all with this folder name because some Web servers have problems reading spaces. Like I've mentioned, if you need to use spaces, use an underscore. Here, I've named mine ny_night_gallery, all lowercase, with no spaces. Next, click on the Browse button to the right of Save Location and choose where you want to save this folder.

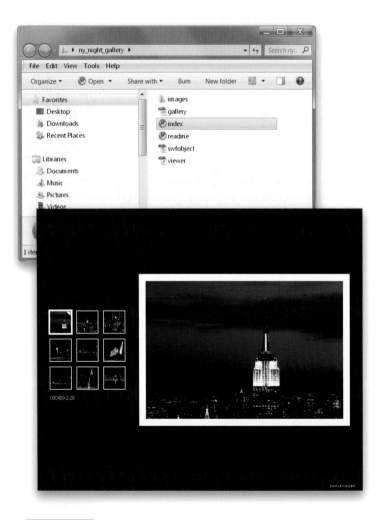

STEP FOUR:

Now, just click the Save button at the bottom of the panel and you'll see you have a folder containing your Web gallery wherever you chose to save it. Open that folder, double-click on the index file, and it'll open in your Web browser for you to check out.

Now that you have your one-off gallery set up, you can drag that folder into the clientgallery folder you created inside of your website. We'll cover this more in the "Uploading Web Galleries to Your Website" lesson.

CREATING A WEB GALLERY USING LIGHTROOM

After importing images from a shoot into Lightroom, I suggest creating a collection with the images you want to export to your website. This will minimize the amount of time you need to spend searching for the images when your client makes their selections, and also prevents you from uploading more than you need to.

STEP ONE:

Create a collection of the images you want to appear in your Web gallery and then go to the Web module. In the Layout Style panel, you can choose from a series of templates for your gallery. I really like the Airtight SimpleViewer gallery, because of its ease of use and simplicity. Since this is a gallery that is going to be uploaded to my website just for client review, I don't really need a lot of the bells and whistles that other galleries might have. I'm a big fan of clean here. Be sure to enter a name for your gallery in the Site Title field in the Site Info panel, as this is the name that will be visible at the top of the browser window. Also, make sure to turn on the Caption checkbox in the Image Info panel and choose Filename from the pop-up menu, so that your client is able to see the name of the file.

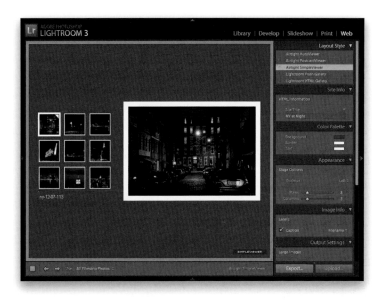

STEP TWO:

While I appreciate having an FTP client built into Lightroom in the Upload Settings panel, I think it lacks some of the features that other FTP clients have, so I don't use it. So, turn off the Put in Subfolder checkbox and click on the Export button to save the gallery.

< CONTINUED >

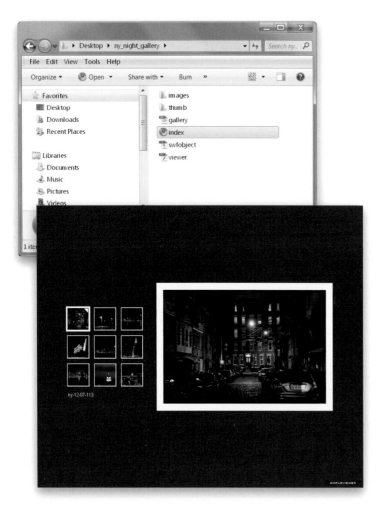

STEP THREE:
In the Save Web Gallery window that appears, name the folder in which you want to save your gallery, choose where you want to save that folder, and click Save. You'll now see you have a folder containing your Web gallery wherever you chose to save it. Open that folder, double-click on the index file, and it'll open in your Web browser for you to check out.

Now that you have your one-off gallery set up, you can drag that folder into the clientgallery folder you created inside of your website. We'll cover this more next.

UPLOADING WEB GALLERIES TO YOUR WEBSITE

Once you have your one-off galleries created, it's time to get them up on your website. I love setting up galleries like this, because it centralizes all of them in one spot. And I don't have to worry about password protecting the galleries, because someone would need to know the name of a specific folder in order to access it.

STEP ONE:

Now that you have your gallery created and exported, it's time to get it up on your website. Go to FileZilla and connect to your website. Navigate to the clientgallery folder in the Remote site section that we created earlier in the chapter and double-click on it to open it. You'll know that you're in the clientgallery folder when you see it highlighted in the top Remote site section. In the Local site section (on the left), navigate to where you saved your Lightroom or Bridge Web gallery. Once you've found the folder, click-and-drag it into the clientgallery folder in the Remote site section to upload it.

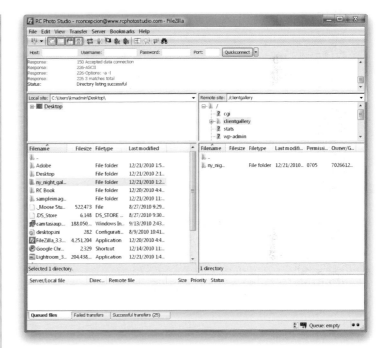

< CONTINUED >

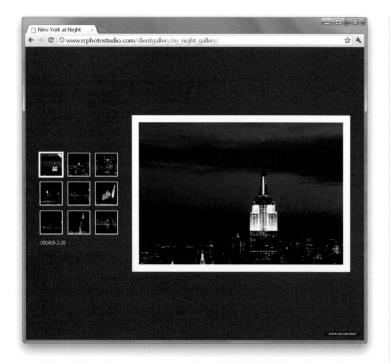

STEP TWO:

Open a browser window and navigate to the gallery page on your website. In my example, I am going to go to www.rcphotostudio.com /clientgallery/ny_night_gallery.

Congratulations! You have uploaded and tested your first gallery. Now, just send this gallery's URL to your client for them to make selections. Include in your email something along the lines of: "Take a look at the images in this gallery and write down the files that you would like to have printed. Once you have all of the ones you want, please email me the list of files."

TIP: Using Flash Galleries

I like to use Flash galleries like SimpleViewer, because they look cleaner, but they also prevent (to some degree) a person from Right-clicking on an image on your website, and saving it to their desktop (here, I've Right-clicked on the image and you can see there's no copy or download option). Now, this will cause a problem for devices with browsers that don't currently support Flash (like the iPad, iPhone, and some smart phones). So, if you feel that you want to make sure the greatest number of people see your content, select an HTML site, instead. Just know that it does increase the rip-off risk, so use things like watermarking and embedding of contact information on your files. By adding a simple watermark to your images or adding your copyright information into the metadata of the file, you can at least increase the chances that the person wanting to use the image can contact you, and the person who's looking to steal it will have a harder time doing so. Check out Chapter 2 for more on watermarking.

USING THE TTG CLIENT RESPONSE GALLERY

While it certainly is easy to upload a gallery to your website, and then email your client to let them know it's there, and then have them get back to you with their selections, sometimes you'd like to make the entire process all-encompassing. The TTG Client Response Gallery from The Turning Gate is a Lightroom gallery template that allows you to do just that.

STEP ONE:
Go to www.theturninggate.net and download the TTG Client Response Gallery (you can find it under the HTML Photo Galleries plug-ins. And you can download a trial version, if you want to check it out first).

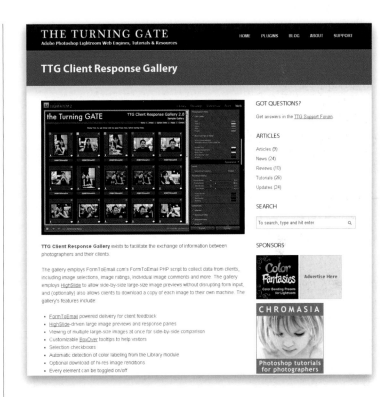

< CONTINUED >

STEP TWO:

When you download the gallery, you'll see a folder called ttg_clientResponse_DEMO.lrwebengine wherever you chose to save it (on a Mac, this will appear as a single file). You're going to move this folder/file into a folder on your computer, but in order to customize the email functionality of the gallery, you'll need to adjust some code first. So, unzip and open the folder (on a Mac, Right-click on the file and choose Show Package Contents) and inside you'll see a Resources folder. Inside of the Resources folder, open the FormToEmail file in Notepad ++ (or whichever text editor you're using). Scroll down to line 83 and replace what is within the quotes with your email address, as shown here.

STEP THREE:

Now, you'll need to move this folder/file into the following folder on your computer:

On a Mac: Users/username/Library/Application Support/Adobe/Lightroom/Web Galleries

Windows users: The AppData folder is usually hidden, so in your Windows Explorer window, go to Organize>Folder and Tool Options or Tools>Folder Options and in the View tab click on the Show Hidden Files, Folders, and Drives radio button to show the AppData folder before you browse to it.

In Windows Vista and Windows 7: C:\Users\username\AppData\Roaming \Adobe\Lightroom\Web Galleries

In Windows XP: C:\Documents and Settings \username\Application Data\Adobe\Lightroom \Web Galleries

STEP FOUR:

Once you've copied the folder/file over, restart Lightroom and in the Web module, you'll see a new gallery in the Layout Style panel called TTG Client Response Gallery. Customize your gallery as you'd normally do with any other gallery. You'll see in the Site Info panel that the TTG gallery has a lot of other fields, like Collection Description, that let you place custom messages into your gallery. Spend some time going over these fields to see how you can actually customize this gallery to your liking.

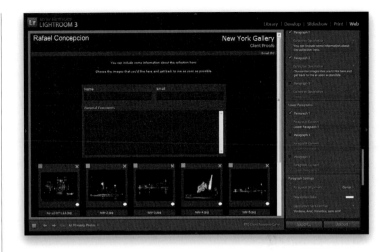

STEP FIVE:

Export the gallery like we did in the previous Lightroom lesson and then upload the gallery to your website. Here, I uploaded this gallery to the following address: www.rcphotostudio.com /clientgallery/ny_ttg. A client can now make selections and send information to you right from your website!

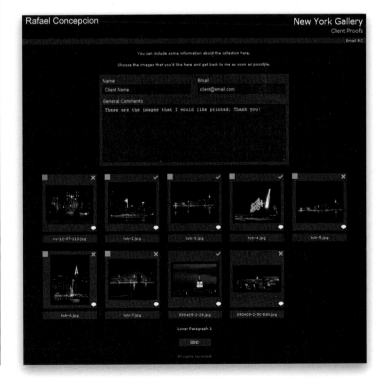

© ISTOCKPHOTO

CASE STUDY 01:

MOOSE PETERSON

WWW.MOOSEPETERSON.COM

THE PROBLEM:

Moose is a man of many talents: acclaimed photographer, research associate with the Endangered Species Recovery Program, writer published in over 143 magazines worldwide and author of 24 books, and lecturer, to mention a few. With so many years behind the lens, it's no surprise that he was also the owner of many websites.

"When I put up my first website in 1994, business was pretty simple. As time went on, the business grew, and I'd simply create a new website for the newest facet of the business. After a while, I needed a map to find them all. Galleries were on one site. Teaching seminars were on another. Videos were on another. In order to see everything, you had to go to several sites."

< 210 >

GET YOUR PHOTOGRAPHY ON THE WEB

To top it off, the site designs were a combination of hand coding, Dreamweaver, and some FrontPage extensions for navigations, which made the management of each site cumbersome.

Having separate sites for separate parts of Moose, people weren't able to see the breadth of what he can do. By combining all of the content into one spot, you get one site with a lot of traffic instead of a bunch of sites with a little traffic.

Also, putting so much information out there made it very easy for people to take the images for their own use. "The grabbing of my images on an hourly basis got really old, but more importantly, the main reason for folks coming to my site—my photography—was being devalued by those not respecting it. The goal of all our sites is to share our images and the story behind them to inspire others. But it's a labor of love, so protection is a must."

So, Moose needed to solve two problems here: having so many separate sites and his images being vulnerable.

THE SOLUTION:

WordPress with a Modified Theme from StudioPress

Because Moose had a lot of written content (over 2,000 pages), we needed a theme that would support a large amount of written information. This, combined with the fact that Moose combines blogging with article writing, videos, and multimedia presentations, made it apparent that he would need more of a news-y type theme. Studio-Press has got some great themes that you can install in WordPress to facilitate this. Customize some graphics and categories, and import all of the data, and we're off to a good start.

SWF Files

"What an easy solution to keep honest people honest. Using Image2SWF and a very simple line of handwritten text, we can share our images. It has brought online theft to nearly zero." Because Moose wanted to prevent individuals from hot linking his graphics, reading his content without visiting the site, or having someone Right-click on the graphic and save it, the majority of his images on his site are actually single-frame Flash (SWF) files. This prevents individuals from being able to save them locally, they don't show up in RSS readers, and it forces individuals to visit his site to view his images and read his content.

The Moosecam

"Tapping into the current trend of delivering content via video was at first very scary, but with such tools as CS5 Premier, QuickTime and blip.tv, we now have over 150 original video programs on our website with one million views in 18 months!" Video plays an important part in Moose's teaching of photography. When he's out shooting images, he takes a similar video of the scene and includes it in the post. Having video on your site can slow performance down, so he uploads the videos to his free blip.tv account. This allows users to see the videos on his site, using blip.tv's bandwidth, and exposes users of the blip.tv website to a new channel. This service will even aggregate the content to an iTunes podcast if you set it up correctly.

If you want to take a look at Moose's newest venture, the Air2Air workshops, or his most recent book, *Captured*, visit www.moosepeterson.com.

THE PROBLEM:

As NFL return specialist Devon Hester ran back a 64-yard punt from Chris Kluwe on December 20, 2010, there were tons of camera lenses trained on him. Every photographer was poised to capture a record-breaking moment. In the middle of all of the photographers, Michael McCaskey aimed his 400mm f/2.8 lens, smiling a little broader than everyone else. You see, Michael's not just a great photographer, he's the current chairman of the board of the Chicago Bears. Eschewing the skybox, Michael wanted to be right on the field when the moment happened.

Aside from running the Bears organization, Michael has been an avid photographer for several years. As he gets ready to retire, he is incredibly excited about being able to share this passion with the world, and wanted to have a website where he can showcase his work. Michael's portfolio includes a variety of images, from portraits from around the world, to sports, and even includes community events. He wanted a way for viewers to purchase these images should they want to.

THE SOLUTION:

WordPress with a Customized Theme from Themeforest

Michael wanted to have a clean layout that showcased his work. Using a GoDaddy.com hosting account, we installed WordPress and replaced the original 2010 template with a theme called Pacifica found at Themeforest .net. Pacifica was clean enough to give us a great visual start to the site, but required a little bit of reading to get it fully operational. The help files were great, and in no time we were setting up custom galleries and getting the website up and running.

Fotomoto for Selling Images

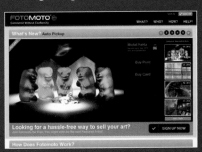

Setting up a website to showcase your images is one thing. Getting that website ready for e-commerce is something entirely different. Not wanting to jump into the technical deep end, we needed something that would quickly provide a way to sell images at specific prices, and let someone else deal with the fulfillment of the orders. Fotomoto provided a free service that took care of what images needed to be sold, at what price, and created an e-commerce solution without having to go back to the drawing board on the design of the website. Their service looks great as a complement to his images.

FotoMagico and YouTube for Slide Shows

Michael loves to give people the option of viewing his images in a slide show. While many online services allow you to make slide shows with your images, Michael wanted to have control over how they transitioned, and what music ran in the background. To achieve this, he creates his slide shows in FotoMagico and uploads them to his YouTube account. By being on YouTube, viewers who would normally not visit his site, stumble on his videos and track back to his site. This also helps in terms of bandwidth. YouTube does one thing extremely well: it serves up high-quality videos. By hosting his videos here, he can be assured that they will load up quickly, letting his website focus on delivering the pictures.

CASE STUDY 03:
KATHY PORUPSKI
WWW.KPORTRAITS.COM

THE PROBLEM:

Kathy Porupski works as a veterinary technician in Oldsmar, Florida. She spends her time getting animals of all shapes and sizes ready for their surgeries, something that she'll tell you is a great love of hers. What many people don't know of my friend is that she's a pretty talented shooter, as well.

Kathy spends her free time shooting dance photography in the Tampa Bay area, and manages one of the largest Meetup groups

in Tampa, the Tampa Bay Digital Photography Strobist & Photoshop Collective (www.meetup.com/photocollective). With her passion, projects, and groups, it is not uncommon to find her roaming the streets of Ybor City as often as she is in front of the ballet stage. More and more, she's finding herself working with different types of clients, and needs a Web presence to showcase her work.

THE SOLUTION:

WordPress with a Customized Theme from Themeforest

Kathy's website is a basic implementation of WordPress with a theme called Traject from Themeforest.net. After replacing the main logo at the top, the rest of the structure was already built. All Kathy needed to do was start adding content through posts and pages in the WordPress back end. This blog format also allowed her to share images on a more recurring basis, highlighting the breadth of her photography.

One-Off Lightroom Galleries

Kathy wanted to have a quick way to be able to share groups of pictures of her shoots with her clients, so most of her assignments are exported into Lightroom galleries that are uploaded to a specific directory on her site. This allows her to give her clients a custom URL for them to look at the images. From there, they can pick the images they would like to use, and send her an email with her choices.

Mpix Fulfills the Prints

Once the selections are made, Kathy logs into her Mpix account and uploads the images for printing. Most of the jobs are printed and shipped directly to her, but from time to time she is able to use their Boutique Packaging service to ship the images directly to her clients.

LEARN
PHOTOGRAPHY
ONLINE

Mastering photography, Adobe Photoshop®, and creative design has never been easier or more affordable. Subscribe today to receive unlimited access to our entire online training catalog, featuring exclusive classes from the photography world's most talented and gifted teachers.

for more information visit www.kelbytraining.com
or call 1.800.201.7323

Kelbytraining.com™
EDUCATION FOR CREATIVES

your world. our stock.

20% off orders over $50 USD

Whether you're a designer, advertiser, entrepreneur or blogger, we can help you tell your story with royalty-free photos, illustrations, video and audio. Say anything with iStockphoto.
www.istockphoto.com/kelbytraining-offer.php

iStockphoto®